Dreamweaver UltraDev 4: Dynamic Web Development

James L. Mohler and
Matthew E. Mooney

ONWORD PRESS

THOMSON LEARNING ™

Australia Canada Mexico Singapore United Kingdom United States

ONWORD PRESS
THOMSON LEARNING

Dreamweaver UltraDev 4:
Dynamic Web Development

James L. Mohler and Matthew E. Mooney

Publisher:
Alar Elken

Executive Editor:
Sandy Clark

Acquisitions Editor:
James Gish

Managing Editor:
Carol Leyba

Editorial Assistant:
Jaimie Wetzel

Executive Marketing Manager:
Maura Theriault

Executive Production Manager:
Mary Ellen Black

Production Manager:
Larry Main

Production Editor:
Tom Stover

Technology Project Manager:
David Porush

Cover Illustration:
Nicole Reamer

Cover Design:
Cummings Advertising

For more information, contact:
OnWord Press
An imprint of Thomson Learning
Box 15-015
Albany, New York 12212-15015

Or find us on the World Wide Web at
http://www.onwordpress.com

For permission to use material from this text, contact us by
Tel : 1-800-730-2214
Fax: 1-800-730-2215
www.thomsonrights.com

**Library of Congress
Cataloging-in-Publication Data**
is available for this title.

ISBN: 0-7668-4871-X

NOTICE TO THE READER

Publisher does not warrant or guarantee any of the products described herein or perform any independent analysis in connection with any of the product information contained herein. Publisher does not assume, and expressly disclaims, any obligation to obtain and include information other than that provided to it by the manufacturer.

The reader is expressly warned to consider and adopt all safety precautions that might be indicated by the activities herein and to avoid all potential hazards. By following the instructions contained herein, the reader willingly assumes all risks in connection with such instructions.

The publisher makes no representation or warranties of any kind, including but not limited to, the warranties of fitness for particular purpose or merchantability, nor are any such representations implied with respect to the material set forth herein, and the publisher takes no responsibility with respect to such material. The publisher shall not be liable for any special, consequential, or exemplary damages resulting, in whole or part, from the readers' use of, or reliance upon, this material.

■■ About the Authors

James L. Mohler

James L. Mohler is an Associate Professor in the Department of Computer Graphics at Purdue University. He has authored, coauthored, or contributed to thirteen other texts related to multimedia, hypermedia, and graphics topics. Professor Mohler has presented numerous papers and workshops at local, national, and international conferences, and has published articles in both academic and trade publications.

Mr. Mohler has been awarded several teaching awards and currently serves as webmaster for the School of Technology at Purdue University, lead developer for the Interactive Multimedia Development specialization within the department, webmaster for the Purdue University Virtual Visit web site, and executive editor for the *Journal of Interactive Instruction Development*.

He also enjoys serving as Praise and Worship Leader at Living Word Ministry Center in Frankfort, Indiana. James and his wonderful wife Lisa have three children, Meisha Danielle, Christian Alexander, and Treyton James. He can be contacted via email at *jlmohler@tech.purdue.edu*.

Matthew E. Mooney

Matthew E. Mooney is the World Wide Web Specialist for Agricultural Economics at Purdue University. He has presented numerous papers and workshops at local and national conferences, in addition to working at Purdue toward his Ph.D. in Educational Technology. Mr. Mooney has consulted for numerous Fortune 500 companies, taught at five different colleges or universities, and has served as the webmaster for university departments, centers, and grants.

In addition to his academic and professional responsibilities, he also enjoys playing bass guitar with a variety of groups and plays golf whenever he can. Matthew and his wife Beth Bourdeau keep very busy with school and their six pets: Gidget, Daisy, Peanut, Steve, Cassie, and NiiJii. He can be contacted via email at *memooney@purdue.edu.*

■■ Acknowledgments

I would like to thank my wonderful wife Lisa, who has been patient and loving while I have spent endless hours in the office.

James Mohler

Thanks should go to so many people who have encouraged me along the way. I would like to thank my wife, Beth Bourdeau, for her patience and support while I spent many hours glued to my laptop writing. I would also like to thank my family in Michigan and Arizona for their encouragement and support. Finally, thank you to my friends and colleagues, who offered support, words of advice, and encouragement. Unfortunately, I cannot list all of your names here, but please know that you all receive my heartfelt thanks and gratitude.

Matthew Mooney

We would also like to thank the wonderful team at Delmar for all of their support on this book. Authors are only a part of a much larger team. Thanks should go to acquisitions editor Jim Gish, project manager Tom Stover, managing editor Carol Leyba, and editorial assistant Jamie Wetzel.

This book is dedicated to the memory of Spunky.

Our lives will never be the same.

Contents

Introduction

As the Web continues to grow, developers are being asked to be even more productive. Five years ago, a webmaster was a person with some programming or graphics experience who developed HTML pages. That job description has changed a lot in the last few years. Web sites have also changed a lot in recent years. Long gone are the days of having a web site that just sits on a server and looks pretty.

Sites need to be interactive and engaging. This book introduces you to the world of dynamic web development. With the techniques demonstrated in this book, you can begin truly interacting with and engaging your users, giving them a reason to come back to your site, time and time again.

Life is dynamic, and so is the Web.

■■ Purpose and Approach

The authors are both educators. They have devoted most of their time to helping others learn how to utilize technology. This book is a result of their collaboration and hard work.

The goal of this book is to provide the reader with foundational skills that can be combined as needed. The basic techniques discussed are intended to help readers follow a logical learning process that continually builds on previous knowledge.

Part I focuses on basic design and planning aspects a developer should consider. Part II deals with essential skills needed to take advantage of the power of UltraDev.

To place the exercises presented in this book in context, a fictitious organization named Pedal for Peace is used in many of the examples. Using Pedal for Peace in the examples may give readers some ideas of how to use UltraDev to better manage the content on their web sites. The examples and exercises provided in this book are intended to help readers learn the basics of Dreamweaver/UltraDev, with readers' practice of these basics serving as a springboard to further knowledge of the software and application to more complex situations and projects.

■■ Audience and Prerequisites

This book was written for developers, educators, and students who want to learn how to use UltraDev to enhance their web development skills, classes, and projects. This book assumes prior web development experience and some knowledge of Macromedia Dreamweaver, perhaps limited to the Dreamweaver tutorials.

Many other books on UltraDev spend hundreds of pages teaching the reader how to use Dreamweaver. This book is different. We assume you already understand some basic Dreamweaver terminology and have some basic Dreamweaver skills. We focus on the uniqueness of UltraDev for the majority of this text. Chapters 4 and 5 address some basic application settings and discuss the importance of planning during the development cycle of a dynamic web site. If you are new to Dreamweaver and UltraDev, spend some time completing the Dreamweaver tutorials included in your package.

■■ How To Use This Book

Although many people, the authors included, tend to skip ahead in a technical book, we strongly urge you to start with Chapter 1 and continue from there. Even though some of the material may not be new to you, a short review can only help.

As you begin the exercises, read through each exercise before trying it, to get an idea of what you should learn from it. The exercises are structured so as to build on one another as you progress through the chapters. Each skill learned will be used in a later chapter. This allows you to continually practice and work toward mastering a technique.

Each exercise has one or two key elements or skills to be learned. After you have completed an exercise, think about what skill(s) you have learned and how you could apply the same idea to a project you are working on or have worked on in the past.

■■ Content and Structure

The content of this book is structured as follows. Part I includes chapters 1 through 3. These first three chapters focus on preparing to use UltraDev. Developing dynamic sites means thinking about a site in a different manner. Chapter 1 addresses some of the concerns with developing a dynamic site.

Chapter 2 examines using databases on the Web. There are a number of common pitfalls that are outlined in Chapter 2. Creating a flexible and usable database is a key element in creating a powerful dynamic site.

Chapter 3 provides a short description of ASP, JSP, and Cold-Fusion. A simple comparison is provided to help readers see

the fundamental differences among these three server models and how they function.

Part II includes chapters 4 through 10. Chapters 4 and 5 examine setting up the application and planning the structure of your site. These are crucial steps that should not be overlooked. Without proper planning and correct settings at the beginning, UltraDev is nothing more than an HTML editor.

Chapter 6 is where you begin working with dynamic content delivery. This chapter illustrates how to take data from a database and display it on a web page.

In Chapter 7 you begin interacting with the information found in a database. In this chapter, you will learn how to insert records, delete records, and modify records in a database over the Web.

Chapter 8 examines new features included in UtlraDev 4. These features enable a developer to restrict access to information in a web site based on a login procedure.

Chapter 9 outlines the use of extensions within UltraDev. Extensions allow developers to continually enhance their application of UltraDev by creating new features and shortcuts.

Chapter 10 is where the power of UltraDev can really be seen. Chapter 10 includes numerous advanced examples. These examples utilize features of the application other texts and manuals have not addressed, such as commands. In addition, Chapter 10 provides examples of combining techniques to create sophisticated web applications.

A glossary, several appendices, and an index round out the book. See the following section for more information on the purpose and content of these elements.

▪▪ Book Features and Conventions

The sections that follow describe the book features of, and text conventions used in, this book.

Book Features

In addition to a companion CD-ROM found at the back of the book (see "About the Companion CD-ROM" at the end of this introduction), this book includes a glossary of terms associated with the technical aspects of Dreamweaver/UltraDev. The glossary provides explanations of the acronyms and abbreviations used throughout the book. In addition, the glossary offers definitions of basic web development terminology.

Appendices A through F provide further information on various aspects of Dreamweaver/UltraDev. Appendices A through E provide lists of reserved words in ASP, JSP, ColdFusion, SQL, and MySQL. Avoiding the use of these words when naming variables, tables, or database fields will help prevent errors and confusion as you develop. Appendix F demonstrates how to create an OLE DB (database) connection. OLE DB connections tend to have better performance than ODBC connections.

Text Conventions

Italic font in regular text is used to distinguish certain command names, code elements, file names, directory and path names, user input, and similar items. Italic is also used to highlight terms and for emphasis. The following is an example of the monospaced font used for code examples (i.e., command statements) and computer/operating system responses, as well as passages of programming script.

```
var myimage = InternetExplorer ? parent.
cell : parent.document.embeds[0];
```

The following are the design conventions used for various "working parts" of the text. In addition to these, you will find that the text incorporates many exercises and examples.

 NOTE: *Information on features and tasks that requires emphasis or that is not immediately obvious appears in notes.*

 TIP: *Tips on command usage, shortcuts, and other information aimed at saving you time and work appear like this.*

 WARNING: *The warnings appearing in this book are intended to help you avoid committing yourself to results you may not intend, and to avoid losing data or encountering other unfortunate consequences.*

 CD-ROM icon: This icon points to files and directories on the companion CD-ROM that supplement the text via visual examples and further information on a particular topic.

■■ About the Companion CD-ROM

The companion CD-ROM included with this book is very important. You will be prompted in many exercises to copy specific files or directories to the hard drive of your computer. The CD-ROM includes 30-day trial versions of Macromedia UltraDev for both Macintosh and Windows. All Macintosh-specific files are located in the folder named *Macintosh*.

The CD-ROM also includes all databases associated with the exercises presented in the chapters. Unless otherwise noted in the text, these databases can be found in the *Databases* folder. The *Pedal4Peace* folder contains the database and site structure associated with exercises in chapters 6 and 7. The *Chapter 8* folder contains a modified database used in that

chapter. Microsoft Excel versions of the database tables are included in the *Macintosh* folder.

 NOTE: *Databases that have been copied from a CD-ROM to a hard drive are occasionally set to Read Only. Right click on the database file and select Properties. If the Read Only check box is checked, the Read Only restriction is in effect. To remove this restriction, click once to remove the check mark, and then click on the OK button.*

PART I

Web Development Concepts

Introduction to Dynamic Development

■■ Introduction

The amount of information available on the Web is staggering. We can do research on products we might purchase, buy and sell merchandise, track our favorite team's record, and even order pizza. This is quite impressive, considering that in the mid 1990s most people had no idea what the Web was or saw the Web as a passing fad.

In recent years, we have found the Web to be an indispensable tool that most people could not live without. We can surf the Web from our cellular phones and PDAs. We get up-to-the-second news, stock quotes, and weather.

Late-breaking news and information on the Web has created a demand from users to have access 24 hours a day, 7 days a week, to whatever they deem important. Users expect customized web sites providing them with the specific information they want. Highly customized services mean that static web sites are no longer all that useful. Web sites need to be con-

stantly updated to keep users coming back. This need is where dynamic development comes into play.

■■ Objectives

In this chapter you will learn:

- ❐ The difference between static and dynamic content
- ❐ The importance of real-time information
- ❐ The difference between client-side and server-side scripting

■■ Where the Web Is Going

The Web is continuing to grow and to provide more information, faster than ever, and with more of a television-like appearance. This means we need to be able to produce more sites with greater interactivity, in a shorter amount of time.

Long gone are the days when a web site would be in development for six months before it was released. Web sites are now often produced in a matter of days or weeks.

Until recently, the major concern was getting a web presence. Businesses, institutions, and organizations scrambled to "get their place on the Web." Now these same groups want to do even more. What that means for you is that you have to be able to work faster and smarter. This chapter explores some of the technologies and strategies being used by developers. This is not an exhaustive list of the many technologies being employed, but it does cover most of the common technologies and strategies in use today.

Static Versus Dynamic Web Design

Not long ago a developer creating a commercial web site might have created each page by hand-coding the HTML. The sites were basic and not all that interactive. Of course, most sites on the Web at that time were not very interesting by today's standards.

A client might call with some new information that needed to get to the Web, and the developer would sit down and start creating more pages for this new content. Static pages were the way of the Web back then. If you had a client with 100 items in a catalog, you created over 100 pages, one page for each item and some sort of organizational scheme or categorization to help the user find items.

Static pages are just not efficient on the Web of the twenty-first century. Dynamic web design has allowed developers to create that same 100-item catalog using basically three pages. You would need a page your user could use to search for items using keywords, item numbers, or categories. You would need a page that listed all the matches to the user's search. Finally, you would need a page that would display the information about a specific item the user had found.

Right now that may seem a little confusing, but that is okay. The idea of dynamic development is very similar to generating form letters with a word processor. Instead of writing an individual letter to every person in your address book, if you had your address book in a database of some type, you could write one letter and have the word processor merge the address information from your address book into the letter. The same letter would be customized for each person in your address book.

Dynamic development on the Web works basically the same way. You have information stored in a database and create

pages that display that information. The big difference between static and dynamic development on the Web when performing operations such as a mail merge is that in dynamic applications the user on the web site gets to control what they see based on their search criteria or what they click on to view.

Real-time Information

Real-time information is why our society loves CNN and "Headline News." We can get up-to-the-minute information without having to wait until the evening news. The Web has begun to serve the same purpose.

We can get the latest headlines, events, and stock quotes from the Web. Real-time information extends a lot further than news and stocks, however. If you have ever purchased an item from an on-line retailer such as *Amazon.com* you have gotten real-time information. You know, for example, if the item is in stock, back-ordered, or sold out at the time you place an order.

Real-time information also provides you with consumer information, such as book reviews and ratings. The retailer may also make suggestions to you about other products, based on what you are looking at. For example, if you are looking at a book about Macromedia Flash, you may also want to look at a book on JavaScript.

Managing Monster Sites

Site management is one of the most important aspects of any larger web site. A developer needs to think about three main things when designing a large site.

First, with any site there are going to be major changes needed on a regular basis. For example, copyright dates change on every page. As the developer, do you want to manually go

though each page and change 2001 to 2002? Most likely the answer is no.

Second, can other developers follow your structure and logic for the site? Are files organized into subdirectories? Do file names give a description of what the file is?

Finally, you should think about how you can reuse content. Will there be consistent navigation or graphics used on pages? Can you use cascading style sheets, templates, or libraries?

Whenever you develop a large site, you need to think about the management of it. The tools provided in UltraDev can help you manage a site of any size. You will save yourself a ton of time and energy by going through the Dreamweaver tutorials on using libraries, templates, and cascading style sheets. These tutorials are included on your UltraDev CD-ROM.

■■ Technologies

The sections that follow discuss client-side scripting, server-side scripting, and databases. Client-side scripting involves the use of JavaScript or VBScript, which are discussed in the material that follows. Server-side scripting involves ASP, JSP, CFM, PHP, and other languages, all of which are also discussed in the sections that follow.

Client-side Scripting

Client-side scripting involves embedding small programs or scripts into HTML pages. The scripts are executed by the user's browser. Because HTML is strictly a layout tool for text and images, client-side scripting brought interactivity to the Web.

Client-side scripting is a topic of great debate. There are two basic camps of client-side scripting, the division marked by

which scripting language is used: JavaScript or VBScript. Each scripting language performs roughly the same tasks. A brief explanation and history of each is provided in the sections that follow.

JavaScript

Netscape introduced JavaScript to the Web with Version 2.0 of Netscape Navigator. The intent was to provide a cross-platform, object-oriented scripting language. JavaScript includes objects to control a browser and its Document Object Model (DOM).

JavaScript allowed developers to add client-side scripts that would react to user actions, such as mouse movements, mouse clicks, and form inputs. JavaScript has become one of the most widely used scripting languages on the Web.

There are two major drawbacks, however, to using JavaScript. The first is the learning curve. To hand code JavaScript, there is a lot to learn. The structure of the language is often difficult for beginners to fully understand. The second drawback is browser incompatibilities. As browsers continue to get more sophisticated, JavaScript has also evolved. Unfortunately, older browsers cannot handle most of the modern enhancements found in JavaScript today. In addition to dealing with older browsers, Microsoft Internet Explorer and Netscape Navigator treat some JavaScript differently. This can cause all types of problems for your users.

There is a solution to this down side, however, and you have made the first step toward solving these problems. Macromedia has made great strides toward eliminating these confusing problems. UltraDev contains a number of built-in JavaScript behaviors (found in the Behaviors window). UltraDev will also check a page for browser compatibility for you. This can be done by selecting Check Target Browsers in the File menu.

VBScript

VBScript was developed by Microsoft and introduced with Internet Explorer 3.0. VBScript is based on Visual Basic for Applications. VBScript has all the functionality found in JavaScript and tends to be an easier language to learn. However, VBScript will only work with Microsoft Internet Explorer 3.0 or higher. Thus, it presents a big problem for developers.

If the client-side scripting you create can be used only by Microsoft Internet Explorer users, you are missing a large number of users. At the time of this writing, Netscape had between 40% and 55% of the market share. Thus, roughly half of your users would not be able to execute any VBScript you might include in a page.

Server-side Scripting

Because using client-side scripting presents the developer problems delineated in the previous section, server-side scripting is a much more reliable solution. Server-side scripting relies on the server to execute the scripts. This offers a number of benefits.

Because everything is executed on the server, you do not have to worry about what browser a user has. You can write your scripts for the specific server you will be accessing with the pages. In addition, server-side scripting provides developers with more security and "ownership" of their work. A server-side script is executed by the server and then coded as HTML into the page and returned to the user. This means that if a user views the source code of a page, all they will see is the HTML code, not your scripts. If a user were to do this with client-side scripting, the user would be able to see all of the client-side code.

Server-side scripting does, however, present a couple of problems. Server-side scripting is not very portable. You cannot easily move from one server type to another. In addition, users will be required to have an Internet connection for the server-side scripts to work. This means that developing a web site to be run from a CD-ROM is not possible. A CD-ROM-based site would require client-side scripting.

There are a number of server-side scripting languages available. The language a developer chooses is often dictated by the server he has access. The sections that follow describe some of the more common server-side scripting languages.

Active Server Pages (ASP)

ASP is based on VBScript. It is one of the most common server-side scripting languages on the Web. ASP pages require either a Windows NT/2000 sever or a UNIX server running an ASP add-on such as ChiliSoft.

Java Server Pages (JSP)

JSP is very similar to ASP. JSP pages use Java that is executed on the server. JSP is the most portable of all the server-side scripting languages. JSP can run on virtually any server platform from Windows, Solaris, Mac, and UNIX. JSP servers are often available for free on the Web and tend to offer strong security and fast performance.

ColdFusion Markup Language (CFML)

CFML relies on Macromedia's ColdFusion server. CFML takes a different approach to server-side scripting. CFML is a tag-based language that is very similar to HTML. CFML tags are embedded into a web page and executed by the server. The tag structure of CFML allows developers to quickly gain confidence with the language if they do not have a programming background.

ColdFusion currently requires a Windows NT/2000 or UNIX server.

PHP

PHP is based on Perl, C, and other common programming languages, providing developers with a powerful scripting language. PHP can run on nearly any web server. PHP is gaining popularity among the development community because of its flexibility and performance.

Other Scripting Languages

There are many other server-side scripting languages in use on the Web. You may see references to Perl, Python, and Miva, to name a few. As described previously, most server-side scripting languages work in similar fashions. The server a developer will be using or her previous programming experience typically dictates the choice.

The positive thing for the readers of this book is that UltraDev eliminates many of these programming concerns. UltraDev is designed to work with ASP, JSP, and ColdFusion. Therefore, if you can use one of these three server-side scripting languages on a server, UltraDev can handle the rest.

There have also been developments in the UltraDev community to create PHP functionality for UltraDev. As each new version of UltraDev is released, developers expect to see more flexibility and power presented through the addition of other server-side scripting languages.

Databases

Server-side scripting is also the method used to communicate with databases on a web server. As discussed earlier in the chapter, using databases to store information that will be

displayed on a web page is an efficient way of maintaining the content of a web site.

There are many different databases used on the Web. Microsoft SQL and Oracle are the most commonly used for large-scale sites. Large on-line retailers and corporations tend to use SQL or Oracle because these databases are so powerful and can handle the large amount of traffic these sites attract.

Other common databases being used on the Web are MySQL, Microsoft Access, and FileMaker Pro. Each database offers the ability to store and manipulate data. The key difference between databases such as SQL and Access is the amount of web traffic the database can support.

■■ Summary

The Web is under continuous evolution. As technology improves, web users continue to expect more and more service from web sites. The demand for up-to-the-minute information and interactivity is higher than ever and will continue to grow.

Providing dynamic content through the use of client-side scripting, server-side scripting, and databases is now a necessity. A static web site that simply presents information to a user is becoming a thing of the past. The information needs to be searchable, dynamic, and interactive.

This chapter has illustrated some of the most common methods for achieving the goal of more interactivity through dynamic content. However, each of these methods requires far more understanding of how each method works than can be covered in the scope of this book. The section that follows provides resources that may help you gain more knowledge on these technologies.

■■ Resources

The following web sites and published sources offer information on the topics covered in this chapter.

Web Sites

The following web sites offer information on the technologies, software, and other topics covered in this chapter.

- ❏ *http://www.mysql.com*
- ❏ *http://www.ASP101.com*
- ❏ *http://www.aspwire.com*
- ❏ *http://java.sun.com/products/jsp/*
- ❏ *http://www.jspin.com/*
- ❏ *http://www.jspinsider.com/*
- ❏ *http://www.macromedia.com/software/coldfusion/*
- ❏ *http://www.sys-con.com/coldfusion/*
- ❏ *http://www.cfdev.com/*
- ❏ *http://www.php.net/*
- ❏ *http://www.phpbuilder.com/*
- ❏ *http://php.resourceindex.com/*
- ❏ *http://www.microsoft.com/sql/*

Publications

The following published sources also provide information on specific topics covered or alluded to in this chapter.

Bergsten, Hans, *JavaServer Pages*. Sebastopol, CA: O'Reilly & Associates, 2000, ISBN 156592746X.

Brooks-Bilson, Rob, *Programming ColdFusion*. Sebastopol, CA: O'Reilly & Associates, 2001, ISBN 1565926986.

Hatfield, Bill, *Active Server Pages for Dummies*. New York/Cleveland/Indianapolis: Hungry Minds, 1999, ISBN 076450603X.

Horwith, Simon, et al., *Professional ColdFusion 5.0*. Birmingham, UK: Wrox Press, 2001, ISBN 1861004540.

Kline, Kevin E., and Daniel Kline, *SQL in a Nutshell*. Sebastopol, CA: O'Reilly & Associates, 2000, ISBN 1565927443.

Lerdorf, Rasmus, *PHP Pocket Reference*. Sebastopol, CA: O'Reilly & Associates, 2000, ISBN 1565927699.

Petrusha, Ron, Paul Lomax, and Matt Childs, *VBScript in a Nutshell*. Sebastopol, CA: O'Reilly & Associates, 2000, ISBN 1565927206.

Taylor, Allen G., *SQL for Dummies*. New York/Cleveland/Indianapolis: Hungry Minds, 2001, ISBN 0764507370.

Vander Veer, Emily, *JavaScript for Dummies*. New York/Cleveland/Indianapolis: Hungry Minds, 2000, ISBN 0764506331.

Yarger, Randy Jay, George Reese, and Tom King, *MySQL & mSQL*. Sebastopol, CA: O'Reilly & Associates, 1999, ISBN 1565924347.

CHAPTER 2

Understanding Databases

■■ Introduction

Whether we realize it or not, we interact with databases constantly. Everything from going through the checkout line at the grocery store to surfing the Web relies on databases. Databases are simply a means of organizing information. If you use an address book, or recipe file, or even the telephone book, you use a database. Databases allow us to give structure to information. This structure helps us quickly find the information we need.

This chapter discusses the basic functions of a database and the fundamental elements that make up a database. The chapter also explores setting up a database for use on the Web, pointing out along the way some of the common pitfalls people experience when learning how to create and manipulate databases for Internet use.

There are a number of database applications on the market. Some names you may have heard are Microsoft Access, Microsoft SQL, Oracle, MySQL, Fox, My Database, and Filemaker Pro. All of these databases can be used on the Web, but the databases most commonly used with UltraDev are

Microsoft Access and SQL. This is because Microsoft Access is an application many people have on their computers as part of their desktop environment. Microsoft SQL, the "corporate equivalent," is a much more robust and powerful database used by businesses and larger educational institutions.

NOTE: Do not worry, Macintosh users. Even though Access is not available for the Mac, you can still participate. The Access database structure and data are available on the companion CD-ROM (in the Excel *folder within the* Macintosh *folder) as Microsoft Excel spreadsheets. These will at least allow you to see the data and structure as they are discussed in the book. UltraDev works fine on a Macintosh. However, it does require that you develop your database on a Windows machine, and that you have access to the web server to see the database through UltraDev. (See also the following CD-ROM Note.)*

CD-ROM NOTE: The companion CD-ROM contains three versions of an Access database: A_Pedal4Peace.mdb, B_Pedal4-Peace.mdb, *and* C_Pedal4Peace.mdb. *These are located in the* Databases *folder. These versions provide you with examples of common database design mistakes discussed later in the chapter.*

■■ Objectives

In this chapter you will learn:

- ❐ What a database is and the basics of how one works
- ❐ How to set up a database to suit your needs
- ❐ The importance of unique identifiers

■■ What Is a Database?

A database is a collection of information organized to allow for easy searching and sorting. This technical definition, however, is not the only way of describing what a database is. Let's try a description via an example.

Say you are running a meeting of 25 people from your company or organization. As you look around the room, you can classify or organize people into groups and subgroups based on characteristics such as gender, hair color, height, those who wear glasses and those who do not, and so on. Classifications play a role in how databases organize information.

A database consists of two fundamental parts: records and fields. In database terms, each person in this example represents a record, and the various characteristics of these persons represent fields. Table 2-1 is an example of a basic database, consisting in this case of six records (rows) and five fields (columns).

Table 2-1: Example of a Basic Database

Name	Gender	Hair Color	Height	Glasses
Adam	Male	Blond	5 ft. 11 in.	Yes
Barb	Female	Red	5 ft. 7 in.	No
Chris	Female	Brunette	5 ft. 4 in.	No
Dave	Male	Black	6 ft. 1 in.	Yes
Erin	Female	Blonde	5 ft. 2 in.	Yes
Frank	Male	Brown	5 ft. 9 in.	Yes

Each person in the table represents a record, which consists of five fields (name, gender, hair color, height, and glasses). This simple example is the backbone of understanding databases.

At this point you are saying, yes...and? Most people could manage a room of 25 people and not really need to use a database to keep track of this information. But what if you had to keep track of additional information, such as home addresses, office phone numbers, e-mail addresses, titles, hire date, vacation days, and date of birth? When faced with this task, most people would sit down, fire up their word processor, and make a list of all the employees and their information.

This seems pretty straightforward, until someone needs a list of all people hired before April 22, 1969. At that point, you need to search through your list to locate the people that meet the criterion, as well as log them so that you can create a list of this information to give to the person requesting it. If all of this information were stored in a database, you could perform a simple query (a technical word for a search) and find all records (people) with a hire date before April 22, 1969. It would take a matter of seconds for a database to search through 10,000 records (people) and find only those with a date of hire prior to April 22, 1969.

Sorting is another great feature of databases. You can sort the results of a query by any field. In this example, you could find all people hired before April 22, 1969, and then sort that list by last name.

As you begin to experiment with using databases on the Web, you will quickly see how important searching and sorting data can be. It is important to remember that a database is only as useful as the information it holds. In the previous example, if you were looking for employees hired before April 22, 1969, and the "hire date" data were stored as "April 69," you would not obtain the information you wanted. Controlling the data that is entered into a database is the key to maintaining useful data. Means of applying structure to the data users enter via the Web are discussed in later chapters.

■■ Setting Up a Database

In this section, we will start looking at how to structure the database that will be supporting your web site. The structure of your database will be a key element of how useful and user-friendly your web site can be.

Pedal for Peace

Say you are one of the organizers of Pedal for Peace, a cross-country bicycle tour held to raise money in the campaign against school violence. Last year, there were 134 riders who rode in the tour, from San Diego to New York City.

The first few years of the tour, there were only about 20 riders. This made it easy to keep a file folder for each rider so that you could retain their contact information and inform them of the next tour. You kept the folders organized by the home state of each rider. This was important to the tour because many of the riders helped arrange lodging, meals, and entertainment when the tour came through their area.

This meant, for example, that when you needed some help in Colorado you simply looked through the folders in the Colorado section. But what if you now had 75 people from Colorado? You wouldn't want to go through all 75 to find the six people in Boulder you wanted to contact. Using a database to organize the riders in the tour would allow you to search for riders in Boulder rather than looking through all riders in Colorado.

In the remainder of this chapter, you will work through the process of setting up a database to be used in conjunction with the exercises in this book. You will be building on this database as you progress through the many facets of UltraDev.

The Starting Point of Database Creation

One approach to database creation begins on paper. Take out a few index cards. On the index cards, make a list of all the information you would need to store, for example, about the riders in the Pedal for Peace tour. You might include each rider's name, address, and phone.

At this point, you might be tempted to set up the database and start putting information into it. This would mean that each record would consist of three fields (name, address, and phone). This database setup would most likely work, but let's look at some possible problems with this design, via the files associated with the following CD-ROM exercise.

 NOTE: *You will need to have Microsoft Access 2000 installed on your computer to open the files referenced in the following and subsequent CD-ROM exercises.*

 ## CD-ROM Exercise

The *Databases* folder on the companion CD-ROM contains three databases. Open *A_Pedal4Peace.mdb*. When Access has opened, you will see an interface similar to that shown in figure 2-1. You should have four icons. The top three are used to create new tables, which you will explore later in the book. For now, just double click on the icon labeled *riders*.

The display should look similar to that shown in figure 2-2. In this table, each row is a record (person) and each column is a field. Currently, the database consists of 134 records and three fields. This database contains the information you want to work with: rider's name, address, and

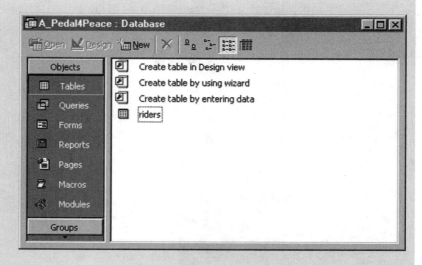

Fig. 2-1. Basic user interface of Microsoft Access 2000.

Fig. 2-2. Sample of information stored in the A_Pedal4Peace.mdb database.

name	address	phone
Jim Holton	31 East St. Lapeer, AK 47909	(200) 207-3276
Dosie Dankoski	303 Milford ct Lebanon, AL 47909	(407) 291-4213
Maura Dankosk	303 Milford ct Lebanon, AL 47909	(407) 291-4213
Phil Dankoski	303 Milford ct Lebanon, AL 47909	(407) 291-4213
Sean Dankoski	303 Milford ct Lebanon, AL 47909	(407) 291-4213
R.L. Aaron	9139 E. Autumn Sage St. Davison, AR 85364	(178) 215-2263
Bill Deacon	210 Exchange Avenue Tucson, AZ 47906	(470) 214-1583
Sharon Deacon	210 Exchange Avenue Tucson, AZ 47906	(470) 214-1583
Jim Kaufman	2410 Happy Hollow B5 Mt. Pleasant, AZ 47906	(238) 116-5897
Lois Kaufman	2410 Happy Hollow B5 Mt. Pleasant, AZ 47906	(238) 116-5897
Jerry Mooney	2166 Anoka Porto Alegre, AZ 47906	(901) 116-2586
Sandy Mooney	2166 Anoka Porto Alegre, AZ 47906	(901) 116-2586
Michael Morgan	636 Ferry St Snow Flake, AZ 48532	(472) 457-8099
Fred Piercy	208 S Santa Cruz St Tucson, AZ 47906	(569) 456-2157
Jaccia Sager	1002 South 20th Yuma, AZ 74532	(740) 710-2598
Ralph Sager	1002 South 20th Yuma, AZ 74532	(740) 710-2598
Larry Spear	1016 S. 22nd St. Wheeling, AZ 40207	(321) 425-7399
Laura Spear	1016 S. 22nd St. Wheeling, AZ 40207	(321) 425-7399
Beth Baumgartr	541 State St San Deigo, CA 90291	(350) 874-8818
Norm Baumgart	541 State St San Deigo, CA 90291	(350) 874-8818
Marcus Binchi	2057 Lodge Rd Ventura, CA 47906	(761) 451-3663
Patricia da Cosi	2057 Lodge Rd Ventura, CA 47906	(761) 451-3663

phone. In the following you will explore the functions a database such as this offers.

Let's first place the table in alphabetical order. If you click on the top of the name column, on the gray portion that says *name*, the entire column will turn black and the text will change to white. (See figure 2-3.) Now click on the Records menu and select Sort. You have a choice of two options under Sort: A to Z Ascending or Z to A Descending. If you select A to Z Ascending, the records (people) in your database are sorted alphabetically by name. Or are they?

Fig. 2-3. The database has been sorted alphabetically by the name field.

name	address	phone
Aggie Ward	7065 Hickory Street Peire, SD 48625	(331) 909-8261
Amy Turner	131 Sylvia St. West Lafayette, IN 47905	(176) 532-0998
Andrew Hill	3111 Pemberly Court Lapeer, CO 48116	(911) 064-7279
Andy Van Assche	116 Garland Way West Lafayette, IN 46256	(912) 906-1195
Andy Westerman	5720 Annibal Dr Lafayette, MI 48475	(255) 905-4613
Ann Smith	4382 Bethany Ln Honolulu, HI 99874	(387) 901-8592
Austin Babrow	3536 Leap Rd Lafayette, KY 48350	(046) 507-3217
Barb Smith	1206 Wells St West Lafayette, IN 47901	(242) 423-5574
Barry Mooney	514 Owen Street Santa Barbara, CA 48446	(351) 905-9994
Bart Spencer	121 N. Fancher West Lafayette, IN 47901	(308) 906-2305
Belinda Long	2331 Arlington Ave. Plain City, IN 47906	(553) 350-0751
Beth Baumgartner	541 State St San Deigo, CA 90291	(350) 874-8818
Betty Turner	12112 Davison Rd West Lafayette, IN 47904	(111) 446-9905
Bill Deacon	210 Exchange Avenue Tucson, AZ 47906	(470) 214-1583
Bill Rose	3422 Beveridge Road Baltimore, MD 48346	(472) 906-7842
Bob Lewandowski	216 Berwick Drive Kalamazoo, MI 47906	(848) 906-9057
Bob Thielen	1135 Andersonville Rd Sante Fe, NM 87332	(104) 557-6687
Brooke Killion	1508 Summit Dr. Fenton, NH 47905	(825) 905-6527
Camille Holton	998 Golf View Dr San Deigo, CA 90215	(552) 905-5729
Carol Anne Clayson	605 Ridgewood Dr. Hilliard, MI 48532	(763) 433-1451
Carol Mooney	124 N. Ferry St Knoxville, TN 47557	(763) 364-8818
Carole Hruskocy	321 Doctors Ct. Plano, TX 85475	(360) 906-9238

NOTE: *When you sort a database, you are selecting a field or fields by which each record is sorted. Even though you select only certain columns, the complete record moves together. If you have ever used a spreadsheet, things work a bit differently. You can sort an individual column in a spreadsheet.*

The data has been sorted alphabetically. However, the database has sorted the entries alphabetically by first name. Because both the first and last name appear in the *name* field, Access did exactly what you asked it to do. That is, it sorted the entries alphabetically according to the first word found in each entry. To sort by last name, you have to approach the task a different way.

Let's take those same three fields and change them a little. The rider's name is a good place to start. Two methods exist for sorting this information alphabetically by last name. First, you could use one field in which last names in entries precede first names. Second, you could use two fields: one for first name and one for last name. The first option would work, but has a lot of potential drawbacks. The biggest drawback is making sure the data is entered correctly. It would only take one person entering first name and then last name to cause an error in the sort.

The same goes for the address. If you want to be able to easily look for people in specific states or cities, it might be easier to break the address into multiple fields. For example, you could use address, city, state, and zip. Thus, two of the original three fields could be broken down into multiple fields. It may require a little more work when setting things up, but as you start using databases on the Web, you will see that the performance assurance and efficiency gained more than make up for the initial investment in structure.

A good approach to setting up a database is to think in terms of "more fields generally equals better data." A rule of thumb to use is that if a field will contain more than one piece of information, create fields for each piece of information. For example, the *address* field in *A_Pedal4Peace.mdb* includes the street address, city, state, and zip code for each rider. This field actually holds four pieces of information. Therefore, you would create four fields: address, city, state, and zip code.

Breaking the data into more fields means you have more sort-ing and searching capabilities and the data is more likely to be entered without errors. If you only had the *address* field, some users would only give you their street address, or their city, and so on. By providing different fields, the user is prompted to enter the data.

Splitting data into multiple fields may mean occasionally leav-ing a field blank. You will probably never look back and wish you had combined two fields instead of using two. To see another approach to designing this particular database, com-plete to following CD-ROM exercise.

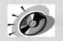 ## CD-ROM Exercise

To see another approach to designing the *Pedal4Peace* database, open *B_Pedal4Peace.mdb* located on the com-panion CD-ROM. This database includes two tables; *new_design* and *old_design*. The *new_design* table (see fig-ure 2-4), consists of the same information found in *A_Pedal4Peace.mdb*, but it has been divided into seven fields: first name, last name, address, city, state, zip, and phone. The *old_design* table is a copy of the *riders* table from *A_Pedal4Peace.mdb* you looked at in the previous exercise. The *old_design* table has been included so that you can compare the differences between the designs.

Let's see if these changes to the database have helped. Select the *last name* column by clicking on *last name* (in gray) at the top of the table. The entire column should be blacked out and the text will again change from black to white, as shown in figure 2-5. Select the Records menu and select Sort/A to Z and watch what happens. The entire database should have been sorted alphabetically by last name.

Fig. 2-4. Here is the same database as before broken into seven fields.

first name	last name	address	city	state	zip	phone
Jim	Holton	31 East St.	Lapeer	AK	47909	(200) 207-3276
Dosie	Dankoski	303 Milford ct	Lebanon	AL	47909	(407) 291-4213
Maura	Dankoski	303 Milford ct	Lebanon	AL	47909	(484) 291-3412
Phil	Dankoski	303 Milford ct	Lebanon	AL	47909	(938) 906-8616
Sean	Dankoski	303 Milford ct	Lebanon	AL	47909	(414) 906-3311
R.L.	Aaron	9139 E. Autumn Sage St.	Davison	AR	85364	(178) 215-2263
Bill	Deacon	210 Exchange Avenue	Tucson	AZ	47906	(470) 214-1583
Sharon	Deacon	210 Exchange Avenue	Tucson	AZ	47906	(027) 446-1712
Jim	Kaufman	2410 Happy Hollow B5	Mt. Pleasant	AZ	47906	(036) 026-3882
Lois	Kaufman	2410 Happy Hollow B5	Mt. Pleasant	AZ	47906	(238) 116-5897
Jerry	Mooney	2166 Anoka	Porto Alegre	AZ	47906	(901) 116-2586
Sandy	Mooney	2166 Anoka	Porto Alegre	AZ	47906	(811) 116-1178
Michael	Morgan	636 Ferry St	Snow Flake	AZ	48532	(472) 457-8099
Fred	Piercy	208 S Santa Cruz St	Tucson	AZ	47906	(569) 456-2157
Jaccia	Sager	1002 South 20th	Yuma	AZ	74532	(740) 710-2598
Ralph	Sager	1002 South 20th	Yuma	AZ	74532	(060) 175-6103
Larry	Spear	1016 S. 22nd St.	Wheeling	AZ	40207	(321) 425-7399
Laura	Spear	1016 S. 22nd St.	Wheeling	AZ	40207	(146) 425-8261
Beth	Baumgartner	541 State St	San Deigo	CA	90291	(350) 874-8818
Norm	Baumgartner	541 State St	San Deigo	CA	90291	(415) 451-8178
Marcus	Binchi	2057 Lodge Rd	Ventura	CA	47906	(761) 451-3663
Patricia	da Costa	2057 Lodge Rd	Ventura	CA	47906	(714) 858-9238

Fig. 2-5. The new database with the last name column selected.

first name	last name	address	city	state	zip	phone
R.L.	Aaron	9139 E. Autumn Sage St.	Davison	AR	85364	(178) 215-2263
Jan	Adams-Byers	Caixa Postal 9566	Chicago	IL	60615	(775) 905-9514
Charlotte	Amaro	992 Devon Street	Davison	WY	85747	(675) 291-8065
Marilyn	Andrews	116 Garland Way	West Lafayette	MA	46256	(670) 906-0978
Austin	Babrow	3536 Leap Rd	Lafayette	KY	48350	(046) 507-3217
Jerry	Baker	PO Box 41	Cedarburg	WI	90441	(961) 532-1705
Dee	Baker	PO Box 41	Cedarburg	WI	90441	(753) 906-7279
Beth	Baumgartner	541 State St	San Deigo	CA	90291	(350) 874-8818
Norm	Baumgartner	541 State St	San Deigo	CA	90291	(415) 451-8178
Marcus	Binchi	2057 Lodge Rd	Ventura	CA	47906	(761) 451-3663
Nancy	Buerkel-Rothfus	1413 Fairfax Dr.	W. Lafayette	IN	47905	(700) 256-9041
Mei-Mei	Chang	W52 N230 Pierce Avenue	Henderson	FL	24175	(236) 906-8065
Pamela	Choice	2100 W. 3rd St. Space #2	Star City	OR	47906	(283) 441-1476
Carol Anne	Clayson	605 Ridgewood Dr.	Hilliard	MI	48532	(763) 433-1451
Laura	Cobb	2744 cooper	Linden	ME	47906	(580) 423-5955
Patricia	da Costa	2057 Lodge Rd	Ventura	CA	47906	(714) 858-9238
Sean	Dankoski	303 Milford ct	Lebanon	AL	47909	(414) 906-3311
Phil	Dankoski	303 Milford ct	Lebanon	AL	47909	(938) 906-8616
Maura	Dankoski	303 Milford ct	Lebanon	AL	47909	(484) 291-3412
Dosie	Dankoski	303 Milford ct	Lebanon	AL	47909	(407) 291-4213
Jonathan	Davis	8772 Sugar Pine Point	Flint	TX	53012	(866) 906-3663
Bill	Deacon	210 Exchange Avenue	Tucson	AZ	47906	(470) 214-1583

To further illustrate the differences between these two database designs, figure 2-6 shows the *new_design* table on the top and the *old_design* table on the bottom. Both tables have been sorted. *Old_design* has been sorted on the *name* column alphabetically A to Z, and *new_design* has been sorted on the *last name* column alphabetically A to Z. As you can

see, there is a drastic difference in how these tables have sorted.

*Fig. 2-6.
Comparison of
new design
sorted by last
name with old
design sorted by
name.*

Naming Fields

When we first started using UltraDev and connecting to a database through the Web, we found ourselves sitting for most of a day convinced the server and computer hated us. Everything

looked fine, but we were getting an error every time we loaded a certain page. It was a simple database that was going to keep track of departmental events.

Eventually, we realized that using a field named *Date* was causing the problem. *Date* is a reserved word for most scripting languages. There are volumes of reserved words you need to avoid using when naming fields and tables. For a list of reserved words for some common languages, see the appendices: ASP (appendix A), JSP (appendix B), ColdFusion (appendix C), SQL (appendix D), and MySQL (appendix E).

The following are guidelines for naming fields in your database. Granted, there are a number of approaches to this, but the following are time-tested tips that should be a part of any database-naming system you might develop.

- ☐ Do not use spaces, punctuation, or special characters (except for _) in field and table names. Use numbers, letters, and the underscore (_) to name fields and tables.
- ☐ Be as descriptive as possible with the name.
- ☐ Come up with a system of naming common entities, such as first name and last name. The authors tend to use, for example, *f_name* and *l_name*.
- ☐ Use generic language. For example, you might use *date_added* for recording the date a record was added, rather than *date* or *today*. The field name is more descriptive and helps prevent the chance of using a reserved word.

Having a consistent system for naming database fields and tables will really pay off as you start developing more web applications. This helps with troubleshooting as well. You always know, for example, that *f_name* is the first name and that *h_phone* is the home phone number.

The file *C_Pedal4Peace.mdb* (database) is used in the text and included on the companion CD-ROM to illustrate a number of topics dealt with in the next few sections. This file includes only one table, the *riders* table. You will be adding additional tables during the exercises in this book. Figure 2-7 shows the field names chosen for the *C_Pedal4Peace.mdb* database. The naming convention used for these field names is one that would translate well for use on the Web.

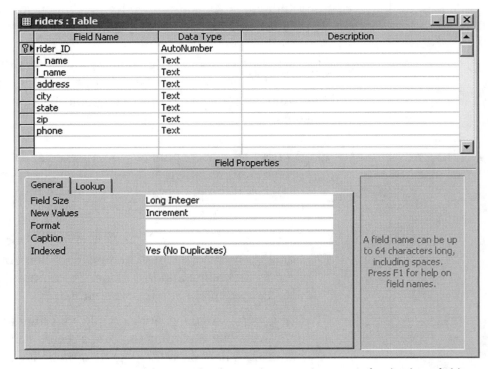

Fig. 2-7. Example of a good naming convention for database fields to be used on the Web.

NOTE: *Figure 2-7 uses the Design view in Access. This view shows you each field and the properties associated with that field. This is where you can add or delete fields and change their properties. (Field properties and data types are discussed in material to follow.)*

Data Types

Each field in a database has a specific data type assigned to it. Data types provide the database with information about how to organize the data found in the field. For example, imagine you have a database with 11 records in it and one of the fields stores a record number. If you sorted the database by the record number from lowest to highest you would expect to see the following order: 1, 2, 3, 4, 5, 6, 7, 8, 9, 10, and 11. However, if the record number field data type were set to text, the order would be 1, 10, 11, 2, 3, 4, 5, 6, 7, 8, and 9. A sort of a text field orders the information in alphabetical, not numeric, order. Therefore, 10 and 11 would come before 2.

Databases offer a variety of data types. The material that follows examines the *riders* table and discusses common data types used in databases that operate on the Web.

 ## CD-ROM Exercise

Perform the following steps to begin examining the *riders* table toward an understanding of common field types used on the Web. This will open the table in the design view.

1. Open *C_Pedal4Peace.mdb*, located in the database directory on the companion CD-ROM.

2. Click once on the *riders* table to select it. If it is selected, it will have a dark blue or black box around the white text.

3. Click on the design button found in the *C_Pedal4Peace:Database* window.

The first field listed in the *riders* table is *rider_ID*. The date type is set to AutoNumber, and Indexed (shown below the table fields in the gray section) is set to Yes (No Duplicates). These two settings are very important. The AutoNumber

data type means that every time a new record is added the *rider_ID* will increment by 1. The Indexed section means that the database will monitor the records and make sure each record has a different *rider_ID* number.

 TIP: *If you are using SQL, there is no AutoNumber field type. You can select Numeric as the data type and then go to the properties for that field and set Increment to Yes.*

Whenever you create a new table, it is strongly suggested that you create an ID field with the field type set to AutoNumber for that table. In the previous example, you will notice that *rider_ID* was used to specify the table ID. As you start adding more tables, it makes your life a lot easier if you have IDs labeled in a way that tells you which table they are from. It is much easier to ignore an ID when you do not need it than it is to add one later.

Microsoft Access typically asks you if you want to incorporate a "primary key" feature in a table when you create it. A primary key is a unique identifier for the table. In essence, it is a field that will not allow duplicates. For example, there can only be 1 *rider_ID 47*. You add a primary key by selecting the table ID field in the Design view and clicking on the Key icon on the toolbar.

Figure 2-7 also shows the other fields included in the *riders* table. Notice the names. There are no spaces or special characters used for any of these fields.

As you look at the other fields, you will see that the data type is either text or memo. Using either of these data types is a time saver. The Text data type accepts any type of character, but is limited to 256 characters. If you need to store more than 256 characters, you should use Memo as the data type. Text and Memo types are very useful and can store almost anything.

Access also incorporates Date/Time, Number, Currency, and Yes/No data types. However, for most web applications you will use Text, Memo, or Number. As expected, the Number data type stores numbers. There are several options regarding the Number data type that you can set in its properties section. However, you can usually leave the defaults for numbers.

Field Properties

In addition to data types, fields also have properties associated with them. Field properties control such things as the maximum number of characters a field can hold, default values for the field, and if the field is allowed to be left empty.

There is a critical property associated with the Text and Memo data types you should change from the default. For use on the Web, Access databases work a lot better if you set the Allow Zero Length property to Yes.

Allowing zero length means a field can be left blank. You might be asking yourself why you would want to allow a field to be empty. The biggest reason is your users. Users do not always follow directions, and sometimes skip fields that ask for information that does not apply to them. This results in blank fields. If a user tries to insert a record with a blank field into a database that does not allow zero length, they will be presented with a cryptic server error stating something to the effect that Zero String Length is not allowed.

 NOTE: *SQL uses Accept nulls or Allow nulls instead of Allow Zero Length.*

Such error messages do not help your user understand what has gone wrong, nor inform them that as a result you did not receive the data they sent. A safe practice is to leave your databases as "wide open" as possible. This means allowing

zero length and not making functionality dependent on any one field of the database itself. This helps avoid user errors resulting in server error messages.

Keep in mind that your users are not interacting with the database; they are interacting with your web pages. You have a lot more control of your web pages than you do over the database. With a little creative coding, explored in later chapters, you can construct required fields and format records exactly how you want them formatted (including mitigating against potential user error or misunderstanding) before the user interacts with the database. This too avoids error messages that potentially require users to retype their data.

Relationships

The first computer databases were not much more than long lists of data stored in specific columns. They were very similar to spreadsheets in a lot of ways. This way of storing data worked, but it required the duplication of a lot of data if multiple tables were to be kept consistent for purposes of comparison. For example, under the old technology, if you were to add another table to *C_Pedal4Peace.mdb* that contained information about each rider's bike, you would need to duplicate any data (such as rider's name) from another preexisting table you might want to associate with the new bike information.

Luckily, in the late seventies a bunch of academics developed the relational database model. The basic idea behind the relational database model is a method of avoiding constant and labor-intensive (as well as error-prone) manual update to information that two or more tables should duplicate exactly. In a relational database, "pieces" of data are linked from table to table as necessary. These "pieces" are shared by, rather than duplicated within, individual tables. This type of link is called a relationship.

Relationships help increase the functionality and efficiency of databases. This would also be important, for example, if a rider had more than one bike. Perhaps *rider_ID* 33 has three bikes. Relational links to the rescue! The Bikes table could contain three *rider_ID* records (each containing different bike information) associated with record 33. A change made to the information on any given bike (i.e., any of the three ID records) would be acknowledged in record 33, and indeed in any table linked to the table containing record 33 (i.e., *rider_ID 33*).

Right now this may seem a little strange or not seem very useful. However, as you start managing data on the Web, you will quickly see how relationships make things a lot easier to manage and maintain in terms of both time and labor.

■■ Tips and Tricks

Setting up the database is the backbone of any web application. There are a few basic settings that will make your experience with UltraDev a much more productive and less confusing one. Keep in mind the following basic settings and practices.

- ❐ Start on paper. Use index cards to organize your data before you start creating it electronically.

- ❐ Use descriptive field and table names that do not have spaces or special characters, other than the underscore (_).

- ❐ More fields make more useful data. When in doubt, use more fields to break your data into smaller pieces.

- ❐ Use a unique ID in every table.

- ❐ Allow Zero Data String or Accept nulls in all fields except ID fields.

❐ Do not make database functionality dependent on the user properly filling in or otherwise manipulating any given field.

■■ Summary

This chapter has covered a number of important points for setting up a database that will be used on the Web. Databases allow developers to dynamically deliver specific information to the user. This makes the job of the developer considerably easier by letting him or her set up one page that can display different data as it is requested by users.

The basic functions of a database are to store, search for, sort, manipulate, and organize information. All of these functions and many more can be accomplished through a web browser, allowing users to manage any type of information without having physical access to the database.

The key components of a database are records, which consist of fields. For example, the information about riders in Pedal for Peace is stored in a database. Each rider is a record and the information associated with each rider (such as name, address, phone, and so on) are the fields within the record.

When setting up a database there are a few simple settings and techniques that will make the experience much easier when it comes time to use UltraDev. Take a look again at the "Tips and Tricks" section for a summary of these.

Pay close attention to the field names and properties you use in your databases. The more you can break your data down into small pieces the more useful your database will be to users. This method also makes it easier to organize database information.

This chapter also discussed the use of relationships between and among tables in a database. As you progress through the book, you will begin to see how unique identifiers and database links can be very useful.

■■ Things to Think About

UltraDev is a rather user-friendly application. There are a few simple steps to get things set up, and then you are off and running. Having good database design skills and knowing some of the more advanced features found within databases can only benefit your web application. However, these advanced skilled are by no means required. You will be amazed at what is possible using a database of the most basic design.

Perhaps the most important thing to keep in mind is to experiment with the possibilities before you set up a database, and to spend time planning your databases before you start developing a web application. The following are some things to think about in designing a database.

❏ Who will be using this database?

❏ What data will the user need to access, search, and sort?

❏ Will users be adding information to the database?

■■ Resources

One of the greatest benefits of learning how to use a database is that once you feel comfortable with designing and manipulating one type of database you can transfer that understanding and practical hands-on knowledge to other databases fairly quickly. Basic database theory and functionality operate

pretty much the same in all database applications. The names of things might change, but you will know what functional features to plan or to look for when you deal with a new type of database or new database application.

The examples and tutorials presented here focused on using Microsoft Access 2000. There are a number of excellent books on the market about this application. You may want to pick one up as a reference. However, do not feel compelled to read it cover to cover before you start using UltraDev. We have provided the basic database for all examples and tutorials on the companion CD-ROM. In addition, this book walks you through the creation process for anything that might be needed in support of the examples or tutorials. In doing so, you will gain experience regarding basic functionality as you work through the exercises.

If you are comfortable with Access, you may want to start learning some SQL. Understanding SQL will help you create some very advanced searches and sorts of your data, not to mention incorporate a number of advanced features, which are covered in Chapter 10.

ASP, JSP, and ColdFusion

■■ Introduction

As a web developer you know there are always choices to be made. Do you develop for a specific browser or for multiple browsers? How much bandwidth are you willing to sacrifice for a graphically attractive site? There are always questions when you develop a site. These are only two of the many questions you have to ask yourself.

Now that you are entering the realm of dynamic development, you have yet another question to ask. Which server platform and associated language are you going to use? UltraDev supports three server models: ASP, JSP, and ColdFusion. Each server model supports a different language or method.

Many times, the decision of which server model to use is dictated by the resources you have available. Most companies, organizations, and educational institutions have adopted one of these server models over the others as an aid to technology management. This chapter will describe these three server models and their associated languages.

This is one of the more "technical" chapters of the book because it must draw in some of the technical specifics in addressing these server technologies. The goal of this chapter

is to discuss each server model as simply as possible. This chapter attempts to summarize volumes written about one or more of the server models and their associated languages. The intent of this book in the end is to give you confidence and experience with UltraDev, not to make you a server administrator or hardcore programmer.

As you are reading through this chapter, things could appear to be written in Greek. If this is the case, do not worry. Simply skim the chapter for its major points regarding options in terms of a choice of server models. However, if you are not administering your own server, you probably will not have much say in which server model you will be using.

The truly "techie" people out there live for the type of material this chapter summarizes. The thing to remember is that UltraDev will do the hard work for you. This chapter is intended to help you better understand how some of the "magic" works.

There is an ongoing debate between developers and system administrators around the world regarding the best server technology.The parties in the debate all make good points. There are three basic camps in this debate. There are those who strongly support the use of ASP, which is easy to use. Windows NT/2000 servers are easy to install and manage and there are many developers who continue creating new code. However, there are many that feel ASP is not a good option for web development.

The most common arguments against the use of ASP fall under one of two topics. The first topic is more of an anti-Microsoft camp. Some developers feel a need to avoid Microsoft products strictly based on the company's success and power within the technology world. The other reason for developers to be against using ASP are the many documented security vulnerabilities in Windows NT/2000 servers. The

security concerns are valid, but Microsoft is diligent about continuously releasing updates and patches to keep its servers secure.

On the other end of the spectrum are the supporters of JSP. The availability and open-source structure of platforms and software that support JSP has brought many anti-Microsoft developers into the JSP ranks. However, those opposed to the use of JSP also make strong points. The management of resources in support of JSP pages is not as user friendly as using Windows NT/2000. However, it is a much more secure approach.

The use of ColdFusion rests somewhere in the middle of these two camps. ColdFusion does not have the widespread use of either ASP or JSP, but has continually gained adoption by developers. ColdFusion provides all of the functionality of ASP and JSP with few coding requirements, as you will see in the following examples.

The bottom line in the ongoing debate is that you will most likely be told by your IT department which server model you can use, or you will need to do some research and see which server model you feel best meets your needs. The beauty of this debate is that UltraDev can handle whichever server model you end up using.

■■ Objectives

In this chapter you will learn:

❐ The difference between UltraDev's three server models

❐ The system requirements for each server model

❐ How to choose a server model

■■ What Are Server Models?

When some people hear the term *server model* they immediately think of the operating system for the computer, such as Windows, Macintosh, UNIX, Linux, and so on. However, server model as used here refers to the server technology used on any given operating system for providing web services.

As mentioned previously, there are three server models supported by UltraDev: ASP, JSP, and ColdFusion. Each of these server models uses server-side scripting to deliver dynamic content to a user. As discussed in Chapter 1, server-side scripting involves small snippets of code, written in a scripting or programming language, that are executed by the server when a page is requested. The server then sends the requested page to the user with HTML code in place of the server-side scripting. The sections that follow discuss the basics of each of the three server models supported by UltraDev.

ASP

ASP stands for Active Server Pages. Microsoft introduced ASP in 1996 when it released Microsoft Internet Information Service (IIS) 3.0. ASP provides server-side scripting through the use of VBScript or JavaScript. ASP pages use ActiveX components and COMs (Component Object Models).

The ability to execute ASP commands (found in a web page with the *.asp* extension) is available to anyone running a Windows NT 4.0 or Windows 2000 server. If you are using a Windows 98 or Windows 2000 Professional computer, you can utilize ASP pages via Personal Web Server (PWS), which is available on your system CD-ROM. ASP pages can also be executed via a UNIX or Linux server using third-party add-ons such as ChiliSoft.

When the server receives a request for an ASP page, the server executes the server-side scripts embedded in the page. After the server has processed the server-side scripts, the results are converted into HTML, combined with the rest of the HTML code from the requested page, and sent to the user.

ASP pages tend to be faster to develop and require less expertise. In addition, the pages tend to be easier to manage after development. An ASP environment is also thought to be less expensive than JSP or ColdFusion to run and maintain.

JSP

JSP stands for Java Server Pages. JSP uses Java as its base language, not JavaScript. The anatomy of a JSP page is very similar to an ASP page in many respects. The biggest difference between JSP and ASP pages is that JSP pages are compiled and cached by the server. When the server receives a request for a JSP page, the time stamp of the page is compared to the cached version of the page. If the cached version is "out of date," the server will recompile the page and update the cached version. However, if the cached version is "up to date," it is sent to the user without having to be compiled.

The result of sending a cached version of a page is improved speed. If the server does not have to compile the page, the page is delivered more quickly to the user. JSP pages can utilize Java classes and Java Beans. Java classes are basically source code that tells an object how to behave; similar to the function of subroutines in early programming languages. Classes can be duplicated and reused numerous times. Java Beans are Java classes that follow specific coding conventions that allow them to be used by other tools within a web application. Java classes and Java Beans accomplish tasks similar to the uses made of ActiveX and COMs in ASP.

ColdFusion

ColdFusion takes its place somewhere between ASP and JSP. Whereas ASP and JSP use embedded server-side scripting based on programming languages, ColdFusion takes a different approach. ColdFusion uses ColdFusion Markup Language (CFML). CFML uses a tag-based language, which is very similar to HTML. Rather than using a scripting language, CFML uses specific tags to send commands. Just as *< table >* is used in HTML to create a table, *< CFloop >* is used in CFML to begin a loop.

ColdFusion was created with the Web in mind, as opposed to retrofitting a scripting or programming language for this purpose, as other technologies have done. ColdFusion has all of the functionality of ASP and JSP pages. It can interact with databases, manage files on the server, and deliver other types of dynamic content.

ColdFusion uses a *.cfm* page extension. When the web server receives a request for a *.cfm* page, it sends the request to the ColdFusion server for processing. The ColdFusion server processes the request and sends back the HTML. ColdFusion has built-in support for languages and protocols such as COM and Java.

ColdFusion can run on a number of different operating systems, ranging from Windows to Solaris. There is currently no way to run a ColdFusion server on a Macintosh web server. However, with the introduction of the OS X server, the Macintosh community is hopeful.

The tag-based nature of CFML is easy to learn and tends to require less coding than ASP or JSP. In addition, with the recent merger of Macromedia and Allaire, the future of using UltraDev with ColdFusion seems destined to become even brighter. Although the installed base of ColdFusion servers is still small

in comparison to Windows IIS and servers supporting JSP, the raw power and easy management and development of ColdFusion are continually winning over more developers.

■■ How Do Server Models Work?

If you have ever learned a programming or scripting language, you have undoubtedly gone through a "Hello World" example. In keeping with this tradition, the sections that follow present examples of how ASP, JSP, and ColdFusion would accomplish the same task.

```
Hello World
Hello World
Hello World
Hello World
Hello World
It is currently 9/20/2001 5:31:33 PM
```

Fig. 3-1. Hello World *on screen.*

Getting *Hello World* to appear on screen is an excellent way of demonstrating the similarities and differences among these server models. The samples of code that follow demonstrate how ASP, JSP, and ColdFusion would get *Hello World* to appear on screen five times, with the current date and time appearing beneath this copy, as shown in figure 3-1.

Let's begin with ASP, as it is the server model used for the tutorials in this book. If you have any prior programming background, ASP's command structure should seem somewhat familiar.

The sections that follow begin with an example of code for producing the *Hello World* text on screen. The discussion following these examples explains in each case elements of the code that are unique to the specific server model. Something you should notice immediately in all of the examples is the standard HTML structure (using opening and closing tags) and the standard sections of an HTML page: *< html >*, *< head >*, and *< body >*.

The basic anatomy of each page is the same as well. Each page executes a loop five times. Each time the loop is executed, *Hello World* is displayed on screen. After the loop has finished, the current date and time are displayed, based on the server's system clock.

Loops are very common in any language. Loops repeat a specific number of times and are usually used for counting, timing, or repeating some element or object.

ASP

The following code shows how the "Hello World" task would be written for ASP.

```
<html>
<head>
<title>Hello World</title>
</head>
<body>
<% for counter = 1 to 5 %>
Hello World <br>
<% next %>
It is currently <% =Now()%>
</body>
</html>
```

ASP uses < % and % > as delimiters. This is very similar to the use of < > and </> in HTML. These symbols tell the server that there is something special contained in within these symbols. In the case of ASP, the delimiters tell the server to execute the script enclosed by < % and % >.

In this code example, < % *for counter = 1 to 5* % > is the first piece of ASP code. This is the first step in a *For/Next* loop. In this example, the loop consists of four primary pieces. The first is *counter*, commonly called an index variable. You might want to start counting, for example, at 100, or 0, or even a negative

number. Here, the next part of the statement, = *1*, tells the server where to start counting.

The *5* in the statement tells the server when to stop counting. The last important piece of the loop is *< % next % >*, which tells the server where the loop ends. In this case, the server would execute whatever is inside the loop five times.

After the server has looped five times, it exits the loop and executes whatever scripts follow *< % next % >*. In this case, the server would execute *< % Now() % >*. *Now()* provides the current time and date, to the second, on the server's system clock the moment the command is executed.

JSP

The following code shows how the "Hello World" task would be written for JSP.

```
<html>
<head>
<title>Hello World</title>
</head>
<%@ page language="java" %>
<body>
<% for ( int i = 1; i <= 5; i++ ) { %>
Hello World <br>
<% } %>
It is currently <%= new java.util.Date() %>.
</body>
</html>
```

JSP pages are a little different. If you do not have previous experience with Java or JavaScript, the syntax used in JSP pages may take a little getting used to. As you can see, JSP uses *< %* and *% >* as delimiters, just like ASP. However, you can also sometimes use others, such as *< %! % >* or *< %@ % >*, depending on what you need to do. The *< % % >* is used to contain what JSP refers to as scriptlets.

The JSP example also uses a *For/Next* loop, but the structure is a little different. The statement *int i* is equivalent to *counter* in the ASP example. Here, *int i = 1* is setting the index variable for the loop (i.e., *i*) equal to 1. This tells the server where to start counting. The *i < = 5* tells the server when to stop counting. The loop also includes *i + +*, which is the same as saying *i = i + 1*. This tells the server to count by ones. It is called the step attribute in other languages. ASP uses the word *Step* and a number. For example, *Step 5* would count by fives.

JSP uses < % } % > instead of the *next* statement. The information enclosed by the curly brackets ({}) is repeated five times. After it has looped five times, the server then moves to the next piece of code. In this case it is the current time and date from the server's system clock, just as *Now()* supplied in the ASP example.

ColdFusion

The following code shows how the "Hello World" task would be written for ColdFusion.

```
<html>
<head>
<title> Hello world </title>
</head>
<body>
<cfloop index = "counter" from = 1 to = 5>
<cfoutput>
Hello World
</cfoutput>
</cfloop>
It is currently <cfoutput># Now() #</cfoutput>
</body>
</html>
```

If you do not have a programming background, you will most likely feel more comfortable with ColdFusion code (CFML). As you can see, CFML uses < > and < / > as delimiters, just as

HTML does. CFML is a more natural language approach to development, which is why you can quickly learn how to use it.

The *< cfoutput >* tells the server to execute the command(s) within the tags or display on screen the text within the tags. The *< cfloop >* is the CFML version of a *For/Next* loop. The loop begins with defining an index variable. In this case, the index variable is *counter.* The *from = 1* tells the server where to start counting, and *to = 5* tells the server where to stop. CFML can also use the *Step* command. For example, if you wanted to count by twos, you would include *step = 2* within the *< cfloop >* tag.

After the server has looped five times, it processes the familiar *Now()* command to provide the current date and time. Each server model is also capable of formatting the date and time to include such things as the name of the month and the current day of the week. Formatting attributes provide you with a lot of control over how information will appear to the user.

What Code Do These Models Produce?

```
<html>
<head>
<title>Hello World</title>
</head>
<body bgcolor="#FFFFFF">

Hello World <br>

Hello World <br>

Hello World <br>

Hello World <br>

Hello World <br>

It is currently 9/20/2001 5:31:33 PM
</body>
</html>
```

Although each of the previous examples of server model coding has its own way of being written, the resulting HTML is basically the same. Figure 3-2 shows the HTML code that is returned to the user from the server. As you can see, all evidence of the scripting is gone, and it looks as if these pages were hard coded to display this information.

Fig. 3-2. HTML code returned from the server by the server model coding examples.

■■ Selecting a Server Model

As mentioned earlier in the chapter, in most cases you will be told which server model you can use. Each server model does a fine job, and you will be able to do amazing things with UltraDev on all of these server models. If you are in a position to order a new server, or are starting a new project for which you have a choice of server model, the following are some things to consider.

If you are not the one responsible for managing the web server, take whatever you can get. The server administrator is a good person for you to take to lunch on occasion and get to know. This person can be a great ally, or an immovable road block. It is important to let server administrators know what you are doing and why you are doing it. However, stand your ground. Providing dynamic content is a new thing for many administrators, and some resistance on their part is to be expected.

If you will be managing the web server, also keep the following in mind. Windows NT/2000 is the easiest to get up and running. However, you need to be vigilant about security updates, as Windows NT/2000 is also the most vulnerable server. If you go with Windows, you can run any server model you want. ASP is built into IIS. If you want to run Cold-Fusion or JSP, you will need to purchase additional software, such as ColdFusion Server, or JRun by Macromedia. You can also use Tomcat, which can run JSP pages on a Windows NT/2000 server, and is available for free at *http://jakarta.apache.org*.

If you have a UNIX or Linux server, you can technically run all three server models. However, ASP does require a third-party add-on such as ChiliSoft. Additionally, if you have never administered a UNIX or Linux server, there is a learning curve and it may take you a while to get everything up and running.

However, the struggle may be worth it because of the security of these operating systems.

If you are going to be on a Macintosh server, look into MacOS X Server. This server is built on UNIX and comes with the Apache web server. OS X Server follows the Macintosh tradition of taking difficult tasks and making them easier. The server software is well documented and relatively easy to manage, even for a novice. Currently, you can only run JSP pages using Tomcat on a Macintosh server. However, they are very secure and powerful, and many would like to see a means of running ColdFusion on an OS X server incorporated in the next version of ColdFusion.

■■ Tips and Tricks

If you are in a large organization, such as a university or major corporation, you may have access to a variety of servers. Check around and see what people are using. They may let you try some tests on their servers to see which you like best.

In that UltraDev will handle all of the difficult stuff for you, the server model may not matter to you at all. In any of the server models, you will be able to achieve the same goals. The best advice here is to obtain access to at least one server that runs ASP, JSP, or ColdFusion and keep reading. The fun is just ahead.

■■ Summary

The goal of this chapter was to help you have a little better understanding of what the three server models supported by UltraDev are and how they work. Most developers will not have much of a say about which server model they are able to

use. However, UltraDev works the same regardless of which model is used.

The most common server model currently in use is ASP. ASP was developed by Microsoft and is based on VBScript. The most flexible server model is JSP. JSP was developed by Sun Microsystems and can run on nearly any server platform, from Microsoft NT/2000, to Macintosh, to UNIX and more. ColdFusion was developed by Allaire. Rather than using a traditional programming language such as Java, or a scripting language such as VBScript, ColdFusion uses a tag-based language, known as CFML, which is similar to HTML.

Part II

Working with UltraDev

CHAPTER *4*

Basic Dreamweaver

■■ Introduction

It may be tempting to skip an introductory chapter such as this, but you are strongly urged you continue reading. This chapter covers basic Dreamweaver terminology and features, and introduces you to the difference between Dreamweaver and UltraDev.

This chapter highlights key features of the program, and offers suggestions for preference settings, and application setup. Topics in this chapter include the development history of UltraDev, basic features of the program's uses, and the program's most commonly used features. Along the way, you will examine the real power of UltraDev, particularly in regard to setting up a site within UltraDev. Throughout, the text offers suggestions that might help you avoid some common errors made by beginning users.

This chapter does require a certain level of knowledge of the technical aspects of the server(s) you plan to use. This means you may have to talk with your network or system administrators to get some basic information. When you have finished this chapter, you will be ready to start using databases

in your web sites and to start developing your own web applications. Let's get started!

■■ Objectives

In this chapter you will learn:

- ❏ The difference between Dreamweaver and UltraDev
- ❏ The basic features of Dreamweaver and UltraDev
- ❏ About reusable content
- ❏ The various design and view modes
- ❏ The differences among the various server models
- ❏ How to customize the setup of Dreamweaver and UltraDev
- ❏ The options available in common windows
- ❏ How to define a local and a remote site

■■ Pedal for Peace

The database for Pedal for Peace is all set up and has been working great for sending out form letters, membership directories, and managing the membership. This has led to a boost in membership and a greater number of people wanting to learn about this great cycling tour.

Somebody decides it is time get Pedal for Peace on the Web, and you have been put in charge. You do your research and find out that Macromedia UltraDev is the application you want to use. In that you already have a logo and a lot of information that can be placed on a web site, this project should not take you too long.

You find a reasonable host that helps you register your domain name and gets you all set up. Now it is time to get Pedal for Peace on the Web. This chapter will help you through the basics of using Macromedia UltraDev to realize just such a project as this.

■■ Dreamweaver Versus UltraDev

Preliminary to attacking the "nuts and bolts" of the hypothetical web site project, this section discusses the history of Dreamweaver and UltraDev development toward an understanding of the context in which these programs are used, as well as the basic features of Dreamweaver and UltraDev.

A Little History

Since about 1997, the web development community has embraced the power and flexibility of Macromedia Dreamweaver. It took very little time for Dreamweaver to become the industry standard for web development. It seemed Macromedia had overcome the common complaints developers voiced about other HTML generators and editors. Of course, you most likely know this or you would not be reading this book.

However, there was still something missing. Static web sites were no longer enough. The explosion of e-commerce and the need for more up-to-the-minute information required dynamic, data-driven sites that could provide a user with customized information. Dreamweaver at the time really did not address this issue. Other products, such as Microsoft Visual InterDev and Claris Home Page (in conjunction with File-Maker Pro), allowed developers to more easily incorporate dynamic data into their web sites. Other developers started writing common gateway interface (CGI) scripts to manage data in their sites.

This is when Macromedia again shocked the development community with the release of UltraDev, a product built around the power and flexibility of Dreamweaver. With Dreamweaver UltraDev, you get all of the features of Dreamweaver and some incredibly powerful additions.

Basic Features of Dreamweaver

Dreamweaver and UltraDev share all of the features found in Dreamweaver. This section discusses the basic features of both applications.

Visual Development

The advent of "What you see is what you get" (WYSIWYG) web development tools has brought a mixed blessing to the Web. For a developer, these tools shortened development time, by making it easier to "create" a web page visually, rather than through hand coding. The other side of this issue is that most WYSIWYG tools generate HTML code that is so confusing and cluttered with "junk tags" that a developer cannot go into the code to make small modifications. This is especially limiting in a collaborative or consulting environment, in which you may be working on pages that someone else created.

Dreamweaver has been praised from version 1 through its current version, version 4.01, for generating clean and pure HTML. If you have ever hand coded a table with column and row spans, you know how time consuming it can be. With Dreamweaver, inserting such items as tables is almost too easy.

The idea of visual development has been carried beyond that of designing a web page. UltraDev offers two different visual layouts for site mapping and layout. Figure 4-1 shows UltraDev's Site Map view (on the left) and Site Files view (on

the right). The Site Map view shows you how pages are linked, as well as what links are found on the pages. This view also allows you to create pages and links between them quickly. The Site Files view provides the directory structure of the site.

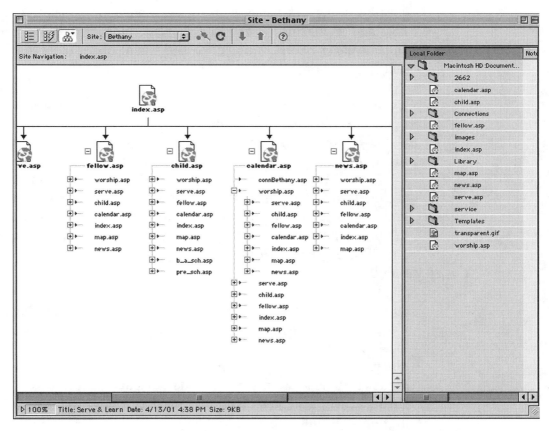

Fig. 4-1. UltraDev's Site Map view on the left and Site Files view on the right.

HTML Editor

As noted, Dreamweaver generates clean and pure HTML. If you enjoy hand coding or ever need to go into the code to "tweak" items, you will love the code created by Dreamweaver and the Roundtrip HTML feature that allows you to

access the HTML code quickly and easily. Dreamweaver also offers you a number of ways of creating and viewing your code (discussed later in this chapter).

Site Management

Creating a few web pages is one thing, but creating, maintaining, and managing a web site is something else entirely. Dreamweaver offers a number of site management tools that will save you time, energy, and frustration.

If you have ever had to go back through pages and pages to update a link because a file name or file location has changed, you know how long it can take. Dreamweaver has the ability to maintain and update hyperlinks as you change things, which is a huge time saver. Dreamweaver maintains a cache of each site, which as you change things allows you to know what pages may be impacted by that change and offers to update the links. As a site grows, accruing more directories and files, Dreamweaver keeps on top of things for you to keep things running smoothly.

Of course, managing a web site is much more than keeping track of links, files, and images. You also need to keep your local files and remote files (the files on the web server) coordinated. Everyone has at some point made changes but forgotten to upload a graphic or update a page on the server. Dreamweaver can help with this too. Dreamweaver has a built-in FTP utility that will allow you to upload, download, delete, and create files and directories. This utility will also synchronize your local and remote sites based on the last modified date.

Another wonderful feature included in Dreamweaver is the Check-in/Check-out feature. If you work in an environment in which multiple people update pages, this feature will stop you from updating a file that someone else is modifying. It

will even tell you who is using it. As people open pages, they are "checked out" on the server. They can still be viewed by visitors to your web site, but if you go to open a page in Dreamweaver that is "checked out," it will stop you and let you know another developer has it checked out.

Templates and Libraries

If you work on pages with common navigation, logos, color schemes, and so on, Dreamweaver can help you in this area as well. Libraries are sections of code that can be reused on pages throughout a site. For example, something like a copyright statement is great in a library. You make it once and then insert it on pages, as you need it. The real beauty of this feature comes, for example, when you need to change the copyright date from 2001 to 2002. You change it in the library and Dreamweaver runs through your site and changes it on every page that has that library. Libraries can also work with larger sections of code, such as navigational links.

Taking the idea of a library one step further is the Template feature. Templates are a feature most developers could not live without once they start using them. Templates allow you to design a page and then make some regions open for edits and others not. Templates let you assign a name to regions that are editable. These editable regions can also have a number of other attributes assigned to them, such as font styles and alignment.

Utilizing templates provides three basic functions. First, templates let you create multiple pages with a similar layout. Second, templates allow you to design a page and let others add the content in the editable regions, without allowing them to easily change the layout. Third, templates let you make changes on hundreds of pages in seconds.

For example, in figure 4-2 you see a basic introduction page for a college course. Two boxes have been drawn on the page for this example. The top box is labeled "Heading" and the lower box is labeled "Body." These two boxes and the document title are editable. The reason this was useful in this case is twofold. First, someone else maintained the content on this site. Therefore, setting up the layout, major navigational links (buttons on the left), color scheme, formatting, and font selection in the template ensured a consistent replication of this design but allowed another user to add the content.

Fig. 4-2. Boxes labeled "Heading" and "Body" are editable regions of a template.

Second, if the layout needed to be changed so that the navigational links were on the top instead of the left, the template could be altered and saved. Dreamweaver would update each page in the site using that template. When the pages are updated, anything in the "Heading" region would remain in the "Heading" region, just as information in the "Body" region would remain in the "Body" region, even if these regions have changed locations on the page.

NOTE: *You can use libraries within templates.*

Cascading Style Sheets

As you will read in Chapter 5, cascading style sheets (CSS) can be very handy. In many ways, CSS are similar to templates, and you may find that it is helpful to use them together. Dreamweaver provides a simple interface for assigning styles to virtually any part of a web page.

TIP: *Accessing a CSS from a template may allow for faster site management, because you only need to upload the CSS page and all pages using a template would reference a single CSS.*

JavaScript

Dreamweaver offers a number of built-in JavaScript elements. Everything from pop-up windows to image swapping is included in Dreamweaver. In addition, you can write you own scripts or call scripts from within Dreamweaver.

In addition, Dreamweaver helps you plan your site for different browsers. You can check to make sure the JavaScript you include in a site will work on browsers greater than 4.0, on 3.0+ browsers, and so on. This can be a big headache saver, not to mention time saver when it comes to testing your sites.

Other Dreamweaver Features

The many features previously discussed are by no means an exhaustive list of Dreamweaver features. In fact, this barely scratches the surface. However, this is not a Dreamweaver book; there are many excellent resources available for Dreamweaver. It is strongly recommended that you utilize the Dreamweaver tutorial that accompanies the application. The features found in Dreamweaver can help any developer perform amazing things on the Web, but we want to focus on the power of UltraDev.

The Power of UltraDev

UltraDev picks up where Dreamweaver leaves off. Static web pages are great, but having the ability to dynamically deliver and maintain information is truly amazing. The key to this power is the ability to use a database to store and deliver information to and from your web site. If you have ever used a database to generate form letters, you have an idea of how useful this can be. Think back to Chapter 2's discussion of databases. There are six basic tasks you can perform with a database.

❏ Store data

❏ Sort data

❏ Search data

❏ Add data

❏ Delete data

❏ Modify data

UltraDev lets you do all of these and many more things through a web browser. How you use the information stored in the database is limited only by your imagination.

UltraDev lets you design your pages in exactly the same manner you would in Dreamweaver. You design a page that has placeholders for the information in a database. You can format these placeholders, and the formatting will be placed on the data from the database when it displays in the browser. You can use simple programming logic to make decisions about the data and how or what to display. You can allow users to add, delete, modify, or simply view existing data. It is all up to you and the needs of your site.

NOTE: UltraDev represents a great way of allowing people that have no web development experience maintain the content of a web site.

You can show all records in a database or display only records that meet specific search criteria. All of this can be done across both Windows and Macintosh platforms and can be used on virtually any server technology.

If you have ever maintained an on-line catalog or directory using static pages, you will love UltraDev. In the past, if you had 100 items in a catalog you needed to display, you needed an HTML page for each item, even if the only thing that was different from one page to the next was the description, picture, and price. With UltraDev, you can take that same list of 100 items, place it in a database, and make one page that will display the details for each item when requested by the user. This means that if you add items, you add the information to the database and a customer can see it.

Take this idea one step further. If you set up an on-line catalog for a client, you could make a special administrative directory in the site that would allow them to manage the database through the Web. This means that your client is empowered to make price changes or add/remove an item.

NOTE: *It sounds like this would decrease your business because clients would not need you anymore. However, once most clients see what is possible, they come up with even more work for you.*

This is where you move from creating a data-driven page to developing a web application. A web application will provide users with a variety of options and controls.

As mentioned earlier, the ability to use data from a database has been around for quite a while, and there were some applications that helped with the process. These applications and the programming that went along with them were not very portable. Each came with specific requirements that were not always readily available. For example, Claris HomePage and FileMaker Pro worked well. However, it required that File-Maker Pro was always running on the server, as well as the use of specific port numbers. Microsoft Visual InterDev required a Windows development platform and server technology.

With UltraDev, you can develop on a Macintosh or Windows machine that will function on virtually any server technology. Dynamic web sites are now showing up in churches, schools, universities, hospitals, and banks. The technology is here, and you are going to love it.

■■ UltraDev Output Types

As discussed in Chapter 3, UltraDev supports three common scripting languages and server platforms. Which you use may depend on what type of server you have access to or with which scripting language you feel most comfortable.

These languages are considered embedded languages. This means that the information is actually embedded into your

HTML page and processed on the server when the page is requested by a user, rather than run via a separate application on the server or client.

Active Server Pages

Active Server Pages (ASP) were developed by Microsoft and were the first to use an embedded approach. ASP is based on the VBScript language. ASP requires that the server is running a Microsoft platform (NT or 2000 Server). Additional software is required for the use of ASP on UNIX-based servers. See *http://www.chilisoft.com* for more information. Mac users can still develop in ASP, but Macintosh servers cannot process ASP pages.

Java Server Pages

Java Server Pages (JSP) are based on the Java programming language. JSP has a number of advantages. With a couple of exceptions, anything you can do in Java, you can do with JSP. If you have Java experience, you are ready to get going. If not, do not worry, you will be provided in this book with more code snippets and samples than you will know what to do with. The other advantage to JSP is that it can be run on almost any server platform, including UNIX-based, Windows, and Macintosh. There is also a free JSP server available named Tomcat.

 NOTE: *Anything that is free has its limitations, and Tomcat is no exception. Tomcat does not have the best documentation, but it is being used all over the Web and online discussion forums are readily available.*

There are commercial versions of JSP servers available as well, including the following.

❑ Allaire (*http://www.allaire.com*)

❐ IBM WebSphere *(http://www.software.ibm.com)*

❐ iPlanet *(http://www.iplanet.com)*

ColdFusion

ColdFusion Markup Language (CFML) is slightly different from ASP or JSP. ASP and JSP are embedded languages that use delimiters in the code to set it apart from the HTML. CFML has extended HTML to include additional tags for Cold-Fusion to work.

If you are new to programming, you are strongly encouraged to look at ColdFusion. It takes a slightly different approach than ASP and JSP, and may be considerably more intuitive than these two. If you have a programming background, Cold-Fusion may take some getting used to.

The Allaire Corporation developed ColdFusion. At the beginning of 2001, Allaire and Macromedia began talks about a merger. By March of 2001, the merger had taken place and it remains to be seen how ColdFusion is more strongly incorporated into UltraDev. ColdFusion is a commercial server package available for UNIX-based and Windows servers. The application is very robust and will work in conjunction with existing web server software.

■■ Setting Up UltraDev

As with any of the Macromedia products, the installation of UltraDev is pretty simple. All you need to do is run the installer found on the Macromedia UltraDev CD-ROM and follow the instructions.

 NOTE 1*: Macintosh users should install the latest Mac OS Runtime for Java before installing UltraDev. There is a*

version of the software on the UltraDev CD-ROM. You may also want to check http://www.apple.com/java/ *for the latest version.*

NOTE 2: *Windows users may need to install Microsoft Data Access Components 2.5 or higher to connect to databases. This is typically installed with Microsoft Office 2000. You may want to check* http://www.microsoft.com/data/ download. htm *for the latest version.*

Now that you have the application installed, it is time to have some fun! In the next section, you will walk through some of the basic preferences and discover some of your options.

■■ Preferences

Macromedia is committed to making its applications as similar in appearance as possible. Windows and panels look the same across different applications, and many of the preference options are the same so that you can tailor your applications to your personal liking. For a complete description of all options, click on the Help button in the Preferences window for each category.

General

General preferences offer you a few handy options. A couple of these options are particularly notable. The first is an option that brought cheers from users around the globe. "Show Only Site Window on Startup" does not sound like much, but to many Dreamweaver and UltraDev users this option represents a lot. Formerly, when you opened UltraDev for the first time, a blank page opened for you. This was nice, the first time, but once you start working within UltraDev, you will likely never want that to happen again. The Show Only Site Window on Startup option does just that.

Another notable option is "Add Extension when Saving." This option is important because it can save you time. If you are going to develop mostly *.htm* files, set it to *.htm*. If you use *.asp*, *.jsp*, or *.cfm*, you will need to post these pages to a server to view them properly in a browser.

 TIP: *Enable Double-Byte Inline Input allows you to enter Double-Byte text into the document window. This is handy if you are using language kits with Japanese characters.*

Code Colors

The more you use UltraDev, the more you will need and want to "play" in the code. The Code Colors preference category lets you assign different color codes to different aspects of the code. Reserved Keywords is one of the most useful color codes for beginners. As you are looking at the code, reserved keywords, HTML tags, and comments will each be a different color than other text.

This option can really help you when it comes time to debug something. The color codes will help you scan through a code quickly for the information you need.

Panels

Panels is another handy preference category that allows you to customize UltraDev to your liking. Because most people do not have a 36-inch monitor on their computer, or dual monitors, this option is really helpful. It lets you decide which, if any, panels are always on top. An alternative is to turn all panels off, reserving screen space for the actual files you are working on.

 NOTE: *For some reason Macromedia has called these Panels in the preferences, but they are found under the Window*

Menu option. We usually refer to them as windows in this book.

File Types/Editors

This is another area in which Macromedia shines. The File Types/Editors option lets you decide which application should open which file extension when you double click on it. Therefore, for example, if you realize that a graphic needs to be resized while you are looking at it in UltraDev, just double click on it to open it in the graphics editor you use, edit it, save it, and close the editor. The more you use UltraDev, the more useful this feature becomes.

Keyboard Shortcuts

The Keyboard Shortcuts option is found just below the Preferences option in the Edit menu. This is yet another way Macromedia is trying to help designers work more efficiently. You no longer have to learn new keyboard shortcuts for each application. You can actually create your own set and export it to other Macromedia products. It may take a little while to get all of the shortcuts set, but this will save you a lot of time in the long run.

■■ Basic Panels

As mentioned previously, Macromedia uses the term *panels* in the Preferences options, but they are accessed from the Window menu option. Panels allow you to insert objects, change options and properties, add scripts, and so on. There are a number of panels available in UltraDev. This section describes four of the most commonly used panels.

TIP: Find a screen layout you like and stick with it. It is recommended that you place windows on the sides and bot-

tom of the screen to give you plenty of workspace for your web page, while allowing you quick access to panels. A lot of people end up opening and closing windows all the time and have the web page maximized on their screen. This leads to a lot of wasted clicks, time, and mouse movements.

Objects

Fig. 4-3. Objects window with default options displayed.

The Objects window (figure 4-3) is where you can find a number of different elements or objects to insert into your web page. The default Objects window contains the following categories.

❐ *Characters* is where you can find trademark, copyright, and other special characters or symbols.

❐ *Common* is where you would find items such as tables, images, layers, and horizontal rules.

❐ *Forms* holds objects such as the forms, text boxes, lists/menus, and buttons.

❐ *Frames* provides you with a list of predefined frame sets.

❐ *Head* contains objects such as keywords and meta tags.

❐ *Invisibles* is where you would find anchors, scripts, and comments.

❐ *Live* provides shortcuts for dealing with objects from a database.

❐ *Special* holds items such as plug-ins and applets.

Because UltraDev is customizable, you can add or delete objects to and from this window. In addition, the UltraDev Exchange *(http://www.macromedia.com/exchange)* site offers

many extensions, which can be downloaded for free, that will add objects to this window.

Properties

The Properties window (figure 4-4) is one to watch. It changes, depending on what you have selected on a page. For example, if you have an entire table selected, the Properties window provides access to the Table properties. Therefore, if you select text, for example, you can change the options of the text (e.g., color, alignment, size, and style).

It is rather easy to get confused at first with the Properties window, because it does change so often. Learn to glance at it frequently to see the different options for things you select.

Fig. 4-4. The Properties window changes as you select different elements on a page.

TIP: *To see the properties for a table, select the table and press Ctrl + A twice (Windows) or Command-A twice (Macintosh). If you drag through the cells to select all of them, you will not get the table properties.*

Data Bindings

Data bindings define the point at which Dreamweaver leaves off and UltraDev begins! Everything discussed to this point is shared between Dreamweaver and UltraDev, but now we move into UltraDev. The Data Bindings window (figure 4-5) is where you set up your recordsets, modify your connection to

the database, access storage (Store) procedures, and request a variety of variables.

Fig. 4-5. Data Bindings window with two recordsets: rsResults and rsSample.

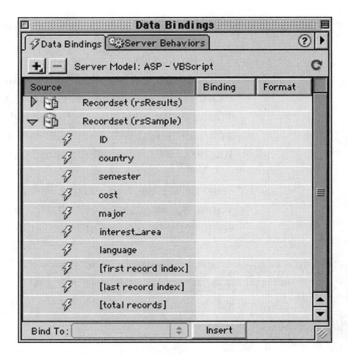

The following describe the features previously mentioned, as well as a few other neat things you can accomplish using the Data Bindings window.

- ❒ *Recordsets* is the name of those records you request from the database. A recordset can have any number of records in it, depending on what criteria you filtered (searched) the database with when you requested the recordset. A recordset can even be empty.

- ❒ *Connections* to the database are what allow you to see the various fields in the database, so that you can use them in your web page.

❑ *Stored procedures* are mini-applications that run within SQL.

❑ Requesting variables refers to moving variables from one page to another or to moving variables around within a web application.

The Data Bindings window is also where you see the fields found in your recordset. This is where the visual development in UltraDev starts to appear. In figure 4-5, you see two record-sets: *rsResults* and *rsSample*. The *rs* indicates that this is a recordset. Below *rsSample* you see 10 items with lightening bolts next to them. The first seven represent the fields selected from the database for this recordset. The last three are automat-ically included through UltraDev and are very handy. (This topic is discussed in detail in the next two chapters.)

The Data Bindings window also lets you change the format-ting of the data you are putting into the web page. For exam-ple, if you are getting prices from an on-line catalog and the data in the database does not have the dollar sign, you can tell UltraDev that a particular piece of data is currency (did you want that converted to the British pound?).

Server Behaviors

The Server Behavior window (figure 4-6) is where things can get really interesting. There are a lot of things that can happen from this window. The following describe the key behavior options. These behaviors are explained in detail in later chap-ters, so do not feel overwhelmed. For the behavior options described in the following, assume you are using the Pedal for Peace database.

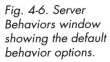

Fig. 4-6. Server Behaviors window showing the default behavior options.

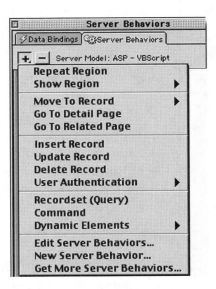

For illustration purposes, assume that a visitor to the Pedal for Peace web site is from Tucson, Arizona. He wants to know if there are any tour riders from Tucson. A search is made for riders in Tucson. The way in which each server behavior might be used in this situation is discussed in the following.

❑ *Repeat Region* allows you to repeat any number of records found in your recordset. The use could have obtained a complete list of riders who met certain criteria or maybe just the first 10 riders from Tucson.

❑ *Move to Record* is where you can set a link to go to the next or previous record(s) in a recordset. If your repeat region in the previous example showed only the first 10 riders from Tucson, you could add a link on the page that would show the next 10 riders from Tucson.

❑ *Show Region* is where you tell UltraDev to hide or show a region you have selected on a web page based on some criterion of the recordset. If there were 100 riders from Tucson, and you had the repeat region set

to show 10 at a time, you would need a link that moves to the next 10 riders and a link that moves to the previous 10 riders. However, you would not want the previous link to show on the first 10 riders, nor would you want the next link to show on the last 10. This behavior lets you tell the server to show the next link until there are no more riders to show. The previous link will not show up if it is the first record in the recordset.

❏ *Go to Detail Page* would take the user to a page containing more information about a specific rider. If there were someone in the list of riders that lived near the user, you could click on that rider and go to a page containing more information about that rider (e.g., a picture, a bio, and so on).

❏ *Insert Record* would be used to add a new rider to the database.

❏ *Update Record* would be used to modify the information about a rider through the Web. If the e-mail address changed, you could update the address from a page that used this behavior.

❏ *Delete Record* would be used to remove the record for a rider that is no longer in the Pedal for Peace tour, so that the record would not appear in the list.

❏ *User Authentication* is a great feature that allows you to set up user names, passwords, and access levels. For example, this feature would be used to give only certain tour members the ability to add or delete riders to or from the member list while providing all members with the ability to modify their individual information.

❏ *Recordset Query* will let you set up a recordset just like you do in the Data Bindings window.

❑ *Command* is used to execute a stored procedure or commands within a database.

❑ *Dynamic Elements* is used to include data from a recordset in a form element. For example, perhaps you are tired of typing all of the state abbreviations when you add new members. You could have these pulled from the database and populate a drop-down menu. This feature could even alphabetize them for you.

❑ The rest of the options are for creating and getting new server behaviors.

You can download hundreds of free server behaviors and extensions from the Macromedia UltraDev Exchange.

■■ Design Modes and Views

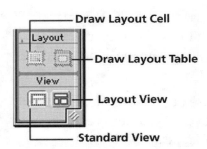

One of the many reasons UltraDev has been so successful is its flexibility. This flexibility is highlighted in regard to the View and Design modes offered within UltraDev. Icons associated with these two modes are shown in figure 4-7.

Fig. 4-7.The Standard and Layout View icons and the Draw Layout Cell and Draw Layout Table icons.

Standard View

The Standard view is the default WYSIWYG look for UltraDev. You are limited to three alignments: left, center, and right. That is, you cannot simply place an image anywhere you want. This would be like trying to move a picture around in a word processor without an anchor or frame for the picture. You select the Standard mode by clicking on the icon at the bottom left of the Objects window.

Because getting objects and text to lay out on the page exactly how you want them is very tricky in HTML, most people use tables to help with the layout. However, defining a table to do exactly what you want it to do can be very difficult. This is where the Layout view comes in.

Layout View

The Layout view allows you to draw a table and table cells very precisely. The HTML for the table is still basic HTML, but it uses exact pixel widths and heights for the table and cells to hold things in place.

You start by selecting the Layout View icon. You then use the Draw Layout Table option to draw the outer borders of your table, and the Draw Layout Cell option to draw the cells you want. As you do this, UltraDev will create temporary cells to accommodate the cells you draw.

If you click back to the Standard view, you will see a very detailed and complex table for you to use. When you get a chance, play with this and look at the code that is created.

Design View

The Design view is the visual development view you see when you open a page. This provides a WYSIWYG development environment for a web page. As you add HTML elements such as tables, images, and text, you see them on screen much as they will appear in a browser. This view shows objects as they would appear in a web browser, with the exception of tables with borders equal to 0. These borders are displayed as dashed lines so that you can see them.

Code View

The Code view is just that. It shows you the HTML code that is behind a web page. You do have a few options in this view. First, if you want to edit things at the code level, this is not a problem. Just click and start typing.

You can also select to see the line numbers. This is a really handy option if you are getting errors in specific line numbers. Another option is to use Word Wrap. This option keeps your code confined to the size of the Code window.

NOTE: Word Wrap can sometimes cause problems when you are doing some fairly advanced things. Such potential problems are discussed as they relate to various topics in this book.

Code and Design View

The Code and Design view is probably one of the best tools a beginner can use. It shows you the code as you are visually creating a page in a split window. Use of this view is a great way of learning more about HTML and how the code works. It is also a faster to use the Code and Design view to make small changes at the code level than to open the Code view, especially when you have really long files full of code.

NOTE: The more you use UltraDev the more you will be using form elements and data bindings. You will soon discover that it is much faster to change element names within the Code view than within the Design view. If you are not very comfortable with reading through the HTML code, the Code and Design view is perfect for you. This view obviates having to click back and forth between views and lets you edit things very quickly.

Live Data

The Live Data view can really help you understand what your page will look like when it is on the Web and is displaying data from a database. The Live Data view actually takes data from the database, creates a recordset, and displays data for you. Within this view, you can edit the way your page is laid out as the data is appearing on the page.

■■ The UltraDev Workflow

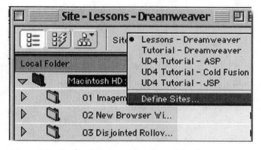

Fig. 4-8. Defined sites listed and Define a New Site option shown in the Site drop-down menu.

It is time to move from being a passive reader to an active participant. Let's set up a site. Open UltraDev and make sure that the site files are showing (look under the Window menu). Look in the Site drop-down menu. You should see five sites that have already been defined when you installed UltraDev (figure 4-8).

Select Define Sites at the bottom of the list. It is quite possible that these next few steps are some of the most difficult when using UltraDev, because there are a lot of options and you need to pay close attention when adding information. You should now have the Define Site window opened (see figure 4-9).

The first thing you need to do is to define the local site. Defining the local site is pretty simple. This is where you will save your site on your computer. A good place to do this might be in a folder within My Documents (Windows) or Documents (Macintosh). With UltraDev, you develop your site off-line and then post it to the server.

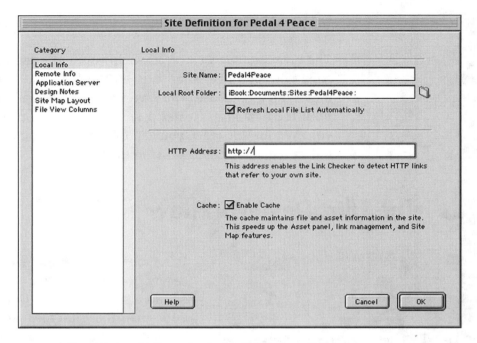

Fig. 4-9. Local information in the Define Site window.

TIP: *Setting up a folder on your hard drive that holds all work done in local sites makes backing things up pretty easy. In addition, you do not have to spend a lot of time looking around for things.*

Local Site

Let's define a local site. Give your site a name. This can be just about any name, which is used only within UltraDev in the Sites drop-down menu. In the example, we used *Pedal for Peace*. Click on the folder icon next to the Local Root Folder input box. This should bring up a dialog box that lets you navigate to where you want to store this site locally. If you have not created a folder yet, you should be able to do so within this dialog box. You may need to refer to your operating system help to learn how to do this from the dialog box, but it is typically a button somewhere in the window.

NOTE: *UltraDev places the complete path to the folder into the input box. Most likely this will differ from that shown in figure 4-9.*

The check box for Refresh Local File List Automatically is selected by default. This option automatically updates the file list whenever you add or modify a file in the site. This can be a bit annoying at times, and if you have a large site it can be rather time consuming. For now leave it checked, but remember that you can always speed things up by deselecting it.

HTTP Address allows UltraDev to verify absolute links that may appear in your site. The idea is that you can place the complete URL for the site in the box, which allows UltraDev to keep track of things. This is an option that is not all that necessary for most situations. For now, leave it blank, because you do not know where this site will reside on the Web.

Enable Cache creates a cache file of the site, which helps UltraDev maintain links and assets while you are developing. This is an incredibly helpful feature. When you click on OK, you will be prompted with a dialog box asking about caching the site. Click on OK. Now you have made a home for your local site.

NOTE: *If you do not have access to a server right now, you will not be able to perform the next two steps. Read through them and refer back to this section when you get access to a server. You will still be able to use quite a bit of UltraDev's power locally. If you are working in Windows 98, 2000, or ME, you may want to look into downloading or installing Personal Web Server (PWS). Alternatively, UltraDev comes with a development copy of ColdFusion that can be used on a Windows system.*

Take some time and look at the Site Files window. Right now it does not have anything listed in it. However, adding a new page is a snap. If you right click (Windows) or Ctrl + click (Mac) within the Site Files window, you will get a contextual menu. From this menu, you can add new pages and folders. There are a number of options that will be grayed out right now, but this is where to start.

TIP: *Familiarize yourself with the contextual menus of UltraDev. They can be a big time saver for you, especially when editing tables.*

Remote Info

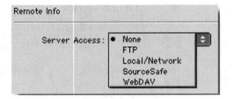

Fig. 4-10. Choosing the connection to the remote site.

The Remote Info feature is where you take advantage of UltraDev's FTP functions. This is where you define your remote server, or actual web server. UltraDev then uses that information to maintain the site on the web server using FTP to get and put files. If you do not administer the server, you will need the following from the person or people that do. Figure 4-10 shows the options that need to be established, which are explained in the following.

- ❏ *Server Access* is how you will get to the server. If you are accessing a network drive, you would use LAN. FTP would be used to access a remote web server or FTP server. These are the two most common options. UltraDev also supports WebDAV (Web Distributed Authoring and Versioning) and SourceSafe. These are emerging technologies aimed at helping collaborative environments work more efficiently. If you have access to these services, check with your system or network administrator for the proper way to connect to a remote site.

❐ *FTP* (see figure 4-11).

- FTP Host is the "address" of the FTP service on your remote host.

- Host Directory is the path on the server to the directory for your web site.

- Login and Password entries are usually supplied by your administrator.

Fig. 4-11. Defining a remote FTP site.

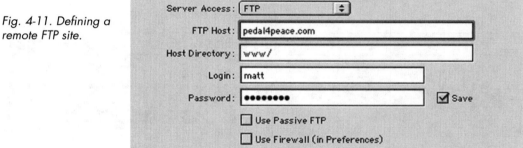

❐ *Local/Network: Remote Folder* is on a mapped drive (Windows) or *AppleTalk Connected* drive (Macintosh).

❐ *Use Passive FTP* is used when firewalls are in place. Some firewalls require passive FTP, which lets your software set up the connection to the server, rather than having the remote server set it up.

❐ *Use Firewall* is used if you are connecting to a server that is behind a firewall. This option is configured from the Site option under Preferences.

❐ *Check in/Out* is used when you are working in a collaborative environment. For now, leave this option

unchecked.

 NOTE: *You may need to talk with your network or system administrator to gain access to these types of services.*

Click on OK and Define Site Window to make sure things are set up correctly at this point. When you are back to the Site Files window, click on the connect icon to the right of the Site drop-down list. It looks like the ends of an extension cord. This is used to connect to your remote server. (See figure 4-12.)

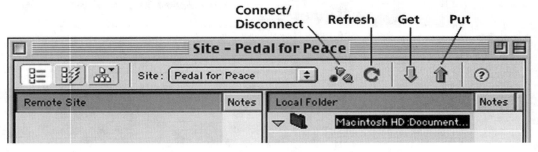

Fig. 4-12. Remote site control icons.

If you connect to your remote server, you should see an empty folder in the Remote Site side of the Site Files window. If you get an error, it is likely you made a typo somewhere in the Remote Info section or that you do not have remote access to this directory. Double check the Remote Info settings. If you have questions, contact your network or system administrator.

 NOTE: *Most hosting services provide all of the connection information you will need (in their initial confirmation of your hosting agreement).*

If you are connected, you are making good progress. Now it is time to go back to the Define Site window and get your application server information taken care of (see figure 4-13). This

requires that you know a little about what type of server you will be using available scripting languages on.

Fig. 4-13. Defining the application server.

Application Server

Server Model:	ASP 2.0
Default Scripting Language:	VBScript
Default Page Extension:	.asp
Server Access:	FTP
FTP Host:	pedal4peace
Host Directory:	db/
Login:	matt
Password:	●●●●●●●● ☑ Save
	☐ Use Passive FTP
	☐ Use Firewall (in Preferences)
URL Prefix:	http://www.pedal4peace.com/

The URL Prefix is the location of the site's root folder on the application server.

Application Server

The first thing you need to do is decide which server model you are using. Server models were discussed earlier in the chapter. You have three options: ASP 2.0, JSP 1.0, and Cold-Fusion 4.0. There is no simple way to know which server model you need. Ask your network or system administrator.

If you are using ASP, you also need to decide which scripting language to use: VBScript or JavaScript. Use the language with which you feel most comfortable. When you select a server model, a default page extension is selected. This extension tells the server to treat the page differently from regular HTML pages.

 WARNING: *Do not change the page extension to* .htm *or* .html. *This will disable any dynamic content you might have on the page.*

Now you need to set up the server access. UltraDev automatically assumes that your application server runs on the same system as the web server you specified in Remote Info. If this is what you want, move on to the URL Prefix. If the systems are different, you will need to enter the information needed to access your application server in the Application Server window. You will need to provide the FTP host, host directory, log-in, and password for the application server. The text boxes are automatically filled in by UltraDev with the information from your Remote Info settings.

 NOTE: *In figure 4-13, you will notice that Home Directory is set to* db/ *instead of* www/. *This is because many servers are set up to store databases in directories that are not part of the web site root directory.*

The URL Prefix setting is incredibly important. This allows UltraDev to connect to your application server and to display live data in the Live Data view. If you leave this blank, you will not be able to connect to your databases.

The URL prefix is the URL a user would type into a browser field to get to your web application, without including specific file names. For example, if the URL were *http://www.agecon. purdue.edu/webapp/home.asp*, the URL Prefix setting would be *http://www.agecon.purdue.edu/webapp/*.

At this point your site is defined and you can begin work. There are three other options available in the Define Sites window. These are briefly reviewed before moving on to working with UltraDev.

Design Notes

Design notes allow you, the designer, to leave yourself and others messages attached to specific files. This can be very helpful if you have other people working on a site. This is also a good way of keeping track of specific page information, such as who created it, when it was created, when it was approved by the client, and so on.

These notes will not show up on the Web or in source code, only through UltraDev. In a collaborative setting, they are the equivalent of electronic sticky notes, and they can be a real time saver.

Site Map Layout

If you are a visual person, this is an option you may really like. By telling UltraDev what the "home page" or starting page of your site is, the Site Map Layout option found in the Site Definition window will provide a graphical map of your site. The map shows HTML files and page content as icons. You can modify pages and the structure of your site from the site map as well.

 NOTE: *It is very difficult to see the structure of a large site in the site map. Thus, for larger sites this tends to be rather inefficient.*

File View Columns

The File View Columns option found in the Site Definition window allows you to customize the columns that appear in the Site Files window. You can change the order of columns, and add or delete (up to 10) columns, for remote and local folders. Some developers like to see the data last modified near the file name; others may first want to see if a file is

checked out. It is up to you to customize this option. Of course, the default setting works great for a lot of developers.

■■ Summary

The goal of this chapter was to help you understand some of the basics of UltraDev. The windows discussed are some of the most commonly used windows in the application. You will use the Objects and Properties windows for nearly every part of development.

Data bindings and server behaviors are what set UltraDev apart from Dreamweaver. The Data Bindings and Server Behaviors windows are what allow you to visually interact with databases. Without them, you have to hand code web applications.

In addition to the windows, various views were discussed. Accessing raw HTML code is easy to do in UltraDev. You can even watch the code appear as you visually create a page in the Code and Design view. This feature is helpful to the beginner in learning more about HTML structure and tags, particularly in that UltraDev generates pure HTML.

Gaining an understanding of how to do things and where to access various options in any application is a tough first step. UltraDev is no different. Dreamweaver veterans have an advantage. The interface is the same for UltraDev. Those of you that are new to the Dreamweaver interface need to experiment with it to become used to how things work and where they can be found.

An added bonus from Macromedia is that most features in their applications can be accessed from at least two, and often three or more, ways within the application. Contextual menus

provided with UltraDev were discussed in this regard. These menus offer various types of time savers.

In addition to exploration of the common windows, you walked through the site definition process. Defining a site is the backbone of UltraDev. Without a defined site, UltraDev is nothing more than a nice HTML generator. The true power of this application comes from its ability to manage large, complex sites via such things as libraries and templates.

UltraDev allows you to connect to databases to store and manipulate data through a web interface. This makes for a dynamic and interactive site that will keep users coming back, and that will streamline your development process.

Macromedia has focused on efficient development. It is up to you to find your own methods and routines. For example, the "ritual" one person goes through when he sets up a new site might not make sense to you, but for that person it works and it is reliable and consistent. Your "ritual" will develop over time. Being consistent in how you set things up, what you name things, and where you save them can shorten your development time more than you may think.

Believe it or not, you now have the basic building blocks needed to get UltraDev working for you. Unfortunately, there is a lot of technical information in this chapter you may need to get from someone else (e.g., network and system administrators). Getting this information is sometimes more difficult than any programming you might try. However, once you have the necessary information, you can start doing some amazing things with UltraDev. In Chapter 6 you will start accessing a database and begin developing your first web application.

■■ Things to Think About

The following are points to consider in regard to this chapter. You may want to add your own to these.

❏ What server are you going to access?

Finding a server can be a bit of a trick in some situations. When all else fails, there are a number of great web hosting services available that will provide you with all of the features you need, for as little as $15 a month.

❏ Where are you going to save your sites locally?

Be consistent and save all of your web sites in one place on your hard drive. This lets you quickly and easily locate them and back them up.

❏ What screen layout should I use?

Figure 4-14 is a screen shot from an iBook set at 800 x 600. Granted, your screen resolution is most likely different, but the important thing about this screen shot is how things would work.

The user of this iBook has quick access to the Site Files window, Server Behaviors and Data Bindings windows, Properties window, and the Objects window. This seems to be an efficient layout for developing sites for this particular user. The point is to find a layout you are comfortable with and stick with it.

❏ Where do I get the information I need about my company's web server?

Network and system administrators can be a tough bunch to get information from at times. Be an informed person when

Fig. 4-14. A sample screen layout at 800 x 600.

you ask for information. Know what you need and why you need it. Be up front with them and explain why it is important for you to have access.

■■ Resources

UltraDev is quickly becoming the industry standard for web application development. This means that there are many resources regarding UltraDev at your fingertips.

The first place to start for extra information about the topics covered in this chapter is the Dreamweaver manual and tutorial packaged with your software. Understanding the basics of Dreamweaver will make you a much better UltraDev developer. Many web sites contain tutorials and samples that can help you improve your Dreamweaver skills.

There are also many web resources. The Macromedia web site offers many helpful hints, tutorials, and support options. There are also a number of discussion forums that are monitored by Macromedia employees.

Nothing can take the place of practice. It does not matter what content you put up; it just matters that you are using the application and becoming familiar with the way it works. Set up some sites about your vacation, hobbies, family, and yes, even your work. Setting up simple sites and actually posting them to a web server is great practice.

There are many hosting companies that will give you free server space just for viewing their advertisements. Sign up for a few of these to experience various server configurations and limitations. Keep in mind, however, that these are free and therefore you will most likely not have database capabilities. Many also have specific FTP requirements.

CHAPTER 5

Planning a Dynamic Site

■■ Introduction

As web sites have continued to grow in size and complexity, planning has become imperative. Before doing any coding or graphics development, a developer should start with paper and pencil and sketch the site. The sketches should include the basic file and directory structure, as well as drafts of navigational tools such as user interfaces.

Developing a dynamic site requires even more planning on the part of the developer. Not only does the developer need to be concerned with traditional planning elements, some of which were previously mentioned, a dynamic site requires the developer to think about how users and administrators will interact with the site in managing content.

This chapter explores some of the differences between planning a static site and a dynamic site. In either case, a developer should invest time into planning a web site. A few hours of working with paper and pencil will save countless hours of development time. This idea is analogous to trying to build a doghouse without some plans. Ideally, you would know how much space you have to work with and the general dimensions of the doghouse before cutting and nailing any wood.

■■ Objectives

In this chapter you will learn:

❑ Useful naming conventions

❑ File structure suggestions

❑ Planning for reusable content

❑ How to plan

■■ Who Should Maintain Site Content?

Traditionally, the developer is responsible for adding and maintaining the content of a web site. With tools such as UltraDev, this requirement of the developer is no longer necessary. Using dynamically generated content requires the developer to do the initial layout and creation of the site, but the content can be managed by other users or administrators of the site.

If a developer were supporting the Pedal for Peace web site with static web pages, he would most likely be the only person adding or changing information on the site. With this traditional approach, every time a new member is added to the group, someone has a change of address, and so on, the developer is contacted and the information changes on existing pages or new pages are added.

For example, when a new member joins the group, the developer would add a page for the new user, including personal contact information and the like, and make any needed links to that new page from existing pages. From a planning standpoint, a traditional web site is easier to plan. In the previous example, the developer may use a page that lists all users,

with links to each user's page. All of this would be located in a specific directory within the site.

Developing a similar scenario for a dynamic site would require the developer to do more work in the planning phase, but would relieve the developer from the responsibility of adding and maintaining the information. Let's examine how a dynamic site can accommodate these tasks.

The traditional example required one page for listing all users, and one page for each user. In comparison, a simplified dynamic site would require four pages, whatever the number of users. The first page would list all users found in the database. There would be link to a page that would display the user's information from the database. This page would take the place of individual pages for each user in the traditional example. There would need to be two other pages: one for adding users and one for modifying user information. Granted, this is a very simplified design, but it would easily accomplish the goal.

You will quickly discover that you can use the same basic site structure for nearly all sites you create under UltraDev. A dynamic site usually needs a place for adding, deleting, and modifying information. As you become more comfortable with UltraDev, you will develop your own personal file and directory structure to accomplish these tasks. The structure you develop will help you quickly create sites and allow you to reuse basic content, which will save you time. One of the key components of a standard structure is a common naming convention.

■■ Naming Conventions

If you have been developing web sites for a while, you most likely use some type of naming conventions to help you

organize the files and directories you create. If you do not, now is a really good time to start.

When developing dynamic sites, using a consistent naming convention for files and directories can save you a lot of keystrokes and mouse clicks. For example, you may find that you frequently have sites that need the ability to add new users and allow the users to modify their own information.

In this case, you might have a directory named *user_info*, which contains files named *add_new.asp* and *modify_info. asp*. Although this naming scheme may seem simplistic at first glance, many developers forget the importance of simple file and directory maintenance. Being consistent with how directories and files are named really pays off as sites you develop become more complex.

Another area in which using a consistent naming convention is helpful is when you need give some users more options than others. For example, in the Pedal for Peace site, you do not want just anyone adding himself or herself to the member list. Only people that have officially signed up for the tour should be listed. In this case, only organizers would need the ability to add new members.

In this situation, it would be helpful to have a directory specifically for administrative tasks. Experience shows that if there is one administrative task incorporated into a site, there will be more as soon as administrators figure out how useful these types of features are. It may therefore be helpful to create an administrative directory that stores all administrative pages.

 TIP: *Choose a directory name that is logical and easy for you to remember, but not too obvious. For example, you might use* admin_mgmt, admin_only, *or* site_mgmt.

In Chapter 8 you will learn about the "user authentication" server behaviors of UltraDev. These server behaviors are added to individual pages. At this point, all you need to do is think about how you would want to structure and organize these files and directories.

Just as using a consistent naming convention can save you time, there are many ways in UltraDev to reuse content. The following section addresses some of the ways you can plan ahead so that you can reuse content.

■■ Reusable Content

There are three vehicles for incorporating reusable content in UltraDev: cascading style sheets, libraries, and templates. Each of these tools is discussed in the Dreamweaver manual that came with your software or in the on-line help within UltraDev. The following provides a brief description of each and then offers some ideas about how to incorporate these tools into the planning phase of site development.

Cascading style sheets allow a developer to set specific attributes for different HTML tags. Although setting attributes for HTML tags can be done for an individual page, cascading style sheets allow you to set the attributes of specific HTML tags for multiple pages within a site.

This means that if there is a change in the attribute, the cascading style sheet is changed and all pages that reference that cascading style sheet are automatically updated. This becomes very helpful when a developer is managing a site of hundreds or thousands of pages and a change is needed. One or two cascading style sheets can be changed and uploaded to the site, with the result that the appearance of hundreds of pages is changed.

NOTE: *Cascading style sheets require a 4.0 or higher browser. Also, there are differences in how Microsoft and Netscape browsers display the information stored in a cascading style sheet.*

The Library feature in UltraDev is great if you have content that is repeated throughout a site and needs to occasionally change, such as a copyright date. UltraDev searches the site, looking for pages that include a specific library, and makes the changes needed. Libraries do not hold HTML formatting such as alignment and color.

A template is basically an advanced library. A template is used to create an entire page layout, including graphical navigation, scripting, cascading style sheets, and libraries. Templates also allow the developer to format regions of a page individually so that, for example, one region can be edited whereas other regions cannot. Editable regions can be labeled by the developer to enhance on-screen organization of the page. For example, if there is a region on the page that holds a logo or a product description, the developer can mark it as being editable and establish specific attributes of the selection, such as alignment, size, and other formatting features.

As pages are added to a site, each page can have a template applied to it. If a template is changed, UltraDev will search the site for pages using that template and make the necessary changes. The really wonderful thing about using templates is how editable regions are utilized. For example, if a region named *logo* were in the lower right-hand corner of a page and then moved to the lower left-hand corner of the page, each page using that template would move any information in the *logo* region accordingly.

Templates, cascading style sheets, and libraries can save you a lot of time and make managing a large site a lot easier. Thinking through ways of making use of a combination of

these tools in your site while planning a project will help you develop an efficient site that is easy to manage.

■■ Developing a Planning Scheme

As has been stressed throughout, planning is key. The hypermedia aspect of web development allows for a lot of flexibility in terms of approach. Unfortunately, this flexibility translates into "hit and miss" development strategies, with or without structure and organization.

One of the most common reasons some developers do not spend time planning a site is because they do not know how. The material that follows includes guidelines that may help you develop a planning strategy. The sections that follow raise a question you should ask yourself or your client. As you get answers to these questions, you can start to see how the site may need to be structured. In addition, these questions may help you identify ways of incorporating reusable content.

What Is the Site For?

The first thing you should probably ask the client is what the site is going to be used for. Most sites fall into one of three categories of objective: persuasion, education, or entertainment.

What the site will be used for influences how the site should be designed. For example, if a site were being developed for Macromedia Flash, the intent of the site would have a significant impact on how the site was designed. If the purpose of the site was to educate, the site would need to have tutorials and lessons to help users learn how to use or learn about Macromedia Flash. If the purpose of the site was to entertain, the site should provide a variety of Flash movies that would

entertain the user. Finally, if the site were intended to persuade or sell Macromedia Flash, it would need to provide the user with information about why they should purchase Macromedia Flash.

As you can see, each of these types of sites would have different needs. It might be very tempting in each case to develop a site replete with really cool Flash movies. However, if the purpose of the site were to educate, including movies that had no educational value would have the developer redoing the site to match the client's wishes.

Who Will Be Using the Site?

Audience analysis should be a major part of any web site development. Unfortunately, this aspect is often overlooked. Exploring the issue of who will be using the site can provide you with a great deal of information on any number of issues you should be taking into account.

For example, if a site is being used only within a corporate intranet, with a little investigation this should tell the developer a lot about the users. Most corporations use specific computer platforms, all with similar configurations, and the network connection in this case would most likely be very fast and able to handle larger files.

Other important information a developer should take into account in regard to users is accessibility, screen resolution differences, and browser compatibilities. The average web site can be seen by anyone with an Internet connection. It is important that developers remember that most people do not have computer hardware and Internet connections similar to theirs. This means that developers need to create sites that do not always require the latest and greatest equipment and software to make viewing and interacting with a site possible.

Who Will Maintain the Site?

There is a fine line web developers must walk between creating job security and allowing clients to manage their own site. With a dynamic site, most of the content can be managed by a client, using HTML forms and databases to store information. However, if a logo or address changes, or new sections need to be added to the site, will a different developer be hired or will the original developer be contacted?

Many developers believe that if they make it too easy for someone else to work on their sites, they will loose business. If you do your work well, most clients will continue to call you to perform maintenance or make additions. However, even if this is not the case, it is a professional courtesy to provide comments and documentation along with initial site work to help future developers understand what you have done and why you did it.

Many readers of this book have had the experience of taking over a web site someone else set up. Most of the time this is because the developer has moved, changed jobs, and so on, and quite often the original developer cannot be contacted (or does not want to be). More often than not, web sites consist of one folder containing hundreds of files with no logic to the file names. This means that the new developer must take the time to figure out what the previous developer did and reorganize everything.

In the long run, the client ends up getting the bill for the extra time and often does not understand why the new developer billed them for ten or twenty hours of site reorganization. To the client, the site worked and they only need a few new sections added. This is a common occurrence, and could easily be avoided if more developers took the time to plan sites and provide documentation. Okay, we will get off our soapboxes now! The point is to spend an hour planning a site so that

you can save (or save someone else) four or five hours of development time.

■■ Tips and Tricks

The most difficult part of planning is finding a system that works well for you. Some people really like using outlines for starting a site. Outlining the site helps them see major sections that would need to be included as navigational links and how content will be linked throughout the site. Others like to use flow charts or schematics, or both.

Personally, there isn't a much better way to start brainstorming a site than to use a big dry-erase whiteboard. After some time as been spent on the whiteboard, things get transferred to paper, most likely to 4 x 6 note cards. Then a flow chart of sorts is created that helps illustrate major links needed. From there, it's back to the whiteboard to do mock-ups of graphics. After all of that is done, you might sit down and start working on computer.

Find a system that works for you and continually refine it. The important part is to have a system that allows you to easily edit your ideas (e.g., dry-erase board and note cards) and to follow the system.

■■ Summary

This chapter addressed some of the nontechnical aspects of design and development. As web development tools become better and easier, more and more people tend to just jump in and start making things. UltraDev is a tool a user could use to start doing development without a solid foundation.

Our hope is that readers of this book will take this chapter to heart and begin using some type of planning when they develop web sites. UltraDev will allow you to accomplish a number of advanced tasks, but without good planning, most sites are likely to have poor organization, waste resources, and not take full advantage of the management tools found in UltraDev.

This chapter offered some suggestions about naming conventions for files and directories. Using a consistent and logical naming strategy will help you be more efficient with your development.

The chapter also examined some of the different maintenance concerns between static and dynamic web sites. With a dynamic web site, planning becomes much more important. However, after a dynamic site is completed, simple content management can be left to the client through the use of HTML forms and databases for storing information.

An additional benefit of planning is the ability to identify potential reusable content. Common navigation tools, logos, copyrights, and so on can be incorporated into libraries and templates. In addition, the use of cascading style sheets can provide site-wide color schemes and formatting.

Finally, planning a site requires a strategy. This chapter has posed a few questions to help guide your planning. It is very helpful to have a simple system to use whenever planning a site. This system should cover everything from brainstorming through drafts of navigations and site structure. The more you plan in advance, the more efficiently you will be able to develop dynamic sites with UltraDev.

CHAPTER 6

Accessing and Displaying Data

▪▪ Introduction

Previous chapters have dealt with setting up databases for use on the Web via UltraDev. Two of the basic functions of a database are to store and to deliver data. In this chapter you will walk through procedures for connecting to your database and pulling data from it to be displayed on screen. The visual design features of UltraDev are quite powerful. These tools allow you to easily add database content to a web page.

The "Tips and Tricks" section at the end of the chapter offers some sample ASP code that will require you to view HTML code created by UltraDev and make some modifications, all of which is quite manageable by the nonprogrammer. However, before delving into topics and procedures, perform the following CD-ROM exercise, which (if you have not already done so) will establish a directory as a basis for working along with the tutorial presented in this chapter.

 CD-ROM Exercise

If you have not already done so, copy the content of the *Pedal4Peace* directory on the companion CD-ROM to local site directory you defined in Chapter 4 for *Pedal4Peace*. If you have not defined this local site, do so now.

■■ Objectives

In this chapter you will learn:

- ❑ How to connect to a database
- ❑ What a recordset is
- ❑ How to sort a recordset
- ❑ How to insert database elements into a web page
- ❑ How to show all or part of a recordset
- ❑ How to hide or show a region of a web page
- ❑ How to link to a detail page

■■ Making the Database Connection

In Chapter 4, you added some settings to the Applications Server section of the Define Site window. You learned that this is one of the most difficult procedures when using UltraDev. Making a connection to a database is another tricky procedure in UltraDev. Actually, the procedure is not per se difficult, but it does require that you adhere to a particular series of simple steps.

Database Connectivity Technology and Establishing a DSN

The most common server technology available at this time uses ASP, which can be run on either a Windows NT/2000 server or on a UNIX system running ChiliSoft. However, UltraDev is also capable of connecting to databases through JSP and ColdFusion. If you have access to a ColdFusion or JSP server, you should consult the server administrator or documentation for your server for defining a DSN or JDBC connection to your database.

If you are using ASP, you will need to set up a data source name (DSN) on the server. A DSN contains all information needed to connect the server to your specific database using an open database connectivity (ODBC) driver. ODBC works as a middleman between your web application and your database. You will see the acronym ODBC used with databases quite often. Another option for database connectivity is via Object Linking and Embedding Database (OLE DB), which will improve the performance of your web application. This is discussed later in the book.

Defining a DSN

The next step is to define the DSN. The DSN can be defined on the server or on a local Windows-operating computer. In material to follow, you will walk through the procedure for defining a DSN.

MACINTOSH NOTE: *Macintosh users need to have access to a server to make a database connection. There is currently no way to connect to a local database on a Macintosh computer unless you are running Connectix Virtual PC and work in a Windows environment.*

If you are connecting to a hosting service that supports DSN, you will most likely need to contact the service in advance and request that a DSN be established.

Exercise 6-1: Defining a DSN

To define a DSN, perform the following steps.

1 On a Windows 95/98/NT system, open the ODBC control panel. On a Windows 2000 system, open the Administrative Options from the control panels and then open Data Sources. This will open the ODBC Data Source

Administrator. Figure 6-1 shows the ODBC Data Source Administrator.

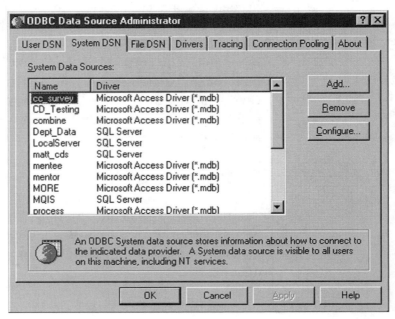

Fig. 6-1. ODBC Data Source Administrator.

2 Click on the System DSN tab in the ODBC Data Source Administrator window, which will list DSNs currently defined on your system.

Your system may or may not have previously defined DSNs, so the list may be blank.

3 Click on the Add button that appears on the right-hand side of the System DSN portion of the ODBC Data Source Administrator window.

You should now see the Create New Data Source window. This window lists the database drivers installed on your system. The examples presented in this book use the *Pedal4Peace.mdb* database you copied to your hard drive from the companion CD-ROM.

4 In the Create New Data Source window, shown in figure 6-2, select the Microsoft Access Drive (*.*mdb*) and click on Finish.

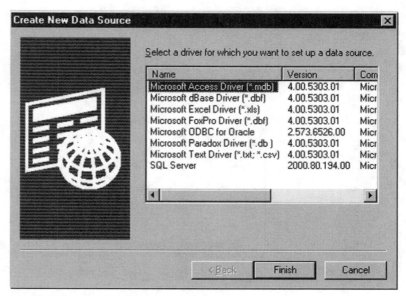

Fig. 6-2. Create New Data Source window.

5 You will next see the Microsoft Access Setup window (figure 6-3), which allows you to name your DSN and select the database you want to associate with this DSN. Type *pedal4peace* in the Data Source Name box in the Microsoft Access Setup window (figure 6-3).

NOTE: *DSNs should not contain spaces or special characters (such as #, $, %, &, punctuation, hyphen). The underscore (_) is safe to use instead of a space. In addition, you cannot have two DSNs with the same name.*

6 Once you have added a DSN, click on the Select button found in the Database section of the ODBC Microsoft Access Setup window.

The Select Database window (shown in figure 6-4) will appear, prompting you to select a database to be associated with this DSN.

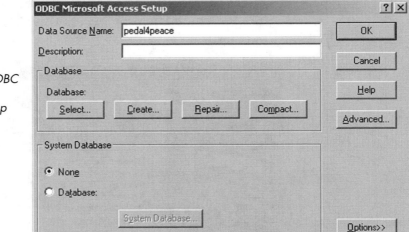

Fig. 6-3. ODBC Microsoft Access Setup window.

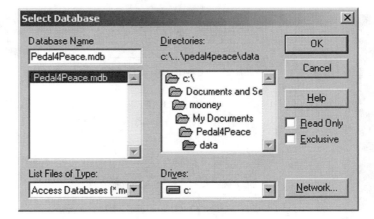

Fig. 6-4. Select Database window.

7 Navigate through your directories and find the *Pedal4Peace.mdb* file you copied to your hard drive.

8 Open the *data* directory within your site. The *Pedal4Peace.mdb* file will appear in the left-hand window. Select *Pedal4Peace.mdb* and click on OK. Click on OK in the ODBC Microsoft Access Setup window and then on OK in the ODBC Data Source Administrator. window

You have now defined a DSN you can use to connect to your *Pedal4Peace.mdb* database through UltraDev. The procedure of exercise 6-1 is basically the same for both server and local system access. However, there are advantages to setting up a local DSN on your system. For example, when traveling, if you needed to do some work and did not have a good Internet connection, you could still work on your web application because there would be no need to connect to the server.

However, there are some drawbacks to using a local DSN. If you change your database locally and then work on your web application, you will need to either make the same changes to your database on the server or replace it with the database to which you have made changes. This means you may be over-writing data you might want to preserve.

 TIP: *Consider the strategy of using a local DSN only when absolutely necessary.*

Connecting UltraDev to a Database

Fig. 6-5. Pedal4Peace *site displayed in the site file window.*

Now that you have a DSN to connect to, let's get to work. Open UltraDev and select the *Pedal4Peace* site you defined in Chapter 4. The site should not currently have much content, and should look something like that shown in figure 6-5.

Now it is time to make a connection between UltraDev and the *Pedal4Peace.mdb* database. This connection happens as a result of a short segment of code (internally created by UltraDev) that points to the DSN.

Exercise 6-2: Connecting UltraDev to a Database

To connect UltraDev to the *Pedal4Peace.mdb* database, perform the following steps.

1 Open *index.asp* from the Site Files window and then select Connections from the bottom of the Modify menu.

The Connections dialog opens, listing all connections defined for the site you have open. Currently there should be no connections defined.

2 Click on New and select Data Source Name (DSN) from the drop-down list that appears. You should now see the Data Source Name (DSN) window, shown in figure 6-6.

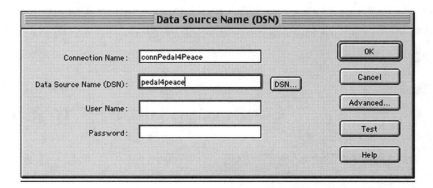

Fig. 6-6. Window used to define the connection to your database within UltraDev.

3 Select the type of database connection you want UltraDev to use: DSN on application server or local DSN. This tells UltraDev where to look for the list of DSNs available.

MACINTOSH NOTE: *Macintosh connection to the DSN is possible only via application server.*

4 Enter *connPedal4Peace* in the Connection Name box.

As with naming database fields, it is a good idea to select a descriptive name that will help you quickly discern which database this connection is associated with, in that you can have multiple connections defined within one site. Remember that connection names cannot contain spaces or special characters other than the underscore (_).

 TIP: *When naming your connections, consider using the following format:* connPedal4Peace. Conn *is commonly understood nomenclature for referring to connections.*

5 Click on the DSN button next to the Data Source Name box and select the DSN *pedal4peace.*

If the *pedal4peace* DSN does not appear in the DSN list, one of two things has happened. Either you did not define the DSN in exercise 6-1 or you have made a connection to the wrong DSN list. If you are using a local DSN, verify that you have selected the correct connection option at the bottom of the Data Source Name window. If you did not define a DSN in exercise 6-1, you can click on the Define button, which will launch the ODBC Data Source Administrator and allow you to define a DSN.

Typically, entering a user name and password in the Data Source Name window is not required. After you have selected the DSN, continue with the following.

6 Click on the Test button to confirm that UltraDev can connect to your database.

If the test is successful, a pop-up message will appear stating the test was successful. If the test is successful, you are ready to move on to the next step. If the test is not successful, you might want to double check the DSN configuration or make sure the system has read/write/delete privileges in the directory that holds your database for the site.

UltraDev creates a new directory in your site after you define a connection. The *Connections* directory holds all connections you create in UltraDev. If you performed exercise 6-2, you should have a file named *connPedal4Peace.asp* in this directory. This file contains the connection information used by your web application to connect to your database.

Now whenever you connect to a database in UltraDev, the *connPedal4Peace.asp* file will be included as a server-side file used to make the connection. If you are curious about what this type of connection looks like, open the *connPedal4-Peace.asp* file in UltraDev and view its source by selecting the Code view from the View menu. However, do not change anything.

Defining a Recordset

Whenever UltraDev accesses a database, UltraDev requires some or all of the records from the database. The records received from the database are stored in something called a recordset.

A recordset consists of all or some portion of the records of a database. In UltraDev, you use the Data Bindings window to define a recordset. In exercise 6-3, which follows, you will define data as a recordset to extract data from a database.

Exercise 6-3: Defining Data as a Recordset to Extract It from a Database

To extract data from a database by defining that data as a recordset, perform the following steps.

1 Create a new file in the *Pedal4Peace* site. Right-click the mouse (Windows) or press the Ctrl key and click the mouse button (Command + mouse click, Macintosh) within the Site Files window.

2 A contextual (pop-up) menu will appear, in which you can add a new file by selecting New File from the contextual menu. This will create a file named *untitled.asp* in your Site Files window. Click on the file name once and enter the file name *list_all.asp* (see figure 6-7).

3 Open *list_all.asp* and add the following text at the top of the page: *Pedal4Peace Membership Roster*. Then create a table consisting of two (2) rows and two (2) columns.

Fig. 6-7. Adding a new file to the site.

For now, leave the default settings for the table as they are.

4 Open the Data Bindings window by pressing Ctrl + F10. The Data Bindings window, shown in figure 6-8, is where you define recordsets and access elements of your database. Click on the plus sign (+) and select *Recordset (Query)* from the list of options.

This opens the Recordset window, in which you define your recordset (see figure 6-9).

You now need to set certain options of the Recordset window, as follows.

5 You need to give the recordset a name. Enter the recordset name in the recordset name text box. As always, do not use spaces or special characters other than the underscore (_).

Fig. 6-8. Data Bindings window.

TIP: *A common way of naming recordsets is to begin the name with the identifier* rs *(as in* rsListAll*), so that you can easily locate recordsets in code.*

Fig. 6-9.
Recordset
window.

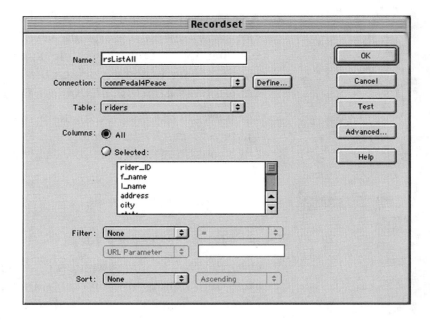

6 Select the *connPedal4Peace* connection you created earlier in the chapter from the Connection drop-down list.

Once you have selected the connection, UltraDev will look at the database and display the available tables and queries within the database associated with your connection. Currently, you should see *riders* in the Tables section. Below the table you can select all or some of the fields in each record.

TIP: *To select multiple fields, press and hold down the Ctrl key while selecting the fields.*

7 Leave the Columns option set to All and leave the Filter and Sort options blank. (The Filter and Sort options are discussed later in the chapter.)

8 Click on the Test button to see the data you will be pulling from the database.

TIP: *When you begin creating more advanced recordsets, you will find the Test option a convenient feature for double checking that you are accessing the correct data.*

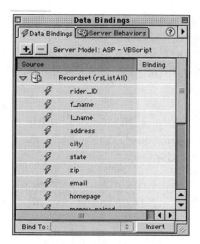

Fig. 6-10. Database fields available in the rsListAll recordset.

9 Click on OK to return to *list_all.asp*. If the Data Bindings window is not visible, bring it to the front of your screen.

You should now see your *rsListAll* recordset.

10 Click on the plus sign (+) to the left of the recordset to access a list showing all available fields, as shown in figure 6-10.

You will notice three additional fields at the bottom of the list: *[first record index]*, *[last record index]*, and *[total records]*. These can be used to display information about the recordset to users, such as total number of records in the recordset.

■■ Inserting Data Elements

At this point, you can begin inserting the database fields into your web page. Exercise 6-4, which follows, takes you through this process for the fields created in previous exercises.

Exercise 6-4: Inserting Database Fields into a Web Page

To insert the database fields into the page you created previously, perform the following steps.

1 Place the cursor in the upper left-hand cell in the table you created earlier and type *Name* in that cell. Then move to the next cell and type *State*.

This row will serve as a header for the table so that your users will know what they are looking at.

2 Place the cursor in the lower left-hand cell of the second row and then click once on the lightening bolt icon next to *f_name*. Once it is selected you can click on the insert button at the bottom of the Data Bindings window or drag it into the table cell.

You should now see {*rsListAll.f_name*} in the cell indicated in step 2. Think of this as a placeholder for the first name of the first record in the recordset.

3 Insert a non-breaking space after the first name data element and insert *l_name* and then put *state* in the second column of the table you created.

NOTE: *Non-breaking spaces are needed to "block out" space after a database element. A regular space will not work.*

You have just inserted data from your database into a web page. If you want to test the insertion and are using a remote server or a personal web server, click on the Live Data View button on the UltraDev toolbar or select Live Data from the View menu.

Exercise 6-4 did not add all of the records for the project being developed. The goal is to show the entire listing of riders for *Pedal4Peace*. Therefore, you need to add more rows (representing rider records) to the table. But how do you know how many rows to add? Actually, UltraDev will do this for you.

Repeat Region

The Repeat Region server behavior provides the ability to incorporate a portion of HTML code for every record in a recordset or for a specific number of records in a recordset. The most common use of a Repeat Region server behavior is repeating table rows to provide a list of information for the

user. Exercise 6-5 takes you through the process of inserting the Repeat Region server behavior.

Exercise 6-5: Adding a Repeat Region Server Behavior to a Web Page

To add a Repeat Region option to your web page, perform the following steps.

1 Click in one of the table cells in the bottom row of your table and then click on the < tr > tag in the Quick Tag editor (shown in figure 6-11) to select the entire table row.

Fig. 6-11. Quick Tag editor for selecting elements on the page.

2 Open the Server Behavior window and click on the plus sign (+). Select Repeat Region.

This opens the Repeat Region window, which allows you to select the recordset you want to use as a reference and to specify how many records you want to repeat, as shown in figure 6-12.

3 Select *rsListAll* from the Recordset drop-down list and enter *10* in the text box to the right of Show to display the first 10 records of the recordset.

When you are done, UltraDev will place a gray box with a tab labeled Repeat in the upper left-hand corner of the table row you had selected in step 1. This is your visual cue that you have added a Repeat Region server behavior.

Fig 6-12. Repeat Region window displayed in UltraDev.

Repeat Region		
Recordset: rsListAll		OK
Show: ● 10 Records		Cancel
○ All Records		Help

4 Upload your page to the server or use the Live Data View option to see how the Repeat Region server behavior creates a table row for the first 10 records in the recordset.

In defining a repeat region, you are not limited to the selection of a single row of a table. For example, if there were three rows of data about each rider, you could select those table rows for inclusion in a repeat region.

 TIP: *Including an empty table row at the bottom of a repeat region often helps make a table easier to read by providing some "white space" around the information.*

Right now you might be wondering about the other records in the recordset. UltraDev provides an easy means of navigating a recordset, as described in the section that follows.

Recordset Navigation

UltraDev provides you with the ability to create navigation bars used to maneuver through a recordset. Navigation bars can incorporate four interface link options for moving through the recordset. Each navigation bar provides a link to the next and previous record and a link to the beginning and ending of the recordset. A recordset navigation bar consists of an HTML table and the text or images used as links to the recordset. The table, links, and text/images are created by UltraDev automatically.

When you insert a navigation bar, two server behaviors are created as a result of using a navigation bar. The first server behavior is a combination of Move To server behaviors. These server behaviors control moving through the recordset via moving to the *first*, *last*, *next*, and *previous* records in the recordset. The other server behavior is a set of Show Region behaviors. Show Region behaviors show information on your

page based on the recordset. The Show Region behaviors included with a recordset navigation bar are described in the following.

❏ The *Show if not first record* Show Region behavior is applied to the navigation link for the first record and previous record. The logic behind this is that if the user is on the first record a link to the first record or previous record is not necessary.

❏ The *Show if not last record* Show Region behavior is applied to the navigation link for the last record and next record. The same logic works here. You would not want to confuse your user with a link to the last or next record if she were on the last record.

To add a recordset navigation bar, place your cursor where you want the table to appear and open the Live Object panel in the Objects panel (or select Recordset Navigation Bar from Live Objects in the Insert menu). The Insert Recordset Navigation Bar window will display. You need to select the recordset you want to navigate and choose between text or images. Because there is only one recordset in the tutorial, you should see only *rsListAll*. Figure 6-13 shows the default text and image options of a recordset navigation bar.

Fig. 6-13. Default text and image options of a recordset navigation bar.

It can be a little confusing when you first start using recordset navigation bars. The links for the first, previous, next, and last records move through the recordset by the number of records you display in the repeat region. For instance, in the tutorial the *next* link would display records 11 through 20.

Note that you can customize the appearance of a recordset navigation bar. You can change the text, add different graphics, and so on.

Recordset Counter

Another helpful recordset navigation feature is a record counter. A recordset counter lets the user know where he or she is in the recordset. For example, your users could see that they are looking at records 21 through 30 of 965 total records. Macromedia has provided a quick and simple way of adding this feature to your page. Place your cursor where you want the counter to appear and select Recordset Status from Live Objects under the Insert menu, or by clicking on the Recordset Status icon in the Live Object window.

Figure 6-14 shows the Insert Recordset Navigation Status window. All you need to do is select the recordset you want to use. An example of the counter is displayed in the window. Once you have inserted the counter, you can customize its appearance (e.g., applying different colors or other formatting features found in UltraDev).

Fig. 6-14. Insert Recordset Navigation Status window.

Insert Recordset Navigation Status

Recordset: [rsListAll ↕] OK

Example: Records 1 to 5 of 10 Cancel

Help

If you have not done so, view your page from the server or via the Live Data View option to see what you have created. Of course, this is only the tip of the iceberg. Let's continue to modify what you have created in the exercises thus far.

Organizing Recordset Data

The *list_all.asp* page is quite handy. However, it does not represent a very efficient way of displaying the data. Getting the recordset a bit more organized is really rather simple. In exercise 6-6 you will put the *rsListAll* recordset in alphabetical order sorted by last name.

Exercise 6-6: Organizing Data in a Recordset

To organize the *rsListAll* recordset alphabetically by last name, perform the following steps.

1 In the Data Bindings window, double click on the *rsListAll* recordset to open the Recordset window. As shown in figure 6-15, in the Sort drop-down menu, select *l_name* from the list. Leave the drop-down menu to the right of the Sort drop-down menu set at Ascending.

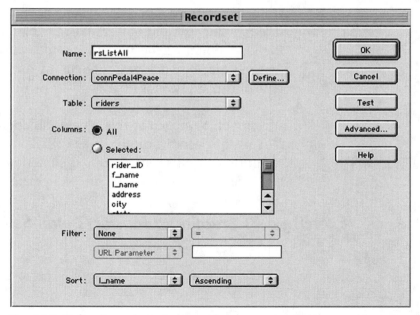

Fig. 6-15. Define Recordset window with the recordset being sorted by l_name.

2 Click on the Test button.

You should see the database sorted by last name.

3 Save the file and post it to the Web, or use the Live Data View option, to see the change.

You can sort by any of the fields in a database. Again, this is another argument for breaking your database into as many fields as possible.

NOTE: *You can sort a recordset in an ascending or descending manner by any field within the recordset. (More advanced sorts are covered later in the chapter.)*

Giving More Information

A list of all members of Pedal for Peace is a nice feature, but it really does not do much. For example, what if you we looking through the list and saw the name of an old high school friend. Wouldn't it be nice to see more information on that person. Macromedia has thought of and incorporated this type of capability as well.

A common approach to this type of function is to make some part of the record link to a page that provides more details about that specific record. This is sometimes called a master/ detail setup. In exercise 6-7 you will create such a setup.

Exercise 6-7: Creating a Master/Detail Setup

To create a master/detail setup, perform the following steps.

1 Create a new page in your site. Name it *rider_detail.asp*. Open *list_all.asp* and select both the *f_name* and *l_name* data elements (i.e., hold down the Shift key and click on each element) in the repeat region.

2 Go to the properties window and click on the folder icon next to the Link text box. This will open a window that allows you select a file to link to from *list_all.asp*. Select *rider_detail.asp* and then click on the Parameter button.

The Parameter button opens the Parameter window (shown in figure 6-16), which allows you to code variables into a hyperlink. Coding a variable into a hyperlink is one of the ways you can pass or send information from one page to another. These variables can be static (i.e., entered by you) or dynamic (i.e., pulled from a recordset). The column on the left is the variable name you want to use.

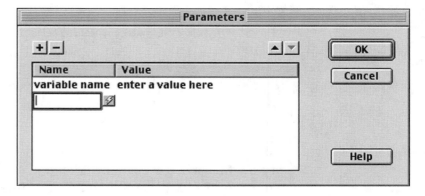

Fig. 6-16. Parameter window used to pass variables through hyperlinks.

3 Enter *rider_ID* in the left-hand column. (The column on the right is the value of the variable.)

4 Click on the lightening bolt icon in the right-hand column, as shown in figure 6-17.

5 Verify that the Dynamic Data window contains the recordset *rsListAll*. If you cannot see the fields in this recordset, click on the triangle icon beside *rsListAll*.

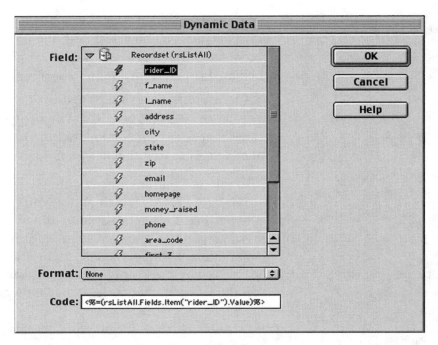

Fig. 6-17. Dynamic Data window used to select the field to be coded into a hyperlink.

6 Select *rider_ID* from the *rsListAll* recordset list. Click on OK in the Dynamic Data and Parameters windows and then click on Open in the Select File window.

You have just coded *rider_ID* into the hyperlink. This means that when a user clicks on one of the hyperlinks in your repeat region he will be taken to *rider_detail.asp* and *rider_ID* will be sent in the URL.

NOTE: *Just as information changes in the repeat region,* rider_ID *is updated in the hyperlink for each record of the repeat region.*

7 Close *list_all.asp* and open *rider_detail.asp*.

Rider_detail.asp will take the information from the URL and create a new recordset. This new recordset will use the Filter option to limit the number of records. Continue with the following steps to create the new recordset.

8 With *rider_detail.asp* opened, open the Data Bindings window and select *Recordset (Query)* under the plus sign (+). Name this recordset *rsRiderDetail* and select the *connPedal4Peace* connection.

Select the *riders* table from the Table drop-down list. You can leave the Columns radio button set at All. The Filter option is the one you are concerned with in this exercise.

9 Select *rider_ID* from the Filter drop-down menu. The drop-down at the upper right will be set to = by default, which you can leave for this exercise.

Below the Filter drop-down you should see another drop-down, set to URL Parameter by default. A URL parameter is a variable passed from one page to another through the URL, as you did previously by adding *rider_ID* to the hyperlink.

You may have noticed that UltraDev placed *rider_ID* in the text box next to URL Parameter when you selected *rider_ID* from the Filter drop-down menu. This feature is why you named the *list_all.asp* parameter *rider_ID* in the parameter settings. You could have entered any name in this text box, but consistency adds to ease of troubleshooting should it be necessary later.

The steps you have just completed will allow the server to look at the URL requesting the page *rider_detail.asp* and to create a recordset for a specific rider whose ID has been sent in the URL. Now that you have a recordset, you can display the data however you wish by dragging and dropping the elements onto the page from the Data Bindings window, as you did earlier in the chapter.

UltraDev includes an automated feature that will create your master and detail pages for you. You can find this master/ detail page set in the Live Object window. Exercise 6-7 gives you an idea of what UltraDev is doing behind the scenes.

■■ Finding Data

Now that you can display data from your database, it is time to learn how to allow users to search through data to find the info they want. In exercise 6-8, you will do just that. In the previous section you executed the basic steps of a search of your database. When you placed *rider_ID* into the URL, you provided a search criterion for the database.

Exercise 6-8: Providing Search Capability

1 Create two new pages. Name them *search.asp* and *results.asp*.

2 Open *search.asp*.

3 Insert a form and the form elements outlined in table 6-1.

Table 6-1: Form Elements to Be Inserted

Text for the Element	HTML Label of Element	Type of Element
Last Name	l_name	Text field
Search for Rider	Submit	Submit Button

4 Select the form and set the form to use the *Post* method. In the Properties window, set Action to *results.asp*. (See figure 6-18.)

Fig. 6-18. Properties window for setting the options of a form.

5 Close *search.asp*.

6 Open *results.asp*.

7 Open the Data Bindings window, click the plus sign (+) and select Recordset (Query) from the menu to open the Recordset window.

8 Set all the options in the Recordset window to match those shown in Figure 6-19.

Fig. 6-19.
Recordset window
filtering on a form
variable.

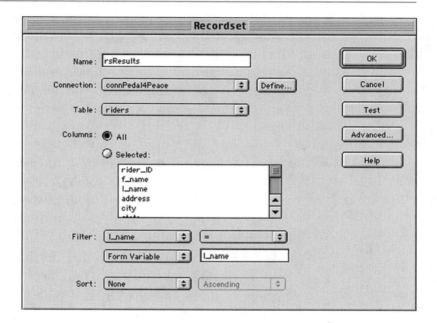

When dealing with forms, you have two choices of methods used to send the information: *Post* and *Get*. The *Get* method sends the information from the form in the URL. The *Post* method sends the information in the body of the message.

When you send a request to a web server for a page (i.e., click on a hyperlink or Submit button), you send data in what is called the header. This information is used by the server to decide what page or information to send back. The *Post* method sends the data from form fields in this portion of the request.

There are a couple of things to think about when deciding if you want to use *Post* or *Get*. The *Get* method is limited by the total number of characters a URL can handle, which is 8,192.

The *Post* method does not have a size limitation. In addition, the user can see the information being passed with a *Get* because it appears in the URL, which does not happen using *Post*.

The method you choose impacts the way you filter the recordset on the *results.asp* page. If you use the *Get* method, you would filter the recordset just as you did previously. Because the *Get* method sends the information in the URL, you could have the recordset filter on *l_name* = *URL Parameter l_name*. If you use the *Post* method, you would need to filter the recordset on *l_name* = *Form Variable l_name*, as shown in figure 6-19.

Once you have set the recordset to filter on the form element *l_name*, you can insert the database elements into the web page for whatever layout you wish by dragging and dropping the database elements onto the page. You might have noticed that defining the recordsets is the key. For most work done in UltraDev, the process of inserting database elements into a web page does not change. You inserted elements at the beginning of this chapter. The key to developing effective web applications is managing the data that supports the application.

The ability to sort and search the data and filter it down to a precise record is the key. For example, in figure 6-19, the recordset is looking for an exact match between the form element *l_name* and the database field *l_name*. Therefore, if you were looking for Eric Johnson and typed in *Johns*, you would not find any matches.

Wild Card and Other Searches

The ability to broaden a search is often very helpful. You can filter recordsets a number of ways within the basic UltraDev interface. Instead of filtering on *l_name* = *Form Variable*

l_name, you could filter on *l_name contains Form Variable l_name*. The *contains* option is listed in the Recordset window below the equals sign (=), as shown in figure 6-20. In the previous example, if the user entered *Johns* into the text box found on *search.asp*, and you had filtered with the *contains* criterion, the user would have found members with last names such as Johnson, Johnston, St. Johns, and so on.

Fig. 6-20. Additional filter criteria provided in the basic UltraDev Recordset window.

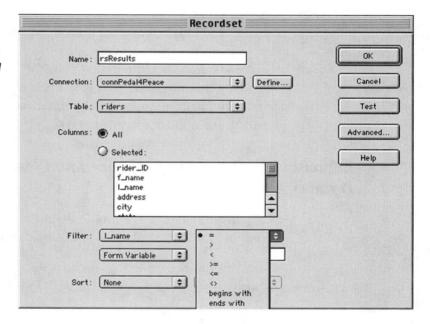

Providing Search Criteria

Another optional search for Pedal for Peace would be to let users look for riders in specific states. You could do exactly what you did in previous exercises and use a text field for state instead of *l_name*. This would work in most cases. Of course, many people make mistakes with postal state abbreviations, so you might run into problems with having users enter the state abbreviation into the field.

It is often useful to limit search criteria to specific information found in a drop-down menu or via check boxes or radio buttons. In this case, because all 50 states would be a few too many radio buttons or check boxes on a page, a drop-down menu might be a good choice for this example.

Before you start entering all 50 states into a drop-down menu, consider how to do this in a more efficient manner to make your life easier. You know that you can pull information from a database and repeat it in a list on a web page. You can populate a drop-down menu from a database as well. This means you create one database table that contains the data and can reference the table from other web pages without having to re-enter the information contained in the database table. Exercise 6-9 gives you the opportunity to try this.

Exercise 6-9: Populating a Drop-down Menu from a Database

1 Open *Pedal4Peace.mdb* and create a new table. You might want to use the following field names.

 ❑ *state_ID*

 ❑ *state_name*

 ❑ *abbreviation*

2 Enter the field names. Alternatively, access the *Databases* folder on the companion CD-ROM and open *extras.mdb*. This file contains the *states* table ready to go. Copy the table and paste it into *Pedal4Peace.mdb*.

3 Create a new page in your web site and name it *state_results.asp*. Open *search.asp* and add another form to the page. In the form, insert a List/Menu option and a Submit button.

4 Create a new recordset in the Data Bindings window and name it *rsStates*. You will use the *connPedal4Peace*

connection and the *states* table. Sort the recordset by *state_name*.

 TIP: *Simplifying sorting is another convenient result of populating a large drop-down menu from a database. The server will sort the data for you.*

5 Select the List/Menu option by clicking on it once. Name it *state* in the Properties window. While List/Menu is selected, open the Server Behaviors window and select Dynamic List/Menu from the Dynamic Elements option, shown in figure 6-21.

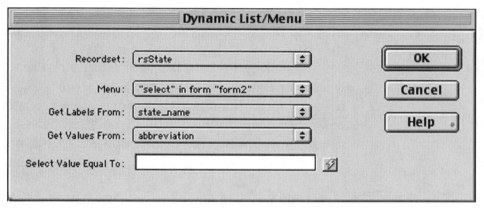

Fig. 6-21. Dynamic List/Menu window used to populate a list or menu with dynamic data.

The Dynamic List/Menu window allows you to select the recordset you want to use to populate the menu. The *Get Labels From* and *Get Values From* options are where you select the fields from the recordset that will be used in the menu.

6 Select the *rsStates* recordset and use *state_name* for the labels and *abbreviation* for the values. (The *Set Value Equal To* option is covered in the next chapter.) Click on OK and you are done.

When this page is loaded in the browser, the server will query the *states* table of the database, sort it, and populate the drop-down menu with the information.

■■ Dealing with Error Messages

When you begin using UltraDev, you may get some server errors. The following is a common error encountered when using ASP.

```
Either BOF or EOF is True, or the current record
has been deleted. Requested operation requires a
current record.
```

BOF and EOF are acronyms for "beginning of file" and "end of file." The most likely explanation for this type of error is that you are looking for data that is not there, or have an empty recordset. This is especially common when you allow your users to search. If a user types in some random text or a badly misspelled name, they would likely not find any results. As the developer, you would prefer they receive a page that tells them there are no records, rather than a cryptic error message.

If you think back to the recordset navigation section, you may remember the *Show if* command. This command is very helpful in these situations. Exercise 6-10 takes you through the process of using this command. The basic idea behind using this command is to avoid users receiving error messages because of the existence of empty recordsets. This is accomplished by dividing your page into two parts. One part is the section that shows the results; the other part is the section that shows the "No records found" message.

Exercise 6-10: Using the Show If Command to Create a "No Records Found" Response

To use the *Show if* command to create a "No records found" response, perform the following steps.

1 Open *results.asp* and place a one-cell table at either the top or bottom of the page.

2 In the table, type a message to the user that tells her no records were found. You can even add a link back to the search page if you want.

3 Open the Server Behaviors window and select the table you just created. Make sure to select the entire table, not just the cell.

4 Click on the plus (+) sign in the Server Behaviors window and select Show Region; then select *Show Region If Recordset Is Empty*. The Show Region options are shown in figure 6-22.

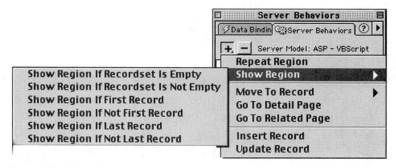

Fig. 6-22. Show Region options.

The Show Region If Recordset Is Empty window will open which allows you to select the recordset you want to use.

5 Select the other information on your page and repeat steps 1 through 4. This time, however, select the *Show Region If Recordset Is Not Empty* option under Show Region.

The procedure outlined in exercise 6-9 allows the server to create your recordset. If the recordset is empty, the server will display the "No records found" message. This eliminates the potential for users getting errors because of empty recordsets.

TIP: You will find that using tables as often as possible to organize pages makes it easier to incorporate Show Region and Repeat Region commands.

■■ Formatting Data Elements

UltraDev also allows you to apply formatting to the database elements you are using on your pages. For example, if you click on a database element inserted on a page, you can change the font, size, color, alignment, and so on. In addition, UltraDev offers a number of server-side formatting options. When you select an element on a page, that element is also selected in the Data Bindings window. To the right of the field name in the Data Bindings window you will see an arrow in the Format column, as shown in figure 6-23.

None	
Date/Time	▶
Currency	▶
Number	▶
Percent	▶
AlphaCase	▶
Trim	▶
Absolute Value	
Round Integer	
Encode - Server.HTMLEncode	
Encode - Server.URLEncode	
Path - Server.MapPath	
Edit Format List...	

Fig. 6-23. Format options in the Data Bindings window.

The Format column will let you apply various server-side formatting options to database elements. For example, in the *riders* table of *Pedal4Peace.mdb* there is a Donations column. This column shows the total amount of donations each rider has raised to date. However, the dollar sign ($) is not included in the data. Special characters such as the dollar sign can sometimes cause problems. Here, therefore, you would simply enter the numbers and allow the server to do the rest, as explained in the following.

As a way of experimenting with this option, add a section on the *rider_detail.asp* for total donations raised and insert the data element *money_raised*. After *money_raised* is inserted, select it and click on the Format arrow to open the list of options, select Currency, and select one of the options. No visible changes will appear in the Design view of UltraDev, but when the server sends this page to a user

the server will format the database field according to the option you have selected, which in this case would be the dollar sign.

You might want to experiment with the various options to see how the formatting of each is handled. You can also write your own formatting using the server scripting language you are most comfortable with. Additional formatting options are available on the Macromedia Exchange site at *http://www.macromedia.com/ exchange.*

Making and Using Links

You made links earlier in the chapter when you used the Repeat Region function to list the members of the tour. However, you can also include URLs from a database or make a URL dependent on the information in a database. The *riders* table, for example, includes a field for home page. If a rider has a personal home page he wishes to share with others, it could be included in his record. Exercise 6-11 provides you with an opportunity to try creating this type of link.

Exercise 6-11: Creating a Database Link

To create an active database link, perform the following steps.

1 Type *Rider Homepage* in *rider_detail.asp*, select Rider Homepage, enter some text into the link box in the Properties window, and press the Tab key. (See figure 6-24.)

Fig. 6-24. Properties window and Data Bindings window.

It does not really matter what text you enter; UltraDev just needs something from which to simulate a link. After you press the Tab key, the text should look like a link (i.e., underlined).

2 With the text still selected, click on the *homepage* element in the Data Bindings window. At the bottom of the Data Bindings window, you should see *a.href* next to the Bind button.

3 Click on the Bind button and the data element will be placed into the link, overwriting the original text you entered.

To make a link to an e-mail address, you simply add one more step to those outlined in exercise 6-10. After you have clicked on the Bind button and the data element has been placed into the Link box, you type *mailto:* in front of the data element, as shown in figure 6-25.

Fig. 6-25. Creating a dynamic mailto *link.*

The Code Behind the Scenes

You may have noticed the unusual code placed into the link box by UltraDev. Have no fear, this is the ASP code (or JSP or ColdFusion, depending on your server selection) for a database element. This is a good time to look at the code doing all this work. The code you saw in the Link box should have looked something like the following code if you are using ASP.

```
<% =(rsRiderDetail.Fields.Item("homepage").Value) %>
```

> The < % and % > are delimiters for ASP, much like < > and
> </ > are tag containers in HTML. *RsRiderDetail* is the record-
> set name. *homepage* is the field you have included. If you are
> feeling adventurous, open the Code view of one of the pages
> you have created and look at the code. UltraDev generates
> lines of code to make all of this work easily for you. In mate-
> rial to follow you will be "going into the code" to start adding
> some features.

■■ Tips and Tricks

> This section focuses on making changes or additions to the
> code UltraDev has created. Do not worry if you are not a
> "code junkie"; you can make these modifications by simply
> adding some simple lines of code. You may be quite surprised
> how much you can do with a few short lines of code.

Replace Command

> The text in a database is not the same as the same text dis-
> played on a web page. Basically, the information stored in a
> database is in ASCII format and is displayed on your web page
> as HTML. (ASCII stands for American Standard Code for Inter-
> change of Information. It is a character set consisting of 128
> text characters, including upper and lowercase letters, 0
> through 9, special characters, and so on.)

> Most of the time, the conversion from ASCII to HTML creates
> no problems. However, if you have a field in a database that
> includes a carriage return (someone hit the Enter key), it is a
> problem. An example would be the Bio field in the *riders* table
> in *pedal4peace.mdb*. This is a field that will eventually hold
> the personal bio of a rider if desired.

It is likely that a person would have more than one paragraph of information in a bio. Therefore, in typing the information it is likely that the Enter (Return) key would be used. You have two choices of what you can do to prevent this from creating a problem.

One option would be to ask the user to add < *br* > at the end of paragraphs, which would be read by a browser and provide a carriage return. Of course, most users do not read, let alone follow, these types of directions. This technique would work, but it is dependent on the user, and there is an easier way. A better option is to use the *Replace* command. If you insert the *bio* element into a page and look at the code, it would look something like the following.

```
<% =(rsRiderDetail.Fields.Item("bio").Value) %>
```

To incorporate user-entered carriage returns, you would simply change the code as follows.

```
<% =Replace((rsRiderDetail.Fields.Item("homepage").
   Value),chr(13),"<br>") %>
```

Basically, you have asked the server to replace *chr(13)*, which is the ASCII code for a carriage return, with < *br* > (the HTML code for a line break).

Alternating Row Colors

The repeat region you created previously is very helpful, but it is sometimes difficult for a user to make sense of all the information in a listing unless you provide some visual cues. A common approach is to alternate the row colors in a table. This takes advantage of the repeat region to change the color of a row (or group of rows). The following code shows a basic repeat region for the *Pedal4Peace* member list, and includes code for alternating row colors.

```
1  <%
2  While ((Repeat1__numRows <> 0) AND (NOT rsListAll.EOF))
3  %>
4  <% if (Repeat1__numRows Mod 2) then %>
5  <tr bgcolor="#FFFFFF">
6  <% else %>
7  <tr bgcolor="#CCCCCC">
8  <% end if %>
9  <td>
10 <%=(rsListAll.Fields.Item("f_name").Value)%>
11 </td>
12 <td>
13 <%=(rsListAll.Fields.Item("l_name").Value)%>
14 </td>
15 </tr>
16 <%
17 Repeat1__index=Repeat1__index+1
18 Repeat1__numRows=Repeat1__numRows-1
19 rsListAll.MoveNext()
20 Wend
21 %>
```

The code in lines 4 through 8 makes every other row in the table a different color. Actually, you only need to add lines 4, 6, 7, and 8; line 5 would already be there from UltraDev. This example introduces the *If/Then* statement. If you have ever used a programming or scripting language, you have most likely used *If/Then* logic.

If/Then compares one thing to another. If the comparison is "true," whatever is after the *Then* statement is done. If the comparison is "false," the *Then* information is ignored. In the case of the previous code, this particular *If/Then* statement looks (using the *Mod 2* statement) to see if *Repeat1__numRows* is an odd or even number. If it is an even number, the table row background color is set to *#FFFFFF* (white). If *Repeat1__numRows* is an odd number, the < % *else* % > command sets the table row background color to *#CCCCCC* (light gray). The < % *end if* % > statement tells the server when the *If/Then* statement is completed.

 TIP: *Always look at the* While *statement before coding. If you have multiple repeat regions,* Repeat1__numRows *will change to a different number, as in* Repeat2__numRows. *You may want to get into the habit of just copying and pasting the* Repeat1__numRows *from the* While *statement.*

More If/Then Tricks

The *If/Then* statement can make your web pages even more dynamic. The *If/Then* statement is basically how the Show Region command works. However, the Show Region command is limited to an entire recordset. With a little coding, you can use an *If/Then* statement to hide or show information on a page according to a record or other variable.

For example, not all riders in the *Pedal4Peace* database will have a personal home page. You can look at the content of the home page field and decide if you want to display it or not. The following code demonstrates the basic principle behind this use of the *If/Then* statement.

```
<% If (rsListAll.Fields.Item("homepage").Value) <> "" then %>
<a href="<%=(rsListAll.Fields.Item("homepage").Value)%>"> Rider's
  Homepage</a>
<% End If %>
```

This statement asked if the field *homepage* is or is not empty by using the < > symbol (which means "not equal to") and "" (which means "empty"). If the field is not empty, the server places the link to *homepage*. If it is empty, the server ignores this section. Note that there is no < % *else* % > delimiter here. It is not needed for this statement.

This same process is strongly suggested whenever you use the Replace command or the formatting options provided in UltraDev. If a database field is empty and you have assigned a format to it or used the Replace command, the user would receive an error. By using this *If/Then* statement (as you did

above the fields that use formatting) or the Replace command, the user would not receive an error.

You will quickly find many uses for the *If/Then* statement. A short search on the Web for things like If Then Statement will provide you with information on all aspects of the *If/Then* statement. Alternatively, thumb through any ASP, JSP, or ColdFusion book to see the various ways in which the *If/Then* statement is used.

 TIP: *The HTML code used to create web pages is not case sensitive. Therefore,* IF, If, *and* if *are all acceptable. However, try to be consistent with your coding. It makes it easier for you (or someone else) to read later.*

■■ Summary

Setting up the connection to your database is often the most difficult task you will encounter when working with UltraDev. Believe it or not, UltraDev has made this process exponentially easier than other applications. Your connection depends on the server platform and scripting language you are using. It may even require a trip to the server administrator's office for a little help.

After you have your connection set up, you need to define your recordset. In your recordset definition you select the connection, table, and fields you plan to use on the page. You can filter a recordset on specific values or allow users to enter values for filtering the recordset. Filtering is a way of searching a database for records that meet specific filter criteria. You can also sort your recordset by any field in ascending or descending order from within the Recordset Definition window. Later chapters will show you how to perform more complex filters and sorts.

After you define your recordset, you can drag and drop database elements onto your web page. These elements can be formatted in a variety of ways. You can use standard HTML formatting techniques or dynamic formatting options provided server-side. You also learned how to use the Repeat Region command to list all or part of your recordset on a page. In conjunction with the Repeat Region command, you began using the recordset navigation tools built into UltraDev to allow your users to move through the records in your recordset or to go to a "details" page for a specific record.

To help limit potential user error, you examined using the Show Region command to show different page content depending on the "empty/not empty" status of the recordset. You then explored extending the use of Show Region by employing *If/Then* statements to hide or show information based on specific records.

This chapter was also your first trip into the code created by UltraDev. You were shown how to use the Replace command and make alternating row colors in your repeat region. The ASP code you were shown sets up a number of advanced techniques discussed in chapters to follow.

■■ Things to Think About

If you are anything like most developers, you tend to develop for specific clients or have a specific server you do your work on. If this is the case, you need to figure out which scripting language and server model you will be using. The differences between ASP and JSP are not significant, but there are differences.

Using ColdFusion is a great alternative. ColdFusion is incredibly powerful, but not that many people have it on their servers at the moment. However, if you are in the process of purchasing a server or configuring one, ColdFusion 5.0 would

definitely be worth looking into. The links between ColdFu-sion and UltraDev will continue to grow based on the merger between Macromedia and Allaire.

Whatever the case, you would benefit by having some good reference materials on the scripting language you will be using. There is no need to memorize every command and aspect of any language, but it sure is nice to be able to put your hands on the resources that have that information when you need it.

Fortunately, basic programming logic applies to any language, so having prior experience with Basic, Visual Basic, C, C + + , Java, and so on will only help you. We have only looked at the most basic features of UltraDev at this point, so continue to be creative and think of ways to implement databases in your web sites.

■■ Resources

The following web sites and references will help you learn more about the concepts and techniques discussed in this chapter.

❑ *http://www.4guysfromrolla.com/*

❑ *http://www.aspin.com/*

❑ *http://www.magicfind.com/magicbeat/ultradev/*

❑ *http://www.asp101.com/*

❑ *http://www.aspcode.net/*

The "for Dummies" series is a helpful reference for ASP, JSP, and ColdFusion. They give you the basics and are usually well indexed. (See, for example, the entries in the "Resources" section of Chapter 1.)

There are so many references out there that it can be really overwhelming. Our advice is to look for a writing style you like. Many of the reference books available are written to a highly technical audience and will likely cover material you do not need.

CHAPTER 7

Manipulating Data

■■ Introduction

The previous chapter covered how to display database information. This ability alone can make your life a lot easier and really impress the people you work with and for. It allows you to, for example, make and post modifications to a database for the purpose of regular updates to those who need them.

However, the ability to add, delete, and modify data using a web interface is where things really get exciting. This means you have a truly dynamic site with up-to-the-minute information. Allowing users to manage data frees your time for developing sites, in that you spend less time performing such mundane tasks as making minor wording changes, adding simple links, and correcting spelling errors.

This chapter takes you through the processes of adding records, deleting records, and modifying records in your database. With guidance, you are shown the basics, as well as exposed to methods of incorporating interesting features that take the fundamentals a step further.

■■ Objectives

In this chapter, you will:

❑ Insert records into a database

❑ Delete records from a database

❑ Modify information in your database

■■ Permissions Concerns and Security Issues

Whenever you allow web users to change items in a database, you need to incorporate this functionality in the database directory or directories. For a user to add a record, for example, her web user account must have write access to the file and/or directory on your server. The same goes for deleting and modifying information. The web user account should be given change privileges to your database, and often to the database directory.

There are differing opinions regarding security issues related to database use on the Web. The minute you make a computer a web server, it is compromised because web traffic needs to have read access to the web directory. However, this is not to say your server cannot be secure. The key is to limit or prevent access to data you do not want users to access without restrictions (or at all). For example, it is common practice to have database directories reside outside the web root. Under this type of setup, work performed in UltraDev will function properly in terms of connectivity. The connection is the key. That is, using a DSN connection, the database can reside anywhere on the server.

What this means is that your web users do not have easy access to the directory. If you had a database directory (named, for example, *databases*) inside the web root, a user

could fairly easily access this by going to *http://www.yourdomain.com/databases*. With that access, the user could download the entire database fairly easily. If, however, the database directory is not in the web root, it makes it a bit more difficult to exploit. Granted, a hacker may find a loophole and obtain access, but if so, does it really matter where your databases are? If you are hacked, you are hacked.

The point is that there is a balance to be struck between providing user access and maintaining security. If you are administering a server, remember to stay vigilant about patches and updates. There are security fixes released almost daily. Stay on top of them and you will greatly reduce your vulnerability, without having to greatly minimize or disallow user access.

▪▪ Inserting Data

If you have ever added records to a database, you have most likely tabbed through a bunch of text fields on a page and maybe even used some drop-down menus, check boxes, and radio buttons. These are also the basic functional components under UltraDev in regard to adding data. The difference, however, between working directly with a database and working indirectly with one under UltraDev is that UltraDev user interfaces are created in HTML.

Every Form object is named by UltraDev when you insert it. It is good practice to change these names in the Properties window to field names within your database. As when you filtered a recordset on a URL parameter, naming Form objects to match database objects will save you time in the long run.

HTML Forms

The HTML form is the foundation for adding data to your database. If you have not played with forms much, you may want to examine this part of the chapter closely. The use of, and options associated with, forms are explored in the sections that follow. Figure 7-1 shows the various form objects found in the Forms window of the Objects panel.

Fig.7-1. Forms window of the Objects panel.

Forms

The form tag serves as a container for Form objects. In Chapter 6, you used a form to hold the search criteria for member searches. Forms can contain standard HTML, graphics, and Form objects.

> **TIP:** *You can place multiple forms on a page as long as they are not overlapping.*

Form Buttons

A Form button incorporates two options: Submit and Reset. When you click on a Submit button, all information contained by a form tag is processed. When you click on a Reset button, any information in a form tag is cleared. Buttons can be labeled in the Properties window to help users know what to do. For example, a button might be labeled *Click here to save your record.*

Using the Insert Image Field option, you can also assign the behavior (functionality) of what would otherwise be a submit

or reset button to a graphic. That is, clicking on the graphic produces the same effect as a submit or reset button. This allows developers to replace traditional-looking buttons with interface controls that work better aesthetically with their graphical layout.

Text Boxes

Text boxes will likely be the Form object you use most. Text boxes have a number of options. You can use single- or multi-line text boxes, add initial values, and even set text boxes to password mode to protect passwords from prying eyes.

Check Boxes and Radio Buttons

Check boxes and radio buttons represent an easy means of providing users with choices. Check boxes allow a user to individually select (or leave unselected) multiple boxes of the same name. You are most likely familiar with this if you have ever completed an on-line survey containing a "Check all that apply" section.

Radio buttons force a user to make a choice of one response among two or more possible selections. In this situation, for example, the user would be allowed only one choice of five sublabeled radio buttons under the label *Question_3*. You will see radio buttons used for yes/no questions or for survey situations in which the developer wants a specific response (and only one response).

Lists and Menus

Choices in list or menu format offer the user flexibility of response while ensuring that the form of the response can be interpreted by the program. That is, this ensures against ambiguity or non-usability of the response. For example, in the previous chapter you created an interface response list of

states that allowed the user to select a state as a response to specifying a search criterion. In this case, the list format ensured that the correct form of the state's abbreviation would be sent to the database. The ability to assign recordsets to lists and menus allows for some very creative possibilities addressed later in this chapter.

Insert File

The Insert File option allows a user to browse the computer they are working on to select a file. This is usually associated with some sort of uploading procedure. UltraDev users have created a number of extensions that make uploading files relatively simple. Look for "PureASP Upload" on the UltraDev Exchange page.

Jump Menus

Jump menus are nice for navigation, but really have little to do with database interaction. They can be very handy, and you are encouraged to experiment with them.

Hidden Fields

Hidden fields may become your best friend by the end of this chapter. Hidden fields let you store static or dynamic data in a web page that will be sent with the form. The only way for a user to know a page contains hidden fields is to view the source of the page. Hidden fields are basically a text box that sits quietly behind the scenes until the user submits the form. You will use hidden fields quite a bit in later chapters.

Collecting and Manipulating Data

Let's try setting up a form for collecting some data from your users. When you have completed the following steps, you will have a way for new Pedal for Peace tour riders to enter their

information on a web page and have it stored in your *Pedal4Peace.mdb* database.

Exercise 7-1: Setting Up a Database for Data Collection

1 Open the *Pedal4Peace* site in UltraDev and create a new folder in the Site Files window by right-clicking (Windows) or Command + clicking (Mac) and selecting New Folder from the contextual menu that appears. You need to rename the folder. When a folder is created, the folder name is automatically selected (i.e., highlighted). If it is not already selected, click once on the folder name (the default name is *Untitled*) to select it. Name the folder *new_user*.

2 Create two new files inside the *new_user* folder by right-clicking (Windows) or Command + clicking (Mac) on the *new_user* folder and selecting New File from the contextual menu that appears. Rename the files *add_new.asp* and *added.asp*.

In *added.asp*, type *Thanks, your information has been added to the directory.* This informs the user that everything has worked. In practice, you may also want to add to this page links to other sections of the web site so that the user has somewhere to go after inserting information.

3 Open *add_new.asp* from the Site Files window. Insert a form on the page.

4 Add to this form the form elements outlined in table 7-1.

Table 7-1: Form Elements to Be Added

Web Page Name	HTML Label	Form Object Type
First Name	f_name	Text Field
Last Name	l_name	Text Field

Web Page Name	HTML Label	Form Object Type
Street Address	street_address	Text Field
City	city	Text Field
State	state	List/Menu (as you did in the previous chapter to search by state)
Zip Code	zip	Text Field
Phone Number	phone	Text Field
E-mail Address	email	Text Field
Home Page	homepage	Text Field
Save My Info	submit	Submit Button

Your page should now look like that shown in figure 7-2.

First Name
Last Name
Street Address
City State Zip Code
Phone Number
E-mail Address
Home Page
Save My Info

Fig. 7-2. Form used to insert a new record into a database.

NOTE: *You can format the information in a form. The use of tables within a form helps you organize the*

appearance of the form. For this exercise, do not worry about formatting. The emphasis here is on procedure.

5 After you have the form and all elements placed on the page, it is time to add the "Insert Record Server" behavior. Open the Server Behaviors window by selecting Server Behaviors from the Windows menu. Click on the plus sign in the Server Behaviors window and select Insert Record from the menu that appears, as shown in figure 7-3.

Fig. 7-3. Menu found in the Server Behaviors window.

The Insert Record window will appear. This window is where you set all options related to inserting the information from your form into the fields of the database you want to contain this information.

6 The first option requires that you select the connection you want to use. Select *connPedal4Peace* from the Connection drop-down list. UltraDev will connect to the *Pedal4Peace.mdb* database you defined in *connPedal4Peace* in Chapter 6.

7 After you select *connPedal4Peace*, you will see a list of the tables in the *Pedal4Peace.mdb* database. Select *riders* from the Inset Into Table drop-down list.

8 Click on the Browse button next to the *After Inserting, Go To* text box and select *added.asp*, which you created in step 2. This tells UltraDev which page to display after the information has been inserted into the database.

9 In the Get Values From section, UltraDev has already selected *form1*, which is the default name UltraDev gave to the form you inserted on the page in step 3. You sometimes have more than one form on a page, and therefore this option is necessary. For now, you can leave it set to *form1*.

The last section is the Form Elements section. You will see a list of the form elements you created previously, except for the Submit button. Because you named the form elements on the web page with the same names used for fields in the database, UltraDev automatically associates the form elements with the database fields (or columns, as UltraDev refers to them) of the same name.

If you look closely at the list of form elements, you will notice that UltraDev has placed *< ignore >* next to the *street_address* form element in the list to tell you the application does not know what to do with this form element. The field in the database you will use to store this piece of information is the Address field.

10 To tell UltraDev which database field to insert the information into, click once on the *street_address* form element in the Form Element list to select it. Then select *address* from the Column drop-down list below the Form Element list. The Submit As drop-down list is set to Text by default, and that is fine for this particular situation. See figure 7-4 for an example of how these options should be set.

Fig. 7-4. Insert Record window with options set for this form.

11 After you have confirmed that all form elements are connected to the appropriate database fields, click on the OK button.

You have just created a way for users to insert information into your database over the Web. To test this capability, continue with the following.

12 Upload the *new_user* folder to your server and give it a try.

NOTE: *It is common to get the following error:* 80004005 – Operation must use an updateable query, *when first using the insert record behavior. This error is caused because the IUSR (Windows term for "default Internet user") does not have read/write permission for the directory that holds the database. You need to have the system administrator give read/write permission to this directory for IUSR.*

Granted, this may seem like a lot of steps the first few times. However, as you start creating pages, these steps will become routine. If you want to make yourself feel better about the number of steps it takes, select Code View from the View menu and look at all the code UltraDev has created based on the steps you just went through. Writing all of this code by hand would take a lot longer.

Modifying and Manipulating Database Information

Now that you have added information to the database, the next thing most people want to be able to do is change or modify information in the database. In exercise 7-2, you are going to make an assumption. For now, ignore the issue of user authentication and assume that only you will be modifying this information. User authentication is explored in Chapter 8.

Exercise 7-2: Database Modifications and Manipulations

Modifying information in the database is very similar to inserting information. You will perform a number of the same steps you did in previous exercises.

Directory Setup

Establishing the following directory structure will provide a framework for easily modifying the information for a specific rider in the database. The result of this structure will allow you to search for a specific rider based on last name, list any matches to your search criteria, and have a linked page that allows you to modify information.

1 The first thing you need to do is create a new folder in the Site Files window. This folder will handle the modification of information. Name this folder *modify*.

Create three files in the *modify* folder. Name these *search.asp, results.asp,* and *modified.asp.* In addition to the three files you have created, in the following you will be shown a time-saving shortcut.

2 In the Site Files window, right-click (Windows) or Command + click (Mac) on *add_new.asp* in the *new_user* folder and select Copy from the contextual menu that appears.

3 Right-click (Windows) or Command + click (Mac) on the *modify* folder and select Paste from the contextual menu that appears.

You have just made a copy of *add_new.asp* in the *modify* folder.

4 Rename the file you just pasted *modify.asp*.

In material to follow, you will make some modifications to *modify.asp*.

TIP: You can also use keyboard shortcuts for a copy-and-paste procedure within the Site Files window.

Searching for a Specific Rider

This exercise searches for a specific rider based on last name. This search method is an enhanced version of the procedure you performed in Chapter 6. In Chapter 6, the search found riders in a specific state. This search will allow you to enter all or part of a rider's last name and search for last names based on that information. For example, if you entered *johns* in the Search text box, riders with the following last names would be returned: Johns, Johnson, Johnston, St. Johns, and so on. This search method means you do not have to enter the complete last name, and it will find possibilities for which you do not know the complete spelling.

1 Open *search.asp* in the *modify* folder and insert a form. Select the form, click on the Folder icon next to the Action text box in the Properties window, and select *results.asp* in the *modify* folder from the list of files in the Select File window that appears. Set the Method option in the Properties window to Post (see figure 7-5).

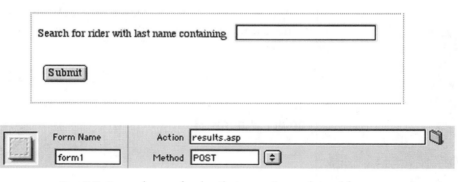

Fig. 7-5. Form element for the "last name" search, and form properties.

2 Insert a text field named *l_name*.

3 Insert a Submit button.

4 Close *search.asp* and open *results.asp*.

Creating a Recordset

results.asp will be similar to the page you created in exercises 6-4 and 6-5. *results.asp* will perform a query of the database and look for any records in which the last name contains the information entered in the *l_name* text field on *search.asp*.

1 Open the Data Bindings window and create a new recordset by clicking on the plus sign and selecting *Recordset (Query)* from the drop-down list.

2 In the Recordset window, name the recordset *rsSearchLastName*.

3 Select *connPedal4Peace* from the Connection drop-down list.

4 Select *riders* from the Table drop-down list.

5 In the Filter section, select *l_name* from the upper left-hand drop-down list, select Contains from the upper right-hand drop-down list, select Form Variable from the lower left-hand drop-down list, and enter *l_name* in the text box on the lower right-hand side.

This step will perform the search for last names that contain the information entered in the *l_name* text field on *search.asp*.

6 Sort the recordset by *l_name*.

See figure 7-6 for an example of how each parameter in the Recordset window should be set.

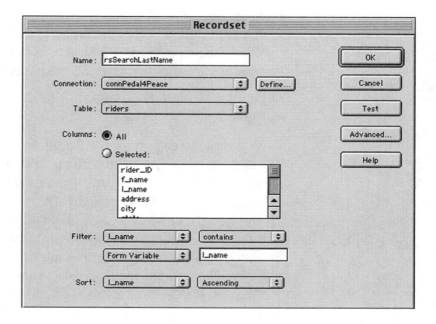

Fig. 7-6. Settings used in the Recordset window for searching on last name.

Displaying the Search Results

This section of the exercise creates a table that lists all matches to the entered search criteria. A link to the *modify* page will be associated with each match.

1 Insert a table with two (2) rows and three (3) columns into *results.asp*. Type *Name* into the upper left-hand table cell.

2 Insert *f_name* from *rsSearchLastName* in the Data Bindings window into the lower left-hand table cell. Add a non-breaking space by selecting Non-breaking Space from the Special Characters menu found in the Insert menu. Insert *l_name* from *rsSearchLastName* in the Data Bindings window. Type *Modify* in the lower center table cell.

3 Select the word *Modify* and click on the Folder icon next to the Link text box in the Properties window. This will open the Select File window. In this window, select *modify.asp*, and then click on the Parameters button.

As you did in Chapter 6, you need to pass the *rider_ID* for the rider.

4 In the Name column of the Parameters window, enter *rider_ID*, press the Tab key to move to the Value column, and then click on the "lightening bolt" icon at the right side of the Value column. This will open the Dynamic Data window, in which you can access record-sets you have defined in the page. If *rsSearchLastName* is not opened, click on the triangle to the left of *rsSearchLastName* and then select *rider_ID* from the list. Click on the OK button in the Dynamic Data window, click on the OK button in the Parameters window, and click on Open in the Select File window.

Show All Matches

The previous steps display the first record of the recordset. Now you need to insert a "repeat" region on the page and add two "Show Region" behaviors to prevent potential errors.

1 Place the cursor in one of the columns in the second row of the table you created previously. Select < tr > from the Quick Tag editor to select the entire table row.

2 Open the Server Behaviors window, click on the plus sign, and select Repeat Region from the drop-down list.

3 Select *rsSearchLastName* from the drop-down list in the Repeat Region window that appears. Click on the All Records radio button in the Show section to show all records in the database that have matched the search criteria.

4 Click outside the table and press Enter. Type *There were no matches for your search criteria.*

5 Select the table by clicking on one of the table or cell borders, open the Server Behaviors window, and click on the plus sign. Select *Show region if recordset is not empty* from the Show Region option. The Show Region If Recordset Is Not Empty window will appear. Select *rsSearchLastName* from the Recordset drop-down list if it is not already selected, and click on OK.

6 Select the text you added below the table and repeat step 5. However, this time, select *Show region if recordset is empty.*

Steps 5 and 6 prevent receiving an error if there are no matches to the search criteria.

Setting Up the Modify Page

This section of the exercise creates *modify.asp. Modify.asp* will have a form containing form elements for database fields you will need to modify. Form elements will contain the data from the database, so that you can make modifications to the information.

1 Open *modify.asp.*

2 Open the Server Behaviors window and click once on Insert Record (form *form1*) in the Server Behaviors window, and then click on the minus sign in the Server Behaviors window. This will remove all code UltraDev inserted to allow you to insert the information entered in the form into the database. However, you now do not have to recreate the form that would be needed to modify the rider information.

3 Open the Data Bindings window and create a new recordset named *rsRiderInfo*. Use the *connPedal4Peace* connection, select the *riders* table, and set the Filter options to filter on *rider_ID = URL parameter rider_ID* (see figure 7-7).

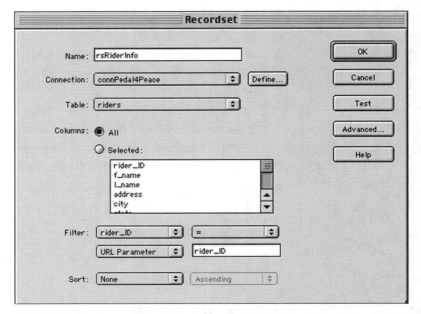

Fig. 7-7. Properties used to create a recordset from the riders *table of the* Pedal4Peace.mdb *database based in the* rider_ID *passed from* results.asp.

It is now time put the information from the database into the form elements. This is basically the same procedure you used in Chapter 6 and earlier in this exercise to insert database information into the web page.

4 Open the Data Bindings window. Click once on the *f_name* form element to select it. Click once on *f_name* in *rsRiderInfo* in the Data Bindings window and then click on the Bind button at the bottom of the Data Bindings window. The Bind button is next to the *Bind to* drop-down list that has *input.value* in it.

This step places any information in the *f_name* database field into the *f_name* text field in the form. Repeat this process for each text field form element on the page (see figure 7-8).

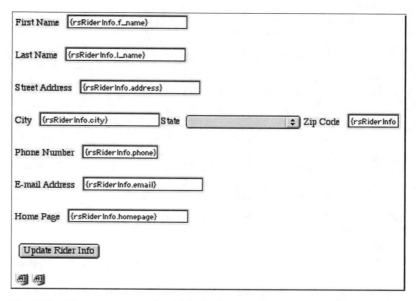

Fig. 7-8. What your page should look like.

5 Set the value of the *state* drop-down. Open the Server Behaviors window. Double click on Dynamic List/Menu (state) found in the Server Behaviors window. This will open the Dynamic List/Menu window. The options you set in Chapter 6 are still there. Click on the lightening bolt to the right of the *Select value equal to* text box.

The Dynamic Data window will open. Open *rsRiderInfo*, if it is not already open, by clicking on the triangle to the left of the recordset name. Click once on the *state* database element in *rsRiderInfo*. Click on OK in the Dynamic Data window, and then click on OK in the Dynamic List/Menu window (see figure 7-9).

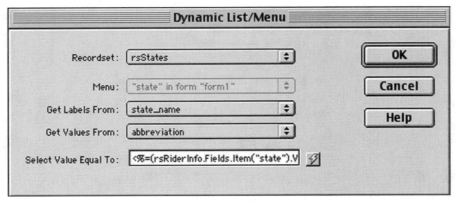

Fig 7-9. Setting the value to a database value.

Adding the Update Record Behavior

You are now ready to insert the Update Record Server behavior into the page. The difference between the Update Record and Insert Record server behaviors is that the Insert Record server behavior creates a new record in the database. The Update Record server behavior modifies or updates information in an existing database record.

1 Open the Server Behaviors window.

2 Click on the plus sign and select Update Record from the drop-down list.

3 The Update Record window will appear. Most of this window should now be looking pretty familiar.

4 Select *connPedal4Peace* in the Connection drop-down list.

5 Select *riders* from the Tables to Update drop-down list.

6 Select *rsRiderInfo* from the *Select Record from* drop-down list.

7 Select *rider_ID* from the Unique Key column, if UltraDev has not done so already. The numeric check box should be checked, because *rider_ID* is an auto number in the

database table. The Unique Key column tells UltraDev which database field is the unique identifier.

8 Click on Browse to the right of the *After Updating, Go To* text box and select *modified.asp* when the Select File window appears.

9 The Get Values From drop-down list should show *form1* by default, because there are no other forms on the page.

10 Just as you did when you learned how to insert a record, the form elements must be connected to database fields. In our example, UltraDev will do this for you because you have named the form elements with the same names used in the database, with the exception of *street_address*. Do not forget to connect *street_address* to *address*, as you did earlier (see figure 7-10).

11 Click on OK and you are done.

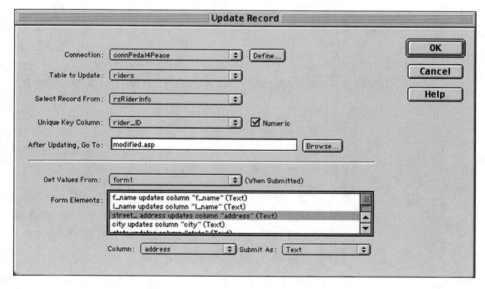

Fig. 7-10. Update Record window with all settings needed to update the riders info.

Creating a Confirmation Message

The final step in all of this is to give yourself a message so that you know the update has been a success. Confirmation messages are very helpful to users. Things on the web can happen pretty quickly. Therefore, it is a good approach to incorporate a message that informs users an operation was completed successfully.

1 Open *modified.asp*.

2 Type *The record has been updated*.

3 Create a link to *search.asp*.

There you have it. You can now add information to and modify information in the database. The more you work with UltraDev the more the steps will become familiar and routine. Of course, no membership directory is complete without the ability to delete member information. In exercise 7-3, you will delete a record from a database.

Exercise 7-3: Deleting a Record from a Database

The following exercise deletes a record from the database. You will be using some of the pages created previously to make a more seamless and user-friendly site.

1 In the Site Files window, right-click (Windows) or Command + click (Mac) on the *modify* folder and select New File from the contextual menu that appears.

2 Name the new file *delete.asp*.

3 Repeat steps 1 and 2 and name the file *deleted.asp*.

4 Open *results.asp*.

5 In the lower right-hand table cell, next to the cell that has *Modify* in it, type *Delete*.

6 Select the word *Delete* and click on the Folder icon next to the Link text box in the Properties window. This will open the Select File window. Select *delete.asp*, and then click on the Parameters button. In the Name column of the Parameters window, enter *rider_ID*, press the Tab key to move to the Value column, and then click on the lightening bolt at the right-hand side of the Value column. This will open the Dynamic Data window, in which you can access recordsets you have defined in the page.

If *rsSearchLastName* is not opened, click on the triangle to the left of *rsSearchLastName* and then select *rider_ID* from the list. Click on OK in the Dynamic Data window, click on OK in the Parameters window, and click on Open in the Select File window.

7 Close *results.asp*.

8 Open *delete.asp* and insert a form on the page.

9 Open the Data Bindings window and create a recordset named *rsDeleteRider*. Select the *connPedal4Peace* connection from the Connections drop-down list. Select *riders* from the Tables drop-down list. Filter this recordset on *rider_ID = to URL parameter rider_ID* (see figure 7-11).

10 Like any good application, this page serves as a double check that you really want to delete the record from the database. In the form, type *Are you sure you want to delete this rider?* Below that sentence, insert *f_name* and *l_name* separated by a non-breaking space. This will insert the rider's name on the page to confirm that the user really wants to delete this particular rider.

11 Insert a Submit button. Label the button *Click here to delete rider* in the Properties window by clicking once on the button and changing the text in the Label text box.

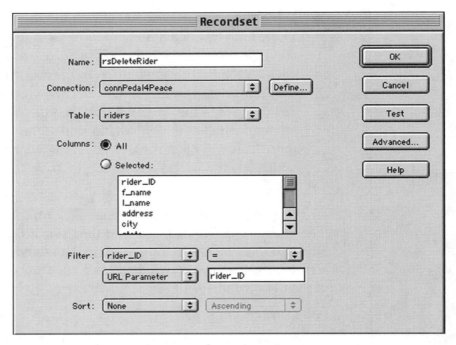

Fig. 7-11. Recordset setting for rsDeleteRider.

12 Add a link below the button that says *Click here if you do not want to delete this rider.* Make the text a link back to *results.asp.*

13 Open the Server Behaviors window and click on the plus sign. Select Delete Record from the drop-down list that appears.

14 The Delete Record window will appear. Again, much of this window should look familiar to you.

15 Select *connPedal4Peace* from the Connections drop-down list.

16 Select *riders* from the Delete From Table drop-down list.

17 Select Record From should be set to *rsDeleteRider.*

18 Unique Key Column should be set to *rider_ID,* and the Numeric check box should be checked.

19 Click on the Browse button to the right of the *After Deleting, Go To* text box and select *deleted.asp*.

20 Delete By Submitting should be set to *form1*.

21 Click on OK and you are done.

See figure 7-12 for all settings.

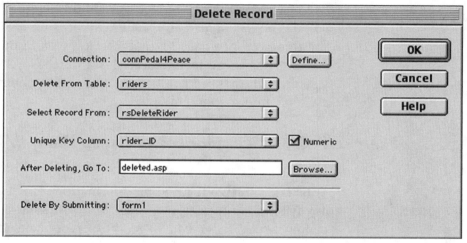

Fig. 7-12. Delete Record window showing the necessary settings.

Your web site has just become dynamic. Information has the potential to constantly change. Riders can be added at any time, and you can quickly update information through a web browser. In the next chapter you will look at ways to allow users to maintain their information rather than just entering their info.

▪▪ Tips and Tricks

In the exercises in this chapter a page was provided to users to tell them they had completed inserting, deleting, or modifying a record. Although this is an acceptable way of doing things, there are alternatives.

Exercise 7-4 outlines the steps of another approach. Just as you did on *list_all.asp* and *results.asp*, it is possible to pass a variable from one page to another. However, in this exercise, you are not going to interact with a database. The *If/Then* statement introduced in Chapter 6 will make another type of dynamic information possible.

Exercise 7-4: Allowing for Fewer Pages Using If/Then

Thus far you have focused on information from a database as dynamic information. However, with some creative coding a developer can have the server make decisions based on variables and on server resources such as the system time.

This exercise streamlines the modification process you performed previously. Here, you will bypass *modified.asp* and send a variable from *modify.asp* back to *search.asp*. This will have the page show a message at the top of *search.asp* telling you that the record has been modified.

1 Open *modify.asp*.

2 Open the Server Behaviors window.

3 Double click on Update Record to open the Update Record window.

4 Click on the Browse button to the right of the *After Updating, Go To* text box and select *search.asp*.

5 Type *?action = modified* after *search.asp* in the *After Updating, Go To* text box (see figure 7-13).

The *?* tells the server a name/value pair is coming. The variable name is *action* and the value is *modified*.

Fig. 7-13. Adding a variable to the redirection page.

6 Save *modify.asp* and upload it to the server. Open *search.asp*.

7 Add a carriage return at the top of the page.

8 Type *Rider Info Modified*.

9 Switch to Code view.

10 Add the following code directly above the text *Rider Info Modified*.

```
<% If request.querystring("action") = "modified" then %>
```

11 Add the following code directly after the text *Rider Info Modified*.

```
< % end if %>
```

Fig. 7-14. Design view of search.asp.

12 Return to Design view. You should see two small yellow ASP shields on your page (see figure 7-14). These are visual cues that ASP code is included on the page.

13 Save the file and upload it to your server. The next time you modify a rider's information, *Rider Info Modified* will appear on *search.asp*.

The *If/Then* statement you added introduces a new term, *request.querystring*. *Request.querystring("action")* translates into the variable action found in the URL.

This little trick can be used in a number of situations. You could include the *action* variable set to Deleted on *delete.asp*. On *search.asp*, you would include Rider Deleted and use the *elseif* command, as shown in the following.

```
<% If request.querysting("action") = "modified" then %>
Rider Info Modified
<% elseif request.querysting("action") ="deleted then %>
Rider Deleted
<% end if %>
```

When you created *add_new.asp*, you included a drop-down for states. When you view this page in a browser, you will see that Alabama is shown in the State drop-down list. A common approach used on the Web is to have a Select option appear in drop-down lists by default. There are two ways to accomplish this task. The first method is to include Select as a record in your database table. Of course, in previous examples, you

wanted the states sorted in alphabetical order. This means Select would show up between Rhode Island and South Carolina, and Alabama would still be displayed by default. In exercise 7-5, you will include the Select option in the List/Menu option at the HTML level.

Exercise 7-5: Working at the HTML Level

The other option is to include Select in the List/Menu option at the HTML level, as follows.

1 Open *add_new.asp*.

2 Click once on the State list/menu form element to select it.

3 Click on the List Values button in the Properties window to open the List Values window.

4 Click on the plus sign in the List Values window to add another line of list values below the recordset information that is already there.

5 Type *Select* in the Name column, press the Tab key to move to the Value column, and type *missing*.

Adding *missing* as the value guarantees functionality if a user does not select a state from the list/menu when they add their record.

6 Click on the Up arrow in the List Values window to move *Select* above the list of states (see figure 7-15).

7 Save *add_new.asp* and upload it to your server to see how it looks now.

Fig. 7-15. Select option appearing above list of states.

■■ Summary

In this chapter you have moved from looking at information from a database on the Web to adding information, modifying information, and deleting information in the database on the Web. The basic building block of all of these actions is the HTML form. You need to insert a form and a variety of form elements on any page that will manipulate information in a database.

In combination with the HTML forms, you learned how to use three different server behaviors that have been included with UltraDev: Insert Record, Update Record, and Delete Record.

Each server behavior requires you to select a connection, table, and page to which to connect after the behavior has been executed. In addition, you need to link each form element to specific database fields (or columns) using the Insert and Update Record server behaviors.

The *If/Then* statement was also used in this chapter and introduced a new term, *request.querystring*. *Request.querystring* is a way of referencing name/value variable pairs in the URL.

The use of *elseif* was also introduced. *Elseif* is a way of nesting *If/Then* logic to make true/false decisions within a web page.

■■ Things to Think About

Keep in mind the following in regard to adding, deleting, and modifying data.

- ❑ Whenever you allow web users to change items in a database, you need to incorporate this functionality in the database directory or directories.

- ❑ The type of connectivity you employ is the key to database security. Using a DSN connection, a database can reside anywhere on the server.

- ❑ The HTML form is the foundation for adding data to your database.

- ❑ The use of forms for providing users with the ability to enter data (and for your program to collect and store that data) obviates having to write a lot of lengthy code to achieve the same purpose.

- ❑ Directory structure is the key to easily locating and modifying information.

■■ Resources

The following web sites and references will help you learn more about the concepts and techniques discussed in this chapter.

❏ *http://www.4guysfromrolla.com/*

❏ *http://www.aspin.com/*

❏ *http://www.magicfind.com/magicbeat/ultradev/*

❏ *http://www.asp101.com/*

❏ *http://www.aspcode.net/*

The "for Dummies" series is a helpful reference for ASP, JSP, and ColdFusion. They give you the basics and are usually well indexed. See, for example, the entries in the "Resources" section of Chapter 1.

There are so many references out there that it can be really overwhelming. Our advice is to look for a writing style you like. Many of the reference books available are written to a highly technical audience and will likely cover material you do not need.

CHAPTER 8

Simple User Authentication

■■ Introduction

Now that you know how to view, add, and manipulate information in a database via the Web, it is time to let your users have more control over their information. Right now, you have the ability to allow riders to modify information on the Pedal for Peace web site. However, the way things are set up right now, anyone can modify anyone else's information.

What is needed is a way to let riders easily access only their individual information. This is where user authentication comes in. User authentication consists of three basic functions: log-in, restriction of access, and log-out. The idea behind user authentication is to validate who the user is based on a user name and a password.

The user name and password entered by the user in an HTML form are compared to information in the database to find a match. If a match is not found, the user is automatically redirected to a different page. The page the user is redirected to can contain information about how to obtain a user name and password, and/or an explanation of why log-in was denied.

This chapter examines each part of the basic functions involved in user authentication. The basic functionality of user authentication in itself represents a great tool, but there

are some really amazing things that can be done once you are able to validate who a user is.

■■ Objectives

In this chapter, you will:

❏ Create a user log-in page

❏ Restrict page access to registered users

❏ Create a user log-out page

❏ Restrict page access to administrators

■■ Session Variables

User authentication is built on the use of session variables. *Session variable* is a new term for a very powerful tool. A session variable is stored temporarily in the memory of the server. There are a few things you need to know about session variables before you start working with the user authentication features of UltraDev.

Session variables are temporary bits of information stored in the server's memory. Thus, session variables should not contain large amounts of information. Session variables require that the user has cookies enabled for his browser. The session variable is treated like a temporary cookie. Session variables exist until one of the following three things happens.

❏ The user logs out of the web site using the UltraDev log-out feature (discussed in material to follow).

❏ When the session variable times out. The default time limit for a session variable is 20 minutes, but it can be modified. If a user is inactive for more than the time

limit of the session variable, the session variable times out, thereby deleting itself.

❏ The user exits or quits the browser application. Closing the browser window will not remove the session variable.

Because a session variable exists on the server while a user is interacting with the web site, the variable is available to web pages for filtering recordsets and for use in authentications. The following sections walk you through creating a user log-in page, creating a user registration page, restricting access to a page based on user information, and creating a log-out page.

■■ Creating a Log-in Page

Before you can create a user log-in page, you need to make sure your database has a unique identifier (such as a user name) associated with it, and that a password is associated with that unique identifier. The exercise that follows takes you through the process of providing this functionality.

CD-ROM Exercise

The material on the companion CD-ROM includes a database that incorporates *username*, *password*, and *access_ level* columns in the *riders* table, as well as a new table named *access_levels*, to make this exercise a little easier. This database is located in the folder named *Chapter 8* on the companion CD-ROM. The file is still named *Pedal4Peace.mdb*, so that you can simply replace the file on the server with this one.

Because the name is the same, if you keep the location the same as the previous *Pedal4Peace.mdb,* any DSNs you have defined and pages you have created thus far will still work. The only difference between the original version and the current version is that the one in the *Chapter 8* folder contains user names and passwords for all riders.

1 In the Site Files window, create a new folder named *login.*

2 In the *login* folder, create four (4) new files named *login.asp, my_info.asp, modify.asp,* and *done.asp.*

3 In the Pedal for Peace web site, create a new folder named *errors.*

4 In the *errors* folder, create a new file named *no_user.asp.*

5 Open *no_user.asp* and type a message on the page that informs the user that she has not entered a valid user name and password. You also may want to add a link to *add_new.asp* in the *new_user* folder and/or a link back to the log-in page for the user to try to log in again.

6 Open *login.asp* and insert a form on the page.

7 Add the form elements outlined in table 8-1.

Table 8-1: Form Elements for the Log-in Page

Name on Web Page	HTML Label	Form Object Type
User Name	username	Text Field
Password	password	Text Field (select the Password option in the Properties window to hide the password when it is typed)
Log-in	submit	Submit Button

8 Open the Server Behaviors window, click on the plus sign (+), and select Log in User from the User Authentication option. This will open the Log In User window.

9 In the Log In User window, you will need to provide information about the database table and columns that will be used. Also, you will need to tell UltraDev where to direct the user if the log-in is successful or if the log-in fails. The following, shown in figure 8-1, is the information to be entered. Enter the following information or make the following selections in the corresponding option or field of the Log In User window. The input appears in italic after the option/field name. Otherwise, the option or field requires a selection, as stated.

 ❑ Get Input From Form: *form1*

 ❑ Username field: *username*

 ❑ Password field: *password*

 ❑ Validate Using Connection: *connPedal4Peace*

 ❑ Table: *riders*

 ❑ Username Column: *username*

 ❑ Password Column: *password*

 ❑ If Log In Succeeds, Go To: *my_info.asp*

 ❑ Select Go To Previous URL (if it exists).

 ❑ If Log In Fails, Go To: *../errors/no_user.asp*

 ❑ Select *username*, *password*, and *access level* in the Restrict Access Based On section.

 ❑ Select *access_level* from the Get Level From drop-down list.

Fig. 8-1. Log In User window with applicable information entered and options selected.

The Log In User window provides a simple means of setting up validation for users. By now, many of the settings or options should seem familiar to you. Here you are continuing to use the *connPedal4Peace* connection to link to the database tables on the server. Because you uploaded the new version of the database in step 1, you now have *username* and *password* columns in the *riders* table.

There are only a few things you have not dealt with in regard to the Log In User window. The server compares the user name and password entered on the web page to user names and passwords found in the *username* and *password* columns

of the database. If there is an exact match (i.e., the user name and password match), the server will redirect the user to *my_info.asp*. If there is not an exact match, the server will redirect the user to the *add_new.asp* page, which you created in Chapter 7.

Go To Previous URL (if it exists) is a helpful feature used when a user tries to access a page that requires some type of user authentication without logging in. This option basically stores the URL the user was trying to access, and if the user logs in successfully, the system will take the user to the URL being stored.

Restrict Access Based on Username and Password sets the user name as a session variable. If you were to select *user-name*, *password*, and *access level*, the access level would also be set as a session variable.

You have just created a user log-in page for your site. Of course, now you need to take advantage of the user authentication capability. In exercise 8-1, you will use log-in information to create a recordset.

Exercise 8-1: Using Log-in Information for a Recordset

When a user logs in, the server looks to see if the *user-name* and *password* variables match information stored in the database. If the information matches, the user is sent to *my_info.asp*. In this exercise, *my_info.asp* could work much like a personalized page found on sites such as *Excite.com* or *Yahoo.com*, in which you might incorporate special information that only users should see, ways of modifying personal information, and so on. *my_info.asp* is a great place to provide riders with announcements or a link to let them update their information. This exercise

walks you through the process of using the user name of the rider after he has logged in successfully.

In this exercise you are providing riders with a means of modifying their contact information. There are a number of things that could also be included on this page, such as announcements, ride schedules for individual areas, and so on. Each of these options would follow the same basic procedure.

1 Open *my_info.asp*.

2 Open the Data Bindings window, click on the plus sign (+), and select *Recordset (Query)* from the drop-down list to open the Recordset window.

3 Name the recordset *rsMyPage*.

4 Select *connPedal4Peace* in the Connections drop-down list.

5 Select the *riders* table from the Table drop-down list.

6 Leave the Columns radio button set to All.

7 In the Filter section, perform the following (see figure 8-2).

 ❐ Select *username* from the Filter drop-down list.

 ❐ Select the equals sign (=) from the upper right-hand drop-down list.

 ❐ Select Session Variable from the lower left-hand drop-down list.

 ❐ Type *MM_Username* in the text box at the lower right.

MM_Username is the variable name UltraDev gives to the *username* session variable created in the Log In User server behavior.

8 Click on OK.

Fig. 8-2. Recordset window using a session variable to filter.

A recordset should appear in the Data Bindings window, listing the database fields in the *riders* table. The steps you have just completed did essentially the same thing done in chapters 6 and 7 when you searched for riders in a specific state or searched for riders by last name. In the examples in those chapters, a variable was sent from one page to another. For example, the variable *state* was sent from *search.asp* to *results.asp* with a specific value.

In some examples, the variable was sent in the URL; in others, it was sent in a form. In this exercise, the variable name is *MM_Username* and the value is the user name entered on *login.asp* and validated successfully by the server. Exercise 8-2 uses the information in the recordset you just created to allow the rider to update her contact information. You could now put a personalized welcome message to the user on the

page using their name from the recordset, or include special announcements that only registered users should see.

This is also an excellent place to provide a link for users to update their personal information. In the following exercise, we will create a page that allows users to modify their personal information.

Exercise 8-2: Providing User Capability for Updating Information

The steps of this exercise are basically the same as those of the exercise in Chapter 7 involving modifying database information. The only real difference between these exercises is how the recordset is created. This is one of the great things about UltraDev. Once you know how to update a record in a database, it does not change. The trick to all of this is understanding how to filter and create recordsets and to utilize tools such as session variables.

1 Open *my_info.asp*.

2 Open the Data Bindings window and click once on *rsMyPage* to select it.

3 Click on the small black triangle in the upper right-hand corner of the Data Bindings window and select Copy from the drop-down menu that appears (see figure 8-3). Close *my_info.asp*.

Fig. 8-3. Cut, Copy, Paste menu for recordsets.

4 Open *modify.asp*.

5 Open the Data Bindings window and click on the small black triangle again. This time, select Paste. This will copy and paste the recordset from *my_info.asp* to *modify.asp*. This way, you do not have to recreate it.

6 Create another recordset that accesses the *states* table, as you did in chapters 6 and 7. Name it *rsStates*. You can also copy and paste the recordset, as described previously, from pages that use it (e.g., *search.asp* and *add_new.asp*).

7 Insert a form on the page.

8 Insert the form elements outlined in table 8-2 on the page.

Table 8-2: Form Elements for the Update Page

Name on Web Page	HTML Label	Form Object Type
First Name	f_name	Text Field
Last Name	l_name	Text Field
Street Address	street_address	Text Field
City	city	Text Field
State	state	List/Menu (As in previous chapters for searching by state. Set the value equal to the *state* column found in *rsMyPage* in the Dynamic List server behavior.)
Zip Code	zip	Text Field
Phone Number	phone	Text Field
E-mail Address	email	Text Field
Home Page	homepage	Text Field
Update My Info	submit	Submit Button

9 As you did in Chapter 7, bind the information in the database to the form element. To do this, select a form element, click once on a database element in the Data Bindings window, and click on the Bind button at the bottom of the Data Bindings window.

10 Open the Server Behaviors window, click on the plus sign (+), and select Update Record Server Behavior. The Update Record window will then open (see figure 8-4).

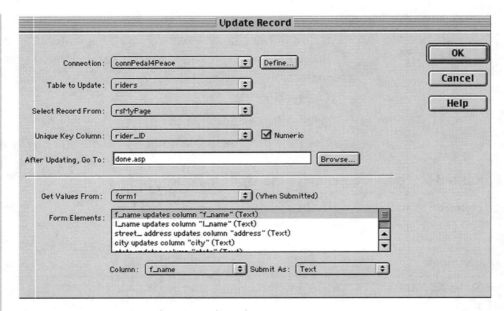

Fig. 8-4. Update Record window.

11 Select *connPedal4Peace* from the Connections drop-down menu.

12 Select *riders* from the Table to Update drop-down list.

13 Select *rsMyPage* from the Select Record From drop-down list.

14 Select *rider_ID* from the Unique Key Column drop-down list and make sure the Numeric check box is selected.

15 Enter *done.asp* in the *After Updating, Go To* text box.

16 Select *form1* from the Get Values From drop-down list.

17 As you did in Chapter 7, in the Form Elements section, make sure the Form Element selections match the columns in the database you want them to update.

18 Click on OK to close the Update Record window.

What you have now is a way for riders to maintain their personal contact information using a user log-in to validate the identity of the user. However, what happens if the user has

not yet been added to the list? The following section explores adding new users to the database.

■■ Adding a New User

Adding a new user to the database is very similar to inserting a new record, which was demonstrated in Chapter 7. The difference between what was done in Chapter 7 and adding a new user is the need to make sure that the user name selected is unique in the database. Much like the *rider_ID* database field discussed in Chapter 2, a user name needs to be unique to an individual rider. Theoretically, the *rider_ID* could be used. However, most people do not like to be referred to as number 48, nor would it be as easy to remember as a user name the new user selected for himself.

In addition, adding a new user is an excellent time to have the user select a password and thereby provide further security. It is the combination of a user name and a password that makes the user authentication functions in UltraDev work. As discussed previously, if the user name and password do not match the information stored in the database, the user is redirected to an error page, thereby restricting access to the user's information.

Exercise 8-3 modifies *add_new.asp*, created in Chapter 7, to incorporate user name and password fields and to check that the user name is unique. (There are additional advanced features that can be added to the user authentication, which are discussed later in the chapter.)

Exercise 8-3: Streamlining User Registration Verification

1 Open *add_new.asp*, which is in the *new_user* folder of your site.

2 Add the text box form elements outlined in table 8-3.

Table 8-3: Form Elements for the Add New User Page

Name on Web Page	HTML Label	Form Object Type
User Name	username	Text
Password	password	Text (with the password options selected as shown in figure 8-5)

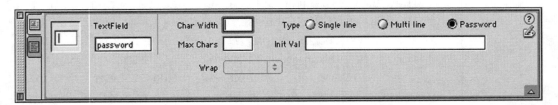

Fig. 8-5. Properties window for the Password text box.

3 Open the Server Behaviors window and double click on the Insert Record server behavior to open the Insert Record window (see figure 8-6). *Username* and *password* should now be in the Form Elements list in the Insert Record window.

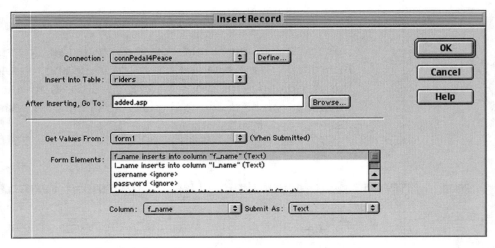

Fig. 8-6. Insert Record window.

4 Select *username* in the Form Elements portion of the Insert Record window, and select *username* from the Column drop-down list. Do the same for the password, selecting *password* from the Column drop-down list.

5 Click on the OK button to close the Insert Record window.

6 Click on the plus sign (+) in the Server Behaviors window and select Check New Username from the User Authentication menu (see figure 8-7). This will open the Check New Username window (see figure 8-8).

7 Select *username* from the Username Field drop-down list.

Fig. 8-7. User Authentication menu found in the Server Behaviors window.

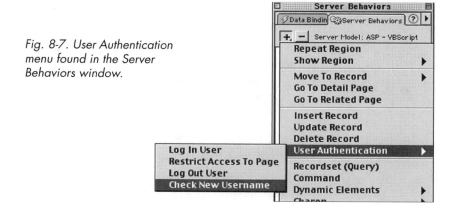

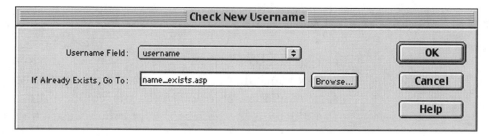

Fig. 8-8. Check New Username window.

8 Type *name_exists.asp* in the *If Already Exists, Go To* text box.

9 Click on OK to close the Check New Username window.

10 Close *add_new.asp*.

11 Right-click on Windows. Ctrl-click on Macintosh in *add_new.asp* in the Site Files window. Select Copy from the contextual menu that appears to copy *add_new.asp*.

12 Right-click on Windows. Ctrl-click on Macintosh in the *new_user* folder and select Paste from the contextual menu to paste a copy of *add_new.asp* into the folder.

13 Rename the file you just pasted as *name_exists.asp*.

Copying and pasting *add_new.asp* saves you from having to recreate the entire form, insert record behaviors, and check new user name behavior. Exercise 8-3 took a basic approach to new user registration. There are many ways to make this process more advanced. Some advanced ideas are addressed later in this chapter.

An additional feature available in UltraDev is the ability to restrict access to specific pages based on user name and password and/or on an access level. The following section examines the access restriction features of UltraDev.

■■ Restricting Access

Restricting access is an excellent way of providing limited access to specific pages. For example, perhaps only registered users should be able to access the contact information for other riders in the Pedal for Peace tour. Restricting access to *list_all.asp* and *rider_detail.asp* would be a simple way of stopping general web site visitors from viewing the rider's contact information.

Restricting is also a great way to give only administrators access to certain areas of a web site. For example, perhaps administrators handle registering user accounts, or changing announcements or calendar events. UltraDev helps make these tasks simple.

There are two basic types of user access restrictions. The first is based on user name and password. The second is based on user name, password, and access level. Both methods redirect users without the proper credentials to other pages. The difference is the use of restricting based on access levels.

User Name and Password

The user name and password restriction requires that users have logged in with a valid user name and password. For example, if someone found the Pedal for Peace web site and wanted to see the contact information for the riders, she would be redirected to a different page because she would not have a valid user name and password. Applying a user name and password restriction is relatively simple. Exercise 8-4 takes you through this process.

Exercise 8-4: Applying a User Name and Password Restriction

Assume that you do not want to give access to the list of riders to individuals that are not registered riders. This means that you need to apply a user name and password restriction to *list_all.asp* and *rider_detail.asp*.

1 Open *list_all.asp*.

2 Open the Server Behaviors window, click on the plus sign (+), and select Restrict Access To Page from the User Authentication menu (see figure 8-9). This will open the Restrict Access To Page window.

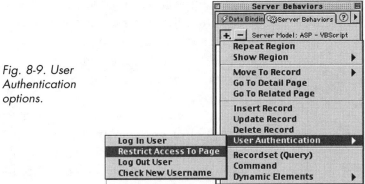

Fig. 8-9. User Authentication options.

3 By default, Restrict Based On is set to Username and Password. For this exercise, the default is fine.

4 Click on the Browse button located to the right of the *If Access Denied, Go To* text box and select *no_user.asp* from the *errors* directory (see figure 8-10).

5 Click on OK to close the window.

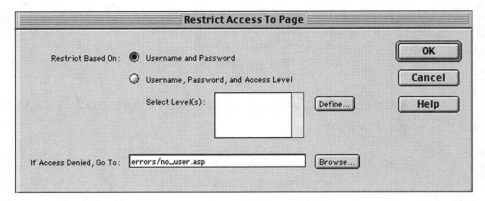

Fig. 8-10. Restrict Access To Page window.

You have just restricted access to the page. There are a couple of things to remember when restricting access to pages. First, the user name is stored in a session variable when someone

logs in successfully. This means that if a user has not logged in, he will not be able to view this page because there is no session variable holding his user name. Adding a link to the log-in page on the error page, or adding the user log-in behavior discussed earlier to the error page, can easily fix this.

Second, session variables time out after 20 minutes of inactivity. If a session variable times out, the user will not have access to the page. Knowing these things in advance will help when planning your site.

You can now set up a page that allows only registered users to see it. However, what if you wanted to have other pages that only certain registered users could see? Macromedia has thought of that, too.

Access-level Restrictions

In the last version of the database you loaded to your server, there were three fields included: *username*, *password*, and *access_level*. In the previous exercise, when a new user was added, the *username* and *password* fields were filled in. The *access_level* has not been dealt with until now. Access levels give additional flexibility to restricting access. There are many times you want to provide some individuals access to pages and features of a web site while restricting others.

The use of access levels allows a developer to assign multiple levels of trust to users. For example, perhaps users should be registering themselves in the Pedal for Peace site. The person that receives the registration form should do this. If that were the case, there would need to be a way to distinguish registered users from the person(s) that handle the registration forms. In exercise 8-5, you will create an access-level restriction for just this purpose.

Exercise 8-5: Creating an Access-level Restriction

In the previous exercise, it would be easy to give the individuals that handle the registration forms a different access level. If you look at the database, you will notice that all records have *access_level* set to Rider. Let's make a change to *add_new.asp* and start using access-level restrictions.

1 Open *add_new.asp* and add a drop-down list to the form. Name the list/menu element *access_level* in the Properties window (see figure 8-11).

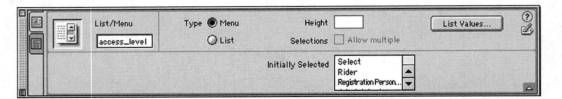

Fig. 8-11. Properties window for the access_level *list/menu.*

2 Click on the List Values button in the Properties window, enter the information shown in figure 8-12, and click on OK.

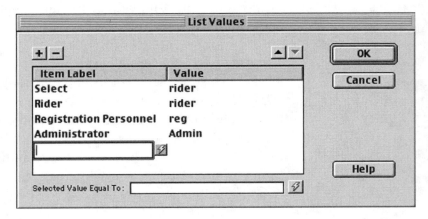

Fig. 8-12. List Values window.

3 Open the Server Behaviors window and double click on the Insert Record server behavior to open the Insert Record window. Look for *access_level* in the Form Elements box and set it to insert into the *access_level* column of the database. Click on OK to close the window.

4 Upload *add_new.asp* to your server and add a new user. Select Registration Personnel as the access level for this user.

5 Reopen *add_new.asp* and open the Server Behaviors window. Click on the plus sign (+) and select Restrict Access To Page from the User Authentication menu.

6 Click on the Define button in the Restrict Access To Page window to open the Define Access Levels window (see figure 8-13).

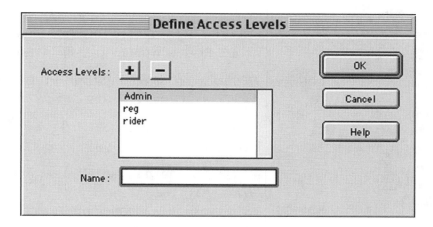

Fig. 8-13. Define Access Levels window.

7 Type *reg* in the Name text box and then click on the plus sign (+) beside Access Levels. This adds *reg* to the access choices. You may also want to add *Admin* and *rider* so that you can experiment with them on your own.

8 Click on the OK button to close the Define Access Levels window.

9 Select Username, Password, and Access Level in the Restrict Based On section of the Restrict Access To Page window (see figure 8-14).

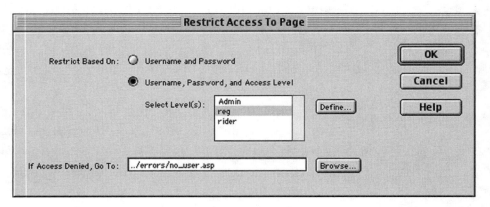

Fig. 8-14. Restrict Access To Page window using access-level restrictions.

10 Select *reg* in the Access Level(s) section of the Restrict Access To Page window (see figure 8-14).

 TIP: *you can select multiple access levels by holding down the Control (Ctrl) key and clicking.*

11 Select *no_user.asp* in the *If Access Denied, Go To* text box.

 NOTE: *For the purpose of these examples, any time access has been denied, the user is redirected to* no_user.asp. *It is common practice to have multiple error pages that would provide more detail to the user. For example, you could have a page named* no_admin.asp *for informing users they had administrative access to a specific page.*

12 Click on the OK button to close the Restrict Access To Page window.

13 Upload *add_new.asp* to the server and try to access the page through a browser without logging in. Add yourself as a new user and see the difference.

Using the Restrict Access to Page server behavior is a good way of securing your information on the Web. However, it is also important that you take measures to protect your users. As mentioned previously, session variables remain active on the server for 20 minutes by default. If a user has logged in and leaves the computer for a while, the session variable could still be functional. This would allow someone else to assume the user's identity and see anything the user had access to. The next section explores use of the Log Out User server behavior.

■■ Creating a Log-out Function

Providing users with a log-out function is a simple and useful thing to do. Many users will not bother to log out. However, for those concerned about their information, a user log-out function is necessary.

Applying the Log Out User server behavior is very straightforward and is something that could be added to a template or library. The Log Out User server behavior works by adding a link on a page. Exercise 8-6 walks you through the process of adding the Log Out User server behavior.

 ### *Exercise 8-6: Applying a Log Out User Server Behavior*

1 Open *done.asp* in the *login* folder.

2 Open the Server Behaviors window. Click on the plus sign (+) and select Log Out User from the User Authentication menu (see figure 8-15). This will open the Log Out User window.

Fig. 8-15. User
Authentication menu.

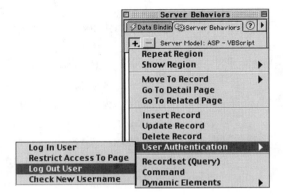

3 The Log Out When section will have Link Clicked
selected by default. This is fine (see figure 8-16). This
option will create a log-out link on the page. The Page
Loads option would log users out when the current page
loads. This option will log out a user without the need
for the user to click on anything. There are times when
this option is very handy.

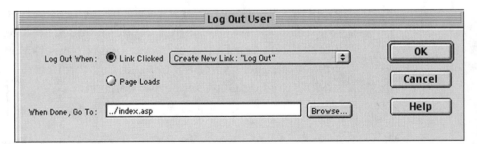

Fig. 8-16. Log Out User window.

4 Click on the Browse button next to the *When Done, Go
To* text box and select *index.asp*. This will take the user
back to the index page of your site after she has logged
out.

5 Click on the OK button to close the Log Out User win-
dow.

When the user clicks on the log-out link UltraDev created in the previous steps, any session variable created for that use will be deleted.

■■ Tips and Tricks

User authentication offers a number of interesting possibilities. This section offers a few tips and tricks that should help make any user authentications you create even better.

The new user registration page you created earlier in the chapter works fine. However, as noted, if a user name is not unique, the other information entered is lost. It is possible to pass the information the user entered to *name_exists.asp* and populate the fields on that page with the information. Passing variables in this situation will require you to edit some information in the code of the page, which is not difficult.

1 Open *add_new.asp* and open the Code View window.

2 In the code, find where the "redirect URL" is defined if the user name already exists. It is most likely between lines 35 and 50 of the code. The line you are looking for follows.

```
MM_dupKeyRedirect="name_exists.asp"
```

This is the variable UltraDev defines based on the page to go to if the user name already exists.

3 If you wanted to pass the first name and last name, you would need to edit the line of code to match the following line.

```
MM_dupKeyRedirect="name_exists.asp?f_name="&request.form("f_name")
  &"&l_name="&request.form("l_name")
```

Request.form("variable name") is how ASP would receive a variable sent from a form, as in the Insert Record behavior in *add_new.asp*. It is not a typo where you see *&"&*. The first ampersand (&) is a way of letting the server know that something new follows the current text. In this example, it tells the server to treat *&l_name* separately from *request.form ("l_name")*.

The second ampersand can be seen in the URL produced by this code. The ampersand is the way ASP separates variables in the URL. There is a lot of technicality in why these symbols are used, but the important thing to remember is that it is a basic formula and all you have to do is duplicate it.

4 Close *add_new.asp* and upload it to the server.

5 Open *name_exists.asp* and open the Data Bindings window.

6 Click on the plus sign (+) and select Request Variable from the menu. This will open the Request Variable window (see figure 8-17).

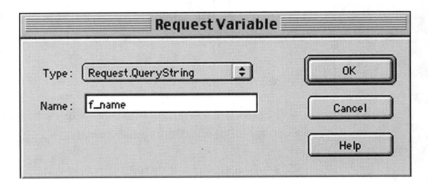

Fig. 8-17. Request Variable window.

7 Select *Request.QueryString* from the Type drop-down list and enter *f_name* in the Name text box.

8 Repeat step 7 for *l_name*.

9 Select the *f_name* form element on *name_exists.asp*, click once on *QueryString.f_name* in the Data Bindings window, and click on the Bind button in the Data Bindings window.

10 Repeat step 9 for *l_name*, selecting *QueryString.l_name*.

These steps will take the variables passed in the URL and place them in the form elements on *name_exists.asp*, thereby eliminating the need to retype them. The technique could be used for all form fields. However, you need to remember two things. First, the information is being passed through the URL, and therefore items such as a password would be easily readable. Second, when passing information through the URL, you are limited to 256 total characters. Passing a lot of information and many form fields may exceed this limit.

■■ Summary

User authentication is an incredibly useful tool. The ability to identify a user is very powerful. Additionally, verifying information about the user while the user is visiting the site allows developers to create personalized sites for each user.

In this chapter, you learned about session variables. Session variables are small amounts of information stored on the server for a specific period of time. There are three ways a session variable is removed from the server.

- ❐ The user logs out.
- ❐ After 20 minutes of inactivity, the session variable times out.
- ❐ The user exits or quits the browser.

You also learned how to create a user log-in page. This page is where you validated the user's identity based on a user name and password. If the user name and password entered by the user matches the information stored in the database, the user is authenticated.

You also created a way to add new users to the database. These pages checked to make sure the user name entered was unique from other user names in the database. If the user name was not unique, the server redirected the user to a page that prompted the user to select a new user name.

The other really powerful feature of user authentication is the ability to restrict access to specific pages based on either user name and password or user name, password, and access level. Restricting access allows developers to set up special sections of a web site reserved for registered users or administrators.

The more complex a site is, the more useful user authentication becomes. Learning to use session variables in creating recordsets, limiting page access, and redirecting users is a powerful tool. These features are expanded on in Chapter 10.

■■ Things to Think About

User authentication requires a lot of planning on the part of the developer. You may want to review Chapter 5, which deals with planning a dynamic site.

The key in using user authentication is to have one central place in your database (a user's table, for example) to store user information such as user names, passwords, and access levels. This data needs to be well controlled.

Users can be haphazard in following directions. As developer, you need to predict as many of the errors a user could make as possible. For example, users must have a user name and a password. If they do not, user authentication will not work. Chapter 10 offers suggestions for required fields and confirmation of data integrity before letting the user continue.

It is best to have a web-based user management tool that allows an administrator to make changes to user accounts. For example, it would be helpful for an administrator to be able to reset passwords and change access levels. This is nothing more than updating a record in the database, but it is important to restrict the access to these pages so that only administrators can view them.

CHAPTER 9

Extensions from Exchange

■■ Introduction

One of the things that have put Macromedia UltraDev ahead of all other web editors is extensibility. Extensibility in simple terms is the ability to add features and components to the application.

Macromedia and the development community create extensions. The best part is, many extensions are free. Macromedia maintains the Macromedia Exchange site (*http://www.macromedia.com/exchange*). At this site, you can download hundreds of extensions for UltraDev (see figure 9-1).

This chapter provides a little more detail about what an extension is and how it works. This chapter also offers some suggestions on extensions you will not want to do without, and explains how to install extensions.

Fig. 9-1. UltraDev Exchange page.

■■ Objectives

In this chapter, you will:

❏ Learn how to download and install an extension

❏ Identify some popular extensions

■■ The Origin of Extensions

Macromedia employs some very smart people. They realized that with every version of software, they were incorporating more and more features developers had requested. This kept developers happy and purchasing subsequent versions of the software. Of course, most people do not like to wait six months to a year for the next version, which will include some new features.

Macromedia made it possible to continually build on an existing application with extensions. The engineers at Macromedia, and many developers around the world, began creating small add-ins to replace repetitive tasks within the application.

The use of extensions means UltraDev is limited only by the imagination and creativity of the development community. Many of the original extensions created for the first version of UltraDev were incorporated into Version 4. At the time of this printing, there are more than 600 extensions listed for UltraDev on the Exchange web site.

New extensions are added almost daily. Macromedia lists the five most recently added extensions on the UltraDev Exchange page (see figure 9-1).

■■ Extension Functions

Extensions are amazing tools. There are extensions that will create Flash buttons, even if you do not have Macromedia Flash. There are extensions that will create photo albums, control pop-up windows, and insert the current date.

There are some extensions that are specifically for one server model, platform, or browser. However, many will work with ASP, JSP, and ColdFusion, on a Macintosh or Windows computer.

The most difficult part of using extensions is figuring out which extensions you want to use. The following provides a short list of "must have" extensions, with brief descriptions of what each extension does. This is by no means an exhaustive list, and you are encouraged to spend time perusing the extensions.

Each extension can be easily downloaded from the Exchange site. Extensions are identifiable as *.mxp* files.

■■ What Are the "Must Have" Extensions?

The following are extensions you should seriously consider acquiring. The sections that follow describe these extensions and their functions.

Advance Open Window Behavior

This extension is a great time saver if you ever have to open browser windows. The extension works with Microsoft Internet Explorer and Netscape. It allows you to set attributes such as where the window will open (e.g., in the center of the screen). This extension is found in the Behaviors window, not

to be confused with the Server Behaviors window. The Behaviors window, opened from the Windows menu, is where JavaScript behaviors are accessed.

Calendar Object

If you ever need to create a table to represent a month, this extension will save you tons of time. You select the month, year, and formatting options, click on OK, and the calendar appears in seconds. This extension is accessed from the Insert menu or from the Goodies window on the Objects panel.

Components Checker

If you do not administer your own server, this extension is a lifesaver. You can include this extension on a page and upload it to a Windows NT/2000 web server. When you request the page with your browser, the extension will check to see if a variety of components are installed on the server (such as ASPMail, SA-Fileup, CDONTS, JMail, and so on). This can be a huge help when server administrators are not forthcoming about the components available on a server. This extension is accessible from the ASP panel in the Objects window.

Download Repeat Region

This extension makes it easy to provide users with customized data for use in such tools as spreadsheets. You might, for example, use this extension to allow users to download a variety of economic data. The extension is accessible from the Server Behaviors window.

Horizontal Looper 2

Allows you to specify the number of rows and columns you want to repeat from a recordset. This is a great extension if

you have on-line catalogs and need to display products. This extension can be accessed from the Server Behaviors window.

Meta Generator

The next time you need to add a bunch of metatags to a page, try this extension. Meta Generator lets you add nearly forty metatags through a simple interface. This extension can be accessed from the Head panel in the Objects window.

Pure ASP Upload 2.0

This extension let's user upload files to the server. It is possible to include an Insert Record server behavior with the upload, which means that you can organize files and database information. In addition, this version allows the developer to rename the file and to restrict file size and the types of files uploaded. The extension can be purchased at *http://www.udzone.com*. This extension is accessed from the Server Behaviors window.

Random Record

This extension pulls a random record from a recordset whenever the page is loaded. This is a great way of delivering headlines or products. This extension can be accessed from the Server Behaviors window.

Super Close Window

If you get tired of hand coding the JavaScript to close a window, or do not know how to make a window close, this extension is for you. Not only will it write the JavaScript necessary to close a browser window, it also allows you to choose the text, image, or button to be used as the link. This extension can be accessed from the Special panel of the Objects window.

UltraSuite 4000

This extension can be purchased at *http://www.Ultra-Suite.com*. This extension contains 130 server behaviors that can save your hours of work. The extension is accessible from the Server Behaviors window.

■■ Installing Extensions

Macromedia has provided a simple way of installing and managing extensions. The Macromedia Extension Manager is included with UltraDev 4.0 (see figures 9-2 and 9-3). It can also be downloaded from the Macromedia web site.

Fig. 9-2. Macromedia Extension Manager for Macintosh.

To install an extension, perform the following steps.

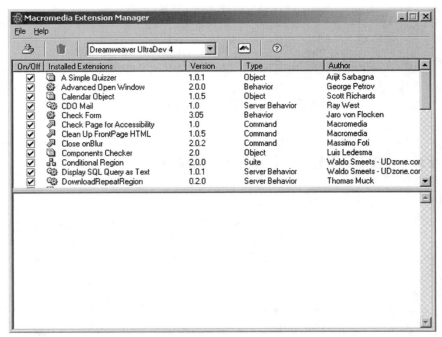

Fig. 9-3. Macromedia Extension Manager for Windows.

1 Open the Macromedia Extension Manager.

Fig. 9-4. File menu for the Extension Manager.

2 Select Install Extensions from the File menu (see figure 9-4).

3 In the Select Extension to Install window, select the extension you want to install.

4 Click on the Install button and follow the on-screen instructions.

The next time you open UltraDev, the extension will be available. To learn more about an extension you have installed, click on it once in the Extension Manager window. A short description of the extension will appear in the lower portion of the Extension Manager window.

■■ Tips and Tricks

Extensions are resources used by UltraDev. This means that as you install more and more extensions you are placing more requirements on your computer. You may want to occasionally clean up your extensions.

In the Extension Manager window, you can select an extension by clicking on it once and selecting Remove Extension from the File menu. It is very easy to accumulate many extensions. You may download and install some extensions and then never really have a use for them. A rule of thumb is, if you have not used an extension in about a month, remove it.

However, do not delete the *.mxp* file for the extension. Make it a habit to archive these files. You never know when you may need an extension you have deleted. Most *.mxp* files are rather small, so archiving them to a disk or CD-ROM does not require much storage space.

As you start using extensions other people have developed, you will quickly start thinking about other extensions you would like to have. You can build your own extensions. Teaching you how to build your own extensions is beyond the scope of this text. However, *Building Dreamweaver 4 and Dreamweaver UltraDev 4 Extensions* by Muck and West is a good reference on this topic (see "Resources" at the end of this chapter).

■■ Summary

Extensions make your life easier. Macromedia has enabled developers to continually improve on its already wonderful application by creating extensions.

This chapter provided a brief overview of what extensions are and where you can get them. In addition, the chapter summarized "must have" extensions. These extensions are those you might well find yourself using on a frequent basis.

There are hundreds of extensions available on the Macromedia Exchange site and other sites around the Web. Some will be extremely useful, whereas others may not be of much help. The trick is to know what is available.

■■ Things to Think About

Extensions are helpful tools that make UltraDev even more powerful. However, remember that developers in the UltraDev community create most extensions. Read the fine print for each extension carefully. There are some extensions that will only work with certain browsers or servers. Other extensions will only work on specific development platforms. Before you download the extension, make sure you understand what you are downloading and what the requirements are for the extension.

■■ Resources

Muck, Tom, and Ray West, *Building Dreamweaver 4 and Dreamweaver UltraDev 4 Extensions*. New York: McGraw-Hill Professional Publishing, 2001, ISBN 0072191562.

CHAPTER *10*

Advanced Applications

■■ Introduction

The intent of this book has been to help you learn the basics of UltraDev. With a few exceptions, the exercises have let UltraDev do the work and allowed you to take advantage of a visual development environment.

The basic features in UltraDev will produce amazing results, but with a little creative coding you can get even more out of UltraDev. This chapter is devoted to showing you some of the more advanced things you can do with UltraDev. Many of the examples in this chapter are taken from work done for the Agricultural Economics department at Purdue University. Each example includes a description of what is being done with the code, sample code, and figures that illustrate results. These examples are for demonstration purposes. The databases used are not included with this book. Feel free to add new tables to *Pedal4Peace.mdb* to experiment with the information demonstrated in this chapter.

■■ Objectives

In this chapter you will:

- ❏ Learn how hidden fields can help you
- ❏ Learn how to use page redirection
- ❏ Learn alternative methods of form validation
- ❏ See examples of dynamic e-mail generation
- ❏ Learn how to make more advanced SQL queries

■■ Hidden Fields

Hidden fields are HTML form elements present in code. The user does not see these elements unless she views the source of a web page in a browser. Hidden fields are extremely useful when users are entering information into a database. The sections that follow present examples of how hidden fields can help keep your data manageable.

Date and Time of Record Entry

There are many cases in which knowing when a record was submitted to a database is important. Using some simple code, you can get the current date and time on the server and insert it into the database using a hidden field. For example, students might be asked to submit assignments or information on-line by a specific date and time. Using the previously mentioned code, you could see when the student submitted the information.

In Chapter 3, you saw how to get the current date and time on the server in ASP, JSP, and ColdFusion. In exercise 10-1, you will insert the current date and time into a database using ASP.

Exercise 10-1: Using ASP to Insert Date and Time Information into a Database

1 Insert a hidden field named *the_date* into an HTML form by clicking on the Hidden Field icon in the Forms panel of the Objects window (see figure 10-1), or by selecting Hidden Field from the Form Objects option in the Insert menu (see figure 10-2).

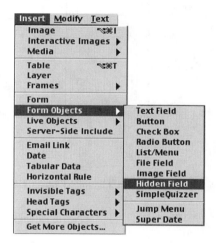

Fig. 10-1. Forms panel of the Objects window.

Fig. 10-2. Form Objects submenu of the Insert menu.

2 Select the hidden field *the_date* by clicking on it once. Enter < % = Now() % > in the Value text box of the Properties window (see figure 10-3).

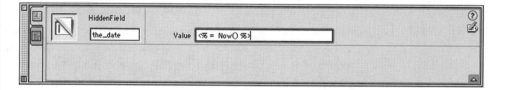

Fig. 10-3. Properties window for a hidden field.

3 Create an Insert Record behavior from the Server Behaviors window.

4 In the Insert Record window, the hidden field *the_date* will appear in the Form Elements box, just like any other form field. Select the column in the database you want *the_date* to be inserted into (see figure 10-4).

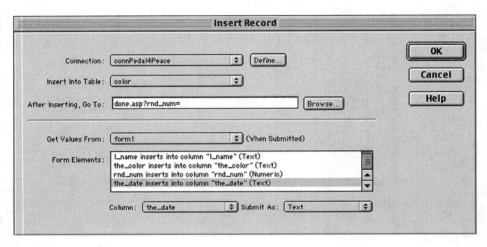

Fig. 10-4. Insert Record window.

5 Click on the OK button.

This is a pretty simple trick that can be rather helpful. However, there are a couple of things you need to know about it. First, the database field you insert this information into can be a number of different data types. If you will need to sort the information based on the date, you will most likely want to use a date data type in your database. If you are only using the date for your own information, you can use any data type that will accept alphanumeric data, such as text, memo, and varchar.

Another thing to note is that the date you are inserting is actually the date and time the web page was requested from the server, and the actual date and time the page was submitted. You incorporate the same idea within the Insert command to get the date and time of the insert, but this method is a bit easier and still gives very good results.

You can also use this method with an Update Record command. This is a nice way of establishing when a record was last updated.

Tracking Who Has Added a Record

Hidden fields can also be a nice way of tracking user activity. For example, Agricultural Economics has an on-line calendar of events that a number of people maintain. Whenever an event is added, a hidden field is included in the HTML form that holds the user name of the person adding the event. The user name is pulled from the *MM_Username* session variable that is set when the user logs in. Adding a session variable as the value of a hidden field is rather easy as well. Exercise 10-2 takes you through this process.

Exercise 10-2: Binding a Session Variable to a Hidden Field

There are a couple of methods for binding a session variable to a hidden field. The first is to hand code the session variable into the Value text box of the field, as you did previously with the date. The second method uses UltraDev's visual interface to bind the session variable to the hidden field. Both methods accomplish the same result. The difference is the amount of time it takes to do it. If you are new to all of this, the second method may be easier. However, as you become more experienced with UltraDev, hand coding things such as this is much faster.

Hand Coding Method

1 Insert a hidden field named *username* into an HTML form.

2 Select the *username* hidden field and type < % = Session ("MM_Username") % > into the Value text box in the Properties window (see figure 10-5).

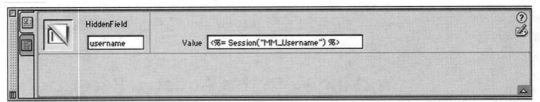

Fig. 10-5. Properties window for the hidden field.

3 The hidden field will appear in the Form Elements box in the Insert Record window, as shown in figure 10-4.

UltraDev-executed Method

1 Open the Data Bindings window, click on the plus sign (+), and select Session Variable from the drop-down list (see figure 10-6).

2 The Session Variable window will open. Type *MM_Username* in the Name text box (see figure 10-7).

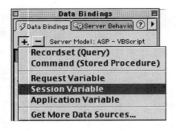

Fig. 10-6. Data Bindings menu.

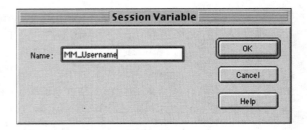

Fig. 10-7. Session Variable window.

3 Click on the OK button to close the window.

4 Insert a hidden field named *username* into an HTML form.

5 Select the *username* hidden field, click once on the *MM_Username* session variable listed in the Data Bindings window (see figure 10-8), and click on the Bind button at the bottom of the Data Bindings window.

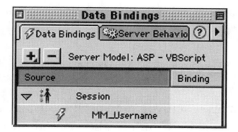

Fig. 10-8. Data Bindings window with a session variable.

6 Figure 10-9 shows the Properties window for the *username* hidden field using this method. As you can see, it is the same as in figure 10-5.

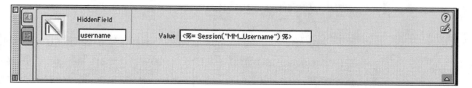

Fig. 10-9. Properties window for the hidden field.

As mentioned, as you become more comfortable using UltraDev, hand coding information (as in this example) will be second nature. However, using UltraDev for these types of tasks in the beginning helps you learn the proper coding syntax.

 WARNING: *It is important to note that hidden fields can be seen and potentially accessed by the user. Therefore, if the information you are including in the hidden field is sensitive, such as access levels, you may not want to use this method. It is possible for a devious user to alter the value of a hidden field and insert it into your database.*

▪▪ Using If/Then

Using *If/Then* logic can do a number of things on a web page. This section will look at some basic uses of the *If/Then*

statement that have hundreds of potential applications in web sites.

Hide/Show Based on Value

There are many times when you may need to display a different graphic, link, or piece of information based on information found in a record in the database. For example, in a multiple-step process, you want the user to complete step 1, then step 2, and so on. You do not want the user to go back to step 1 after completing step 4.

There are many ways to accomplish a task such as this. The one demonstrated in the following can be used in many different situations. This particular example was used in a sales and marketing class at Purdue University. The students were required to complete progress reports about an assignment.

As with any user, we could not rely on perfect student adherence to directions. Therefore, we needed to limit the report they could access based on what they had previously completed. The only report they could access at the beginning was Report A. After they completed Report A, a link to Report B appeared in the list and a check mark appeared next to Report A to show them it was completed. In addition, the link to Report A was removed. Figures 10-10 through 10-12 show the progression of this idea from the first report through completion of the second report.

Reports

Complete Report A

Fig. 10-10. Before completing Report A.

Reports

Report A ✔
Complete Report B

Fig. 10-11. After completing Report A.

Reports

Report A ✔
Report B ✔

Fig. 10-12. After completing Report B.

This is a simple way of guiding the user through specific steps. The setup for this is quite simple. Each student record in the database has two extra fields: *report_a* and *report_b*. When the student completes Report A, he is essentially updating his record in the database. The field *report_a* is updated to Yes. This is also true for Report B. The *If/Then* statements used, numbered for reference, follow.

```
1) <% if (rsSWAS.Fields.Item("report_a").Value)="Yes" then%>
2) Report A <img src="../images/admin/check.gif">
3) <% if (rsSWAS.Fields.Item("report_b").Value)="Yes" then %>
4) Report B <img src="../images/admin/check.gif">
5) <% else %>
6) <a href="SWAS/reports/report_B.asp">Complete Report B</a>
7) <% end if %>
8) <% else %>
9) <a href="SWAS/reports/report_A.asp">Complete Report A</a>
10) <% end if %>
```

The statements in this example do not use any programming shortcuts. There are many ways to make this code more efficient, but for the purposes of this example the code has been left in its simplest form.

Line 1 checks to see if the value of the *report_a* field is equal to Yes. If *report_a* does not equal Yes, line 9 is used, which displays the link to complete Report A. If *report_a* equals Yes, another *If/Then* statement is executed to see if *report_b* equals Yes. If *report_b* does not equal Yes, line 6 is executed. If *report_b* equals Yes, line 4 is executed.

If/Then statements consist of four basic parts: the comparison, what to do if the answer is true, what to do if the answer is false, and an end statement. This example incorporates a nested *If/Then* statement.

Line 1 is the comparison. Lines 2 through 7 are what to do if *report_a* equals Yes. Lines 8 and 9 are what to do if *report_a* does not equal Yes, and line 10 is the end statement. Lines 2

through 7 represent an *If/Then* statement that is executed if *report_a = Yes*.

 NOTE: *In most cases,* If/Then *statements are case sensitive. This means that yes does not equal Yes. It is best to be consistent with these types of comparisons; for example, always using Yes and No.*

Multiple Comparisons

There will be times when you will want to see if two or more conditions are met. For example, perhaps reports cannot be completed until after the instructor records test grades. For this example, assume that there are also two database fields, named *paper1* and *paper2*. The instructor requires that the students have completed both papers prior to completing Report B.

You could replace line 6 with the following lines of code to accomplish this task. The new version would look like the following.

```
6a) <% if (rsSWAS.Fields.Item("paper1").Value)="Yes" and
    (rsSWAS.Fields.Item("paper2").Value)="Yes" Then%>
6b) <a href="SWAS/reports/report_B.asp">Complete Report B</a>
6c) <% end if %>
```

At times you will need to display something if one or more conditions are met. For example, what if the instructor required that either *paper1* be complete or that *proj2* had a score of 90 or higher in order to complete Report B. The previous line 6a would be the only one needing to be changed, as follows.

```
6a) <% if (rsSWAS.Fields.Item("paper1").Value)="Yes" or (rsSWAS.
    Fields.Item("proj2").Value)>="90" Then%>
```

The use of the words *and* and/or *or* can allow for very intricate *If/Then* statements. However, be warned: *If/Then* state-

ments do have a drawback. Every time an *If/Then* statement is executed, the server must make a decision. The more *If/Then* statements you add to a web page, the more time the server will need to process the request.

■■ Redirecting a User

The ability to redirect a user to a specific page based on some criterion is very useful. Most redirections will use a simple *If/Then* statement to decide which page to redirect the user to.

The following example examines the use of a redirect in a log-in situation. Agricultural Economics uses a departmental portal. Everyone logs in on the same page and then based on access level the user is redirected to the appropriate directory.

In the following, in the User Login server behavior, all successful log-ins are set to go to one page. The code follows.

```
<%
If Session("MM_UserAuthorization") = "Staff" Then
Response.Redirect("staff/")
Elseif Session("MM_UserAuthorization") = "Grad"
Then
Response.Redirect("grad/")
Elseif Session("MM_UserAuthorization") = "Student"
Then
Response.Redirect("student/")
End If
%>
```

In the log-in process, UltraDev creates a session variable named *MM_UserAuthorization*. This session variable holds the value found in the database field *access_level*. This code simply looks at the value of *MM_UserAuthorization* and redirects the user to the appropriate directory. This happens in a fraction of a second, and the user never even sees this page

load because it is all executed on the server and nothing is sent to the user.

This code introduces two new tools for you to use. The first thing you will notice is the use of *Response.Redirect*. This is an ASP code that sends the user to the page or directory found between the parentheses.

This sample of code also uses the *Elseif* command. *Elseif* allows you to link a number of *If/Then* statements. For example, if you did not use the *Elseif* command in the previous code, it would look as follows.

```
<%
If Session("MM_UserAuthorization") = "Staff" Then
Response.Redirect("staff/")
End If
%>
<%
If Session("MM_UserAuthorization") = "Grad" Then
Response.Redirect("grad/")
End If
%>
<%
If Session("MM_UserAuthorization") = "Student"
Then
Response.Redirect("student/")
End If
%>
```

The three separate *If/Then* statements would work, but they are not as efficient as using *Elseif*. With fewer lines of code, you are less likely to make a mistake, which means less debugging and more time saved.

There are some extensions you can download from the Macromedia Exchange site (*http://www.macomedia.com/exchange/ultradev*) that automate the redirection process. The greatest benefit of the available extensions is that the developers have thought of all of the various reasons for redirection (and

incorporated options supporting these) so that you do not have to. For example, you can redirect to a different page if a recordset is empty or if a session variable does or does not exist. Looking at the options the developers have included may get you thinking of new ways to use redirection in your sites.

■■ Retrieving a Record

There are times you want to retrieve and use the information a user has just entered into a database. The first thing that might come to mind is to create a recordset and sort it in descending order by ID. This would yield the last record inserted into the database.

However, if the site is used frequently, it is possible that someone might submit a record a fraction of a second after you. That person's record would be the last record inserted into the database, not yours. Exercise 10-3 incorporates a trick that can help you retrieve the record a user has just entered into the database. The example is very simple, but very useful.

 Exercise 10-3: Retrieving a Record

Assume you have a page that asks the user to enter her name and select her favorite color from a list of colors provided on the web page. You want a thank-you page to appear after she has submitted the information. This page should include a personalized thank-you and a comment about the color.

1 Create an ASP page with an HTML form containing the form elements outlined in table 10-1.

Table 10-1: HTML Form Elements

Web Page Name	HTML Label	Form Object Type
First Name	f_name	Text Box
Last Name	l_name	Text Box
Favorite Color	the_color	List/Menu
rnd_num	rnd_num	Hidden Field
Submit	Submit	Submit Button

2 Open the Code view of the page and enter the following text at the top of the page.

```
<% Dim RndmNum
Randomize
RndmNum = Rnd
%>
```

This code generates a random number. You will use this number to retrieve the record after it is submitted. This step introduces some new terms. *Dim* is where the variable *RndmNum* is being defined. Computers use a long and complicated formula to pick a random number. The formula needs a number to start with. *Randomize* pulls the number from the computer's clock, thereby always starting with different numbers. *Rnd* is the ASP command for random number.

3 Close the Code view.

4 Set the hidden field *rnd_num* equal to *RndmNum* (see figure 10-13).

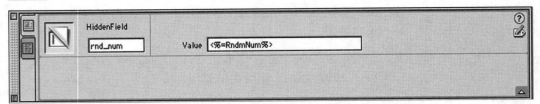

Fig. 10-13. Property window for the rnd_num *hidden field.*

5 Add an Insert Record behavior to the page. Enter *done.asp* in the *After Inserting, Go To* text box.

6 Pass the value of *rnd_num* to *done.asp*. Open the Code view and edit the redirect link as follows.

```
MM_editRedirectUrl ="done.asp?rnd_num="&request.form
    ("rnd_num")
```

This will pass the value of *rnd_num* to *done.asp* in the URL.

7 *Done.asp* would contain a recordset that filters records on *rnd_num* equal to a URL parameter named *rnd_num*. The recordset is sorted by ID in descending order (see figure 10-14). This ensures that if there were two *rnd_num* hidden fields that were equal, it would take the most recent one. Although it is theoretically possible to have identical *rnd_num* hidden fields generated at or near the same time, it is practically impossible.

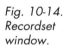

Fig. 10-14. Recordset window.

■■ Form Validation

If you learn one thing from this book, it should be that users cannot be trusted to follow directions. This becomes very troublesome when trying to gather and maintain data from users. If they do not provide the proper information, the database begins to fall apart.

Form validation is a topic of much discussion on a lot of the UltraDev news groups and list servs. Macromedia has included a JavaScript behavior (found in the Behaviors window) that will perform limited form validation. However, this behavior has left many developers needing more.

Exercise 10-4 walks you though a simple, yet effective, way of getting the information you want from users. Although most users do not follow directions very well, if you can catch their mistakes and point them out, users will typically correct the oversight.

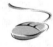

Exercise 10-4: Incorporating Form Validation

Assume that the previous color example is very important and you must have the user's name to properly identify him. You need to add only a bit of code to make this possible.

1 Copy and paste the ASP page that is used to insert the record. Name the new file *no_name.asp*.

2 Open *done.asp* and go to the Code view. Immediately before the *< HTML >*, place the following *If/Then* statement. This example assumes a recordset named *rsThanks*.

```
<% if (rsThanks.Fields.Item("f_name").Value) = "" or if
   (rsThanks.Fields.Item("l_name").Value) = "" then

Response.Redirect("no_name.asp?ID="&(rsThanks.Fields.Item
   ("ID").Value))

end if %>
```

This will check the value of *f_name* and *l_name*. If either are empty, the user will be redirected to *no_name.asp*.

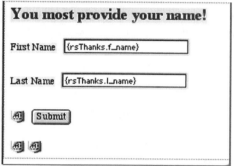

Fig. 10-15. The no_name.asp *file.*

3 Open *no_name.asp* and delete the code that generates the random number and the *the_color* list/menu.

4 Type, in large red letters at the top of the page, *You must provide your name*.

5 Open the Server Behaviors window and remove the Insert Record behavior.

6 Create a recordset that filters records on ID equal to the URL parameter ID.

7 Bind *f_name* from the recordset to the *f_name* form field. Do the same for *l_name* and *rnd_num* (see figure 10-15).

8 Add an Update Record behavior to the page that will update *f_name* and *l_name* in the database.

9 Have the page go to *done.asp* after the update.

10 You will need to edit the redirect URL in the code for the Update Record behavior. Set it to the following.

```
MM_editRedirectUrl ="done.asp?rnd_num="&request.form
    ("rnd_num")
```

Although this may seem like a lot of steps, you will become very proficient at it with some practice. There are other ways to validate form data, but this is an efficient and simple method.

■■ Generating e-mail

Using redirects and other server-side scripts is a great way to do a lot of things automatically. One of the most common

things done behind the scenes is generating an e-mail to a user or administrator based on something the user has done.

How an e-mail is generated depends on the server platform the web site is hosted on. In addition, the server will most likely need to have some sort of component or add-on installed.

A very common way of generating e-mail from a server is to use CDO Mail with ASP pages. CDO stands for Collaborative Data Objects. CDO Mail is part of the Windows NT/2000 SMTP (Simple Mail Transfer Protocol) service. There are similar packages that can be used with JSP and ColdFusion. However, if these pages are run on a Windows NT/2000 server, CDO Mail will work as well.

There are many extensions available that will handle writing the CDO Mail code. UltraSuite 4000, which can be purchased at *http://www.ultraSuite.com*, has a great set of CDO server behaviors. Generating dynamic e-mails can serve a number purposes on a web site. The most common use is to provide a feedback page in which users can send comments and questions.

However, there are many other reasons to use dynamically generated e-mails. For instance, it has become quite common to send a new user a welcome, directions, and a user name when the user registers. Much like a form letter can be personalized, e-mails can use information from HTML forms and/or a database to personalize them. Many developers have for some time been using this process to send out electronic announcements and newsletters.

If you have ever administered a list serv, you know the headaches it brings. Generating dynamic e-mails simplifies this process. There is no longer a need to maintain distribution lists in an e-mail client such as Microsoft Outlook Express or Netscape Messenger, or to administer list servs.

All you need is a database of the e-mail address for the people you want to contact. Using a tool such as CDO Mail, you can easily generate an e-mail to a person in the database. The trick comes in when you want to send a message to all people in the database.

If you wanted to list all records in a database, you would use a Repeat Region server behavior to list all of the records. You can do the same thing to generate an e-mail to each person.

A repeat region does not have to be within the *< body >* section of a web page. You can add a repeat region anywhere on a page and the server will process it. The following includes the code for a page that does just that. This page is used in a class of about 450 students. Each student has a record in the database that includes his or her name and e-mail address. The instructor accesses a page with a simple HTML form (see figure 10-16). The instructor provides a subject and a message and clicks on the Send Mail button. The form is posted to another page named *process_mail.asp*.

Fig. 10-16. Form used for a bulk e-mail.

This option will allow you to send an e-mail to all the students that are listed in your gradebook. Complete the fields below and click the Send Mail button.

Subject:

Message:

Send Mail

Process_mail.asp creates a recordset for all students in the class. There is a CDO Mail behavior on the page that is set inside a repeat region. The same message is sent to every student in the class. The following is the code from *process_mail.asp*. The code does not include the steps for selecting the recordset, only the code needed to send the e-mails.

```
1) <%
2) Dim Repeat1__numRows
3) Repeat1__numRows = -1
4) Dim Repeat1__index
5) Repeat1__index = 0
6) rsStudents_numRows = rsStudents_numRows + Repeat1__numRows
7) %>
8) <% if (cStr(Request("Submit")) <> "") Then%>
9) <%
10) While ((Repeat1__numRows <> 0) AND (NOT rsStudents.EOF))
11) %>
12) <%
13) Dim objCDO
14) Set objCDO = Server.CreateObject("CDONTS.NewMail")
15) objCDO.From = "yourprof@agecon.purdue.edu"
16) objCDO.To = (rsStudents.Fields.Item("email").Value)
17) objCDO.CC = ""
18) objCDO.Subject = request.form("subject")
19) objCDO.Body = request.form("body")&chr(13)&chr(13)&"Your Prof"
20) objCDO.Send()
21) Set objCDO = Nothing
22) %>
23) <%
24) Repeat1__index=Repeat1__index+1
25) Repeat1__numRows=Repeat1__numRows-1
26) rsStudents.MoveNext()
27) Wend
28) %>
29) <%
30) Response.Redirect("../index.asp")
31) End If
32) %>
```

Although this code may look a little intimidating, rest assured, UltraDev did 90% of the work. If you break the code into two pieces, it may make a lot more sense. There is

a section that handles the repeat region and a section that handles sending the mail.

Lines 8 and 12 through 22 are responsible for generating an e-mail using the CDO Mail behavior. Line 8 simply checks to make sure something was submitted from the form. The rest of the lines were created from a CDO Mail behavior that is basically "fill in the blanks." Figure 10-17 shows a common look for CDO behaviors. In each black the developer can type a literal, such as *"yourprof@agecon.purdue"*, or a variable name, such as *request.form("body")*. Literals must be enclosed in double quotes, whereas variables do not need quotes.

Fig. 10-17. Simple CDO Mail behavior.

It is also possible to include multiple pieces of information on a given line, as seen in line 19. Of course there is always a catch. In line 19, you will notice *chr(13)* a couple of times. This is an ASCII code for a carriage return. ASCII stands for American Standard Code for Information Interchange. ASCII is needed in situations such as these because a carriage return would not transfer from the code to the e-mail.

Lines 1 through 7, 9 through 11, and 23 through 27 handle the repeat region. The shortcut for creating these lines is to insert a repeat region on the page, and then cut and paste the lines of code around the CDO Mail code. All of this code occurs

before the < *HTML* > tag on the web page. Because there is a *response.redirect* command in line 30, the HTML for this page would only be displayed if there were an error or if there were no submit. This means you can place a simple error message in the < *body* > portion of this page that gives some direction in the event of an error.

It is easy to take this process to another level by filtering recordsets. For example, a person may have a database of contacts but only certain contacts want to receive a newsletter. As long as there is a newsletter field in the database this would be very easy. On *process_mail.asp*, "filter the recordset for newsletter" equals Yes. This would send the e-mail only to users that had requested a newsletter. The possibilities are endless.

■■ SQL Queries

Learning more about SQL is probably one of the best things you could do to further your abilities with UltraDev. SQL is extremely powerful, and relatively easy to learn.

Fig. 10-18.
Recordset window.

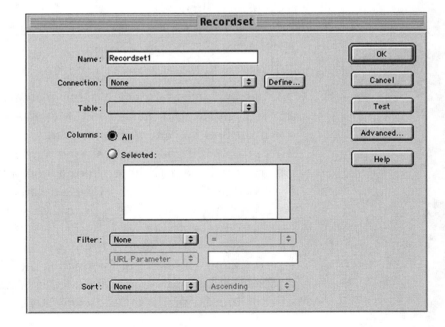

UltraDev has incorporated a number of features that help the developer quickly code advanced SQL queries. In previous chapters, the queries used to create recordsets have been based on one variable using the simple UltraDev Recordset window. However, there is an Advanced button in the Record-set window that allows for much more complex queries (see figure 10-18).

When you click on the Advanced button, a different type of recordset window appears: the Advanced Recordset window (see figure 10-19). This window allows a developer to type SQL directly into the SQL window. This is where you can expand the queries you have done in the past to be more complex.

Fig. 10-19. Advanced Recordset window.

Exercise 10-5: Using SQL

You know how to search for riders in Pedal for Peace that lived in a specific state. However, what if you wanted to see only riders in that state that had raised over $300 in donations? This would be virtually impossible to do with the simple Recordset window. A developer could do this with a simple recordset, but it would require a lot of *If/ Then* logic within the repeat region. In the Advanced Recordset window, it is very possible and would require no *If/Then* logic, thereby requiring less server resources.

1 Create a new folder, named *new_search*, in the Site Files window.

2 Create two new pages, named *search.asp* and *results.asp*, in the *new_search* folder.

3 Open *search.asp* and insert a form set to go to *results.asp* using the *Post* method.

4 Because state will be a search criterion, create a list/ menu containing all states, as you did in Chapter 6.

5 Insert a Submit button.

6 Close *search.asp*.

7 Open *results.asp* and open the Data Bindings window.

8 Click on the plus sign (+) and select *Recordset (Query)* from the menu. When the Recordset window appears (see figure 10-18), click on the Advanced button to open the Advanced Recordset window (see figure 10-19).

9 Name the recordset *rsStateResults*.

10 Select the *connPedal4Peace* connection from the Connection drop-down list.

11 Click on the plus sign (+) to the right of the word *Variables*, to create an empty line in the Variables text area. This is the area for defining the variables needed in the

SQL statement. You can use the following format when naming variables: *varVariableName*.

12 Type *varState* in the *name* column and press the Tab key (see figure 10-20).

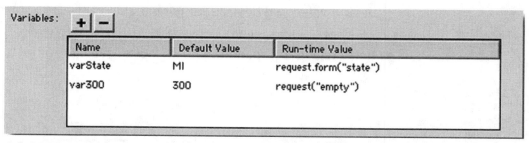

Fig. 10-20. Variables region of the Advanced Recordset window.

13 The Default Value area serves two purposes. This value is used for a dynamic value when testing the recordset. Thus, you can put any state abbreviation in this column. This value is also used as the variable value if the variable is not dynamic, as you will see in material to follow. MI was chosen here as the state because it was known that there were riders that had raised more than $300 from MI, which made testing easy. Press the Tab key to move to the next column.

14 Type *request.form("state")* in the Run-time Value column (see figure 10-20). *Request.form* is used in this situation because the *state* variable is being sent from a form using the *Post* method. If the *Get* method were used, the Run-time Value would be *request.query-string("state")*.

15 Click on the plus sign (+) next to Variables again to add another empty variable line.

16 Type *var300* in the *name* column and press the Tab key to move to the Default Value column (see figure 10-20).

17 Type *300* in the Default Value column and press the Tab key to move to the Run-time Value column (see figure 10-20).

18 Type *request("empty")* in the Run-time Value column (see figure 10-20). An empty request means that the default value will be used for the variable value.

19 Click on the triangle to the left of Tables in the Database Items region to expand the list of tables (see figure 10-21).

Fig. 10-21. Database Items region of the Advanced Recordset window.

20 Click once on the *riders* table to select it.

21 Click on the Select button to the right of the Database Items region. You will notice that the following text will appear in the SQL region (see figure 10-22).

```
SELECT *
FROM riders
```

Fig. 10-22. SQL region of the Advanced Recordset window.

22 Click on the triangle to the left of the *riders* table to expand the list of database fields.

23 Click once on the State field to select it.

24 Click on the Where button to the right of the Database Items region. Directly below *FROM riders* in the SQL region, the following text will appear.

```
WHERE state
```

25 In the SQL region, type = *'varState'* after *WHERE state*.

26 Click once on *money_raised* in the Database Items region to select the field.

27 Click on the Where button to the right of the Database Items region. The last line in the SQL region will look like the following.

```
WHERE state = 'varState' AND money_raised
```

28 Type > = *var300* at the end of this line.

NOTE: varState *is enclosed in single quotes because the state abbreviation is text. However,* var300 *is not enclosed because it is a number.*

29 Click once on *l_name* in the Database Items region to select the Last Name field.

30 Click on the Order By button to the right of the Database Items region. The following text will appear in the last line of the SQL region.

```
ORDER BY l_name
```

31 Type *ASC* after *l_name* to sort from A to Z. By default, SQL sorts in ascending order, but it is good practice to include *ASC*.

The completed Recordset window should look like that shown in figure 10-23.

32 Click on the Test button to see if the recordset looks correct (see figure 10-24). If you get an error, carefully compare the code you have typed and the code shown in

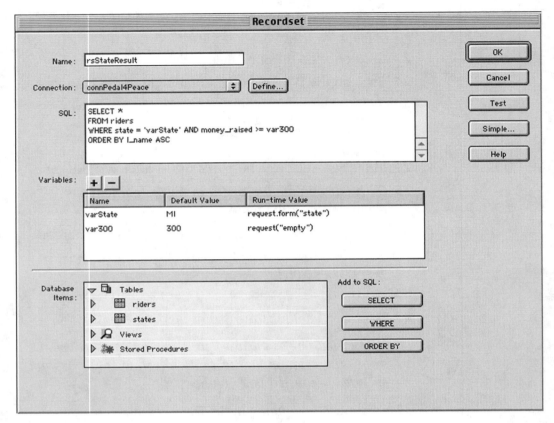

Fig. 10-23. Advanced Recordset window to complete this query.

figure 10-23. It is easy to miss a quote mark or put one in by mistake.

33 Let's examine the SQL code that was created. Line 1 tells the server which fields to select. Using the * tells the server to select all fields from the database table listed in line 2. Line 3 includes the criterion to use when selecting the records. In this example, only riders from the state selected in the form on *search.asp* that have raised at least $300 in donations will be selected. Line 4 sorts the recordset by last name from A to Z.

```
1) SELECT *
2) FROM riders
```

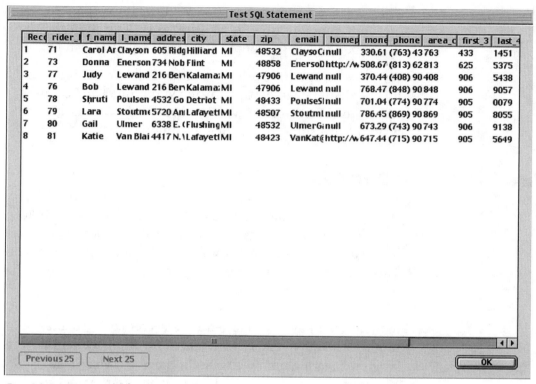

Fig. 10-24. Test results for the recordset.

3) `WHERE state = 'varState' AND money_raised >= var300`

4) `ORDER BY 1_name ASC`

34 After you have finished the recordset, you would need to bind the database elements to *results.asp* and add a repeat region. Do not forget to add the Hide/Show Region behaviors you used in Chapter 6 to avoid errors if there are no records in the recordset.

The Advanced Recordset window allows developers to create very complex queries of databases. The more SQL a developer knows the more complex the queries can be.

TIP: Open recordsets you have created throughout this book and click on the Advanced button. The SQL used to create the recordset will be displayed. This is a good way to learn some simple SQL techniques.

■■ Lost Passwords

Users frequently forget or loose their site passwords. To keep them from contacting you every time this happens, you can create a way to let them retrieve a lost or forgotten password. This idea takes a little bit of setup, but incorporates all of the techniques covered so far.

Many of you have been asked for a secret code, such as your mother's maiden name, city you were born in, and so on, when registering on a web site. In the event you loose or forget your password, you can give your user name and the secret code. If the information you provide matches the information in the database, your password is e-mailed to the address in the database.

As long as you have a field in your database that holds some type of special clue, this is an easy process. This technique uses some *If/Then* statements, redirects, and dynamic e-mail. Figure 10-25 shows a page users access to retrieve a lost password.

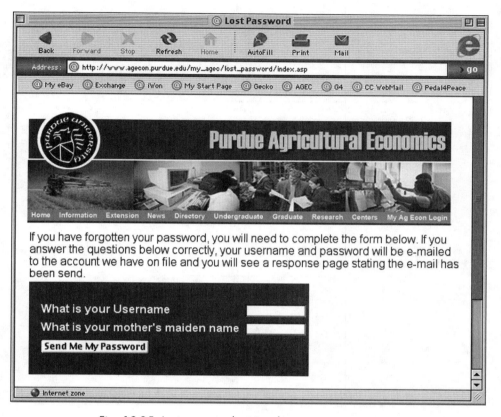

Fig. 10-25. Lost password retrieval page.

After the user enters her user name and mother's maiden name, the form is submitted to *check.asp,* which creates a recordset based on the user name and mother's maiden name sent to it. This recordset requires the use of the Advanced Recordset window, shown in figure 10-26. Note that this recordset selects the following fields from the table: *f_name, l_name, email,* and *mother.*

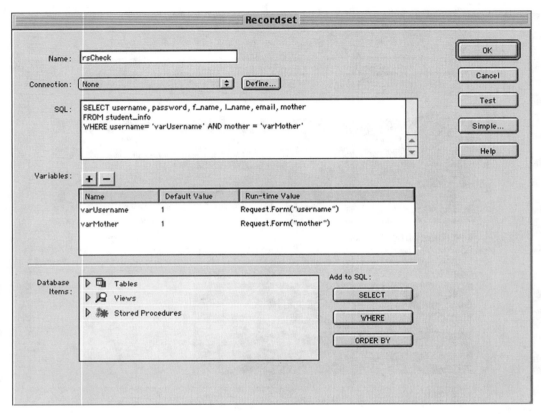

Fig. 10-26. Advanced Recordset window.

Immediately following the recordset code, a check is pre-formed to see if the recordset contains any records. If the recordset contains a record, there has been a match between the information entered by the user and the information stored in the database. In this case an e-mail containing the user name and password for the user is sent to the e-mail address stored in the database. Then the HTML code for *check.asp* is displayed (see figure 10-27).

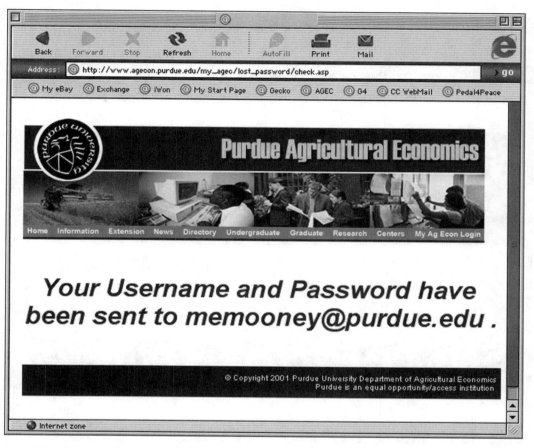

Fig. 10-27. Page a user sees if the information entered is correct.

If the recordset does not contain any records, the user is redirected to an error page (see figure 10-28). The code for creating the recordset, checking to see if the recordset contains a record, and generating the e-mail follows.

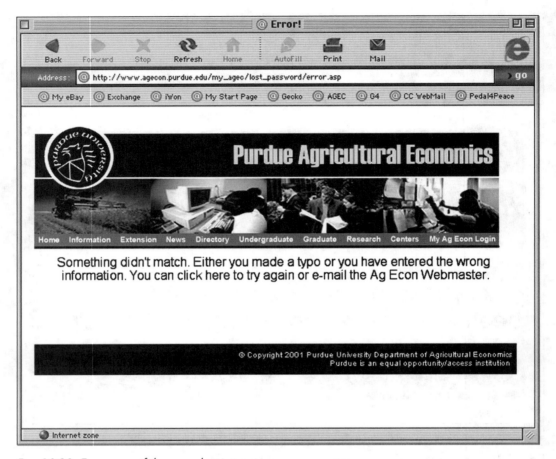

Fig. 10-28. Error page if the recordset is empty.

```
1) <%
2) Dim rsCheck__varUsername
3) rsCheck__varUsername = "1"
4) if (Request.Form("username") <> "") then rsCheck__varUsername =
   Request.Form("username")
5) %>
6) <%
7) Dim rsCheck__varMother
8) rsCheck__varMother = "1"
9) if (Request.Form("mother") <> "") then rsCheck__varMother =
   Request.Form("mother")
10) %>
11) <%
12) set rsCheck = Server.CreateObject("ADODB.Recordset")
```

```
13) rsCheck.ActiveConnection = MM_connResume_STRING
14) rsCheck.Source = "SELECT username, password, f_name, l_name,
    email, mother FROM student_info WHERE username= '" +
    Replace(rsCheck__varUsername, "'", "''") + "' AND mother = '" +
    Replace(rsCheck__varMother, "'", "''") + "'"
15) rsCheck.CursorType = 0
16) rsCheck.CursorLocation = 2
17) rsCheck.LockType = 3
18) rsCheck.Open()
19) rsCheck_numRows = 0
20) %>
```

Lines 1 through 20 were created by UltraDev to generate a recordset based on the user name and mother's maiden name submitted by the user. The recordset was created using the settings shown in figure 10-26.

```
21) <%
22) If (rsCheck.EOF) Then
23) Response.Redirect("error.asp")
24) End If
25) %>
```

Lines 21 through 25 redirect the user to an error page (see figure 10-28) if the user name and mother's maiden name do not match a record in the database. As discussed in earlier chapters, EOF means end of file. In essence, this means the recordset is empty.

```
26) <% Dim objCDO
27) Set objCDO = Server.CreateObject("CDONTS.NewMail")
28) objCDO.From = (rsCheck.Fields.Item("email").Value)
29) objCDO.To = (rsCheck.Fields.Item("email").Value)
30) objCDO.CC = ""
31) objCDO.Subject = "Your account info"
32) objCDO.Body =(rsCheck.Fields.Item("f_name").Value)& " " &
    (rsCheck.Fields.Item("l_name").Value) & chr(13) & chr(13) &
    "Password: "& (rsCheck.Fields.Item("password").Value)
33) objCDO.Send()
34) Set objCDO = Nothing
35) %>
```

Lines 26 through 35 send an e-mail to the address stored in the database if the user entered the correct information. The HTML code for this page is executed after the e-mail is sent. The resulting page is shown in figure 10-27.

There you have it. In 35 lines of code you can provide users with a way to retrieve lost passwords. With the exception of lines 21 through 25, UltraDev or an UltraDev extension generated all of this code.

■■ Using Commands

If you open the Data Bindings window and click on the plus sign (+), you will see an option named Command (a Stored Procedure). As previously discussed, Stored Procedures are scripts that are typically saved on a database server and requested by a web page rather than being coded into a web page. You cannot use Stored Procedures with Microsoft Access. However, you can use commands.

A command is simply a server-side script. Whenever you have used an Insert Record server behavior, UltraDev has basically embedded an insert command into the page. The only real difference between using a command and the Insert Record server behavior is how the information is put into the command. For example, when you use the Insert Record server behavior, you basically fill in the blanks to insert certain form fields into specific database fields and redirect the user to another page. UltraDev does all the work behind the scenes. With a command, you are responsible for more, but the responsibility provides a lot more flexibility.

The server behaviors used to insert, update, and delete records have some constraints placed on them so that it is easier for the user to work. Commands do not have these constraints.

The following sections discuss how to use the Command (a Stored Procedure) option to insert, update, and delete records. In addition, these sections (1) illustrate how to insert or update into multiple tables with one HTML form and (2) present an alternative approach to form validation. The examples are simple, to help keep you focused on the process rather than details. The trick here is to learn the basics of commands. After you have mastered the basics, the possibilities for their application are endless.

A simple web page named *sample.asp* is used for each of these examples. The web page has an HTML form with two text boxes, named *f_name* and *l_name*, and a submit button. The examples also use a database with two tables: *Table1* and *Table2*. The tables have identical structures. Both contain three fields: *AutoNumber* (an ID field), and *f_name* and *l_name* (text fields). Let's begin with the Insert command.

Insert Command

In exercise 10-6, you will use the Insert command.

Exercise 10-6: Using the Insert Command

For this exercise, the HTML form on *sample.asp* would be set to post the form field information to *process.asp*, which would have the command inserted into it.

1 Open *process.asp* and open the Data Bindings window.

2 Click on the plus sign (+) and select Command (Stored Procedure) from the menu to open the Command window (see figure 10-29).

The Command window looks very similar to the Advanced Recordset window. The skills you have gained using the Advanced Recordset window will pay off here.

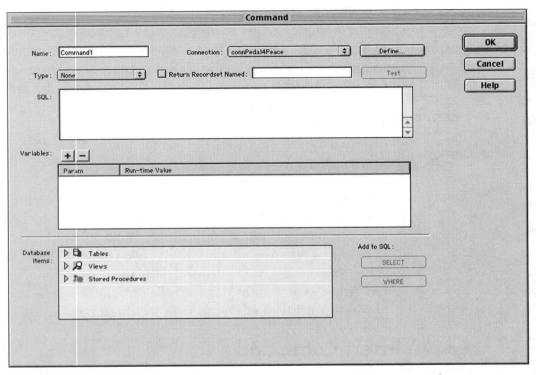

Fig. 10-29. Command window.

3 Name the command *cmdInsert*. Just as you might use *rs* when naming recordsets, you might want to use *cmd* when naming commands.

4 Select the applicable connection from the Connection drop-down list.

5 Select Insert from the Type drop-down list.

NOTE: *Only Stored Procedures return a recordset, and therefore that option is not used here.*

6 Click on the plus sign (+) in the Variables section to create an empty variable line. Type *varFirstname* in the Name column and *request.form("f_name")* in the Run-time Value column (see figure 10-30).

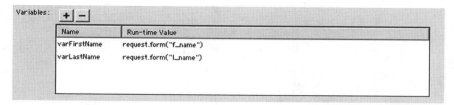

Fig. 10-30. Variable section of the Command window.

7 Repeat step 6, entering *varLastName* in the Name column and *request.form("l_name")* in the Run-time Value column (see figure 10-30).

8 Click the triangle to the left of *Tables* in the Database Items region to list the tables in the database. Next, click on the triangle to the left of *Table1* to list the fields in the table (see figure 10-31).

Fig. 10-31. Database Items region of the Command window.

9 Click once on *f_name* and click on the Column button to the right of the Database Items section (see figure 10-31).

10 Repeat step 9 for *l_name*.

The SQL region of the Command window should now show the following text.

```
INSERT INTO Table1 (f_name, l_name)
VALUES ( )
```

11 Type the following between the parentheses after *VALUES* in the SQL region.

```
'varFirstName', 'varLastName'
```

The completed window should look like that shown in figure 10-32.

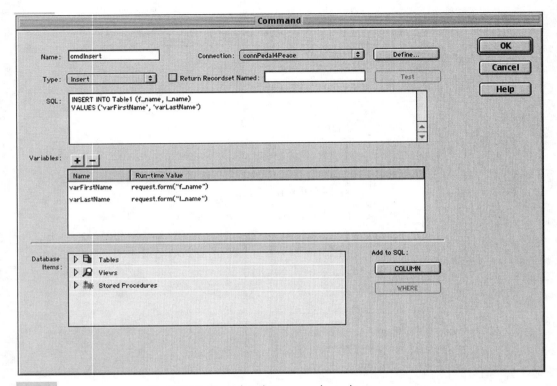

Fig. 10-32. Completed Command window.

 NOTE: *It is important that you enter the variables in the values sections in the order they are listed in the INSERT INTO section.*

12 Click on the OK button to close the window.

13 Open the Code view of *process.asp* and verify that you see the following.

```
1. <%@LANGUAGE="VBSCRIPT"%>
2. <!--#include file="../Connections/connPedal4Peace.asp" -->
3. <%
4. if(request.form("f_name") <> "") then cmdInsert__varFirstName =
   request.form("f_name")
5. if(request.form("l_name") <> "") then cmdInsert__varLastName =
   request.form("l_name")
6. %>
7. <%
8. set cmdInsert = Server.CreateObject("ADODB.Command")
```

```
9.  cmdInsert.ActiveConnection = MM_connPedal4Peace_STRING
10. cmdInsert.CommandText = "INSERT INTO Table1 (f_name, l_name)
    VALUES ('" + Replace(cmdInsert__varFirstName, "'", "''") + "',
    '" + Replace(cmdInsert__varLastName, "'", "''") + "') "
11. cmdInsert.CommandType = 1
12. cmdInsert.CommandTimeout = 0
13. cmdInsert.Prepared = true
14. cmdInsert.Execute()
15. %>
```

The lines of code you see take the two form fields, *f_name* and *l_name*, and insert them into the *f_name* and *l_name* fields of *Table1*. Taking this further, you would need to either provide some HTML on *process.asp* (to display to the user that the record has been added) or add a *response.redirect* to another page.

Form Validation

What does the process described in the previous exercise do that the Insert Record server behavior does not? The honest answer is nothing and everything. That is the beauty of using a command to insert a record. Exercise 10-7 involves a situation in which using this method is preferable to using the Insert Record server behavior.

 ### Exercise 10-7: Validating a Form

What if you wanted to validate the form information prior to inserting it into the database? Assume that the *f_name* and *l_name* fields are required. The following are the steps you could take to validate that *f_name* and *l_name* are not empty. In this exercise, the line numbers from the previous exercise are used to reference where to add additional code. The final code follows the exercise.

1 Copy the HTML form from *sample.asp* and paste it into *process.asp*. You still want the form to post to *process.asp*. Add a message to the user stating that both fields are required.

2 Select the *f_name* text box on *process.asp*. Type < % = *request.form("f_name")* in the Init Val text box in the Properties window, as shown in figure 10-33.

Fig.10-33. Properties window for f_name.

3 Repeat step 2 for the *l_name* text box, entering < % = *request.form("l_name")* in the Init Val text box.

4 Open the Code view for *process.asp* and add the following line of code between lines 14 and 15.

```
response.redirect("done.asp")
```

5 Add the following *If/Then* statement between lines 2 and 3.

```
<% if request.form("f_name") <> "" and request.form("l_name") <>
"" then %>
```

6 6. Add the following after line 15.

```
<% end if %>
```

The code produced in exercise 10-7 should look as follows.

```
1. <%@LANGUAGE="VBSCRIPT"%>
2. <!--#include file="../Connections/connPedal4Peace.asp" -->
2.5 <% if request.form("f_name") <> "" and request.form("l_name")
   <> "" then %>
3. <%
4. if(request.form("f_name") <> "") then cmdInsert__varFirstName =
   request.form("f_name")
```

```
5. if(request.form("l_name") <> "") then cmdInsert__varLastName =
   request.form("l_name")
6. %>
7. <%
8. set cmdInsert = Server.CreateObject("ADODB.Command")
9. cmdInsert.ActiveConnection = MM_connPedal4Peace_STRING
10. cmdInsert.CommandText = "INSERT INTO Table1 (f_name, l_name)
    VALUES ('" + Replace(cmdInsert__varFirstName, "'", "'''") + "',
    '" + Replace(cmdInsert__varLastName, "'", "'''") + "') "
11. cmdInsert.CommandType = 1
12. cmdInsert.CommandTimeout = 0
13. cmdInsert.Prepared = true
14. cmdInsert.Execute()
14.5 response.redirect("done.asp")
15. %>
16. <% end if %>
```

In this code, when *process.asp* is requested on the server, the *If/Then* statement in line 2.5 checks to make sure the form fields *f_name* and *l_name* are not empty. If either field is empty, the insert command is skipped and the HTML on *process.asp* is executed. The HTML is the form again, with the message stating both fields are required.

Including the *request.form* information for each field in the Init Val text box keeps the user from having to retype information. The user can then provide the information and resubmit the form. Because the HTML form on *process.asp* is set to post to *process.asp*, the entire check will be run again. If neither form field is empty, lines 3 through 15 are executed, inserting the information into the database and redirecting the user to *done.asp*, which informs the user that the information has been submitted successfully.

Data Formatting

Another situation in which you might want to use a command rather than the Insert Record server behavior is when you need to format data before entering it. Phone numbers are a perfect example. If you have a form field for a phone

number, users may not provide the format you want. For example, they may not include the area code, or they may enter it in the format 123-456-7890 and you needed it as (123) 456-7890. Dates are another good example of this. For example, you might want mm/dd/yyyy and users enter *Dec. 1, 01*. Exercise 10-8 takes you through another example of using a command to format data.

Exercise 10-8: Formatting Information

Specifying the information needed with separate form fields and then formatting it is a great way to solve this problem. Let's look at the telephone number for this example. Assume there is a web page named *phone.asp* that has an HTML form with three text fields and a submit button. The text fields are named *area_code*, *first_3*, and *last_4*. The HTML form posts the information to *combine.asp*.

The database structure for this exercise has five fields: *AutoNumber* (an ID field), and *area_code*, *first_3*, *last_4*, and *phone* (text fields). Again, this is a simple example to help you learn how to combine form fields into one database field.

1 Open *combine.asp* and open the Data Bindings window.

2 Click on the plus sign (+) and select Command (Stored Procedure) from the list to open the Command window.

3 Name the Command *cmdCombine*.

4 Select the applicable connection from the Connection drop-down list.

5 Select Insert from the Type drop-down list.

6 Click on the plus sign (+) in the Variables section to add an empty variable line.

7 Type *varAreaCode* in the Name column and *request. form("area_code")* in the Run-time Value column.

8 Repeat steps 6 and 7 for *first_3* and *last_4*.

9 In the Database Items region, click on the triangle to the left of the table you plan to insert the records into.

10 Click on *area_code* once and click on the Column button to the right of the Database Items region.

11 Repeat step 10 for *first_3*, *last_4*, and *phone*.

12 Type the following between the parentheses after *VALUES*.

```
'varAreaCode', 'varFirst_3', 'varLast_4', '(varAreaCode)
varFirst_3-varLast_4'
```

Note how the single quotes are used. The *()* and – are added inside the quotes, and *varAreaCode*, *varFirst_3*, and *VarLast_4* are also enclosed in one set of single quotes. This is how the form fields are combined into the format needed. Figure 10-34 shows the Command window with all necessary options set.

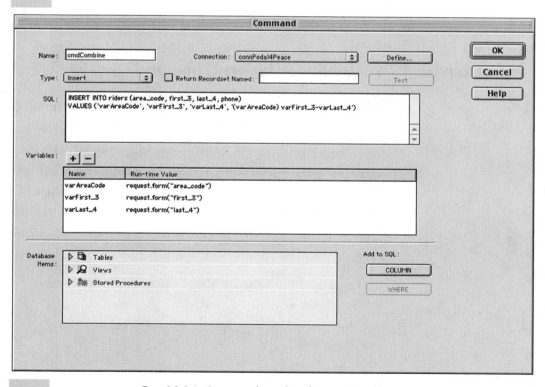

Fig. 10-34. Command window for combine.asp.

You could add a *response.redirect* and the necessary *If/Then* statement as demonstrated earlier to ensure the information was provided. As you can imagine, there are many reasons to use commands when inserting records into a database.

Update Command

Performing an update is not much different than using the Insert command. The key with the Update command is telling the server which record to update. For exercise 10-9, assume you are letting users update their names in the database. As in Chapter 7, you need a way for the user to select his or her record. You also need to create a recordset for that user and fill the *f_name* and *l_name* fields with the information found in the database. For this exercise, let's call that page *my_data.asp*.

Exercise 10-9: Using the Update Command

This time, instead of using the Update Record server behavior you will perform the update with a command.

1 Open *my_data.asp*. The page needs to have an HTML form with three fields and a submit button. The fields needed are *f_name* and *l_name*, both text boxes, and an ID (a hidden field).

NOTE: *ID needs to be some type of unique identifier, such as an AutoNumber or a unique user name.*

2 Make sure to bind the database information to *f_name*, *l_name*, and ID.

3 Set the form to post to *update.asp*, and close *my_data.asp*.

4 Open *update.asp*.

5 Open the Data Bindings window, click on the plus sign (+), and select Command (Stored Procedure) from the list to open the Command window.

6 Name the command *cmdUpdate*.

7 Select the applicable connection from the Connection drop-down list.

8 Select Update from the Type drop-down list.

9 Click on the plus sign (+) in the Variables region to create an empty variable line.

10 Type *varID* in the Name column and *request.form("ID")* in the Run-time Value column.

11 Repeat step 10 for *f_name* and *l_name*, using *varFirstName* and *varLastName* as the variable names and *request.form("f_name")* and *request.form("l_name")* as the run-time values.

12 To see the fields, click on the triangle to the left of the table you plan to update.

13 Click once on *f_name* and click on the Set button to the right of the Database Items region. Do the same for *l_name*.

14 Click once on the ID field and click on the Where button to the right of the Database Items region.

15 In the SET line in the SQL region you will need to type = '*varFirstName*' after *f_name* and = '*varLastName*' after *l_name*.

16 Type = *varID* after *WHERE ID*.

 NOTE: varID *is not enclosed in single quotes because it is a number.*

17 Click on the OK button to close the Command window.

Figure 10-35 shows the Command window for the update command. Pay close attention to the use of single quotes.

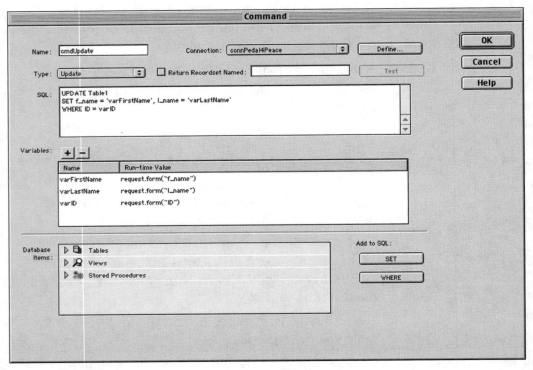

Fig. 10-35. Command window for update.

Again, using a command would allow for the use of form validation and formatting. The steps used in the previous exercises would be combined with an update command, just as they were used with the insert command.

Delete Command

The delete command is basically the same as the update command. The Delete Record server behavior does a fine job of this, with one exception. The Delete Record server behavior will only delete one record at a time. There are times when you may want to delete multiple records.

For example, in the Pedal for Peace situation, there could be a table for the bikes a rider owns. This idea was discussed in

Chapter 2 in the discussion of relationships. If a rider were to quit the tour, she would be removed from the *riders* table in the database. However, there could be many records for this rider in the *bikes* table. Exercise 10-10 deals with this situation.

Exercise 10-10: Using the Delete Command

Assume you want to delete all records in the *bikes* table for a rider that leaves the tour. Because user name is a unique identifier in the Pedal for Peace examples, you can assume that each record in the *bikes* table would have the user name of the rider that owns that particular bike. The steps that follow demonstrate how to delete all records for a specific rider using the rider's user name as the unique identifier.

1 You need a page that passes the user name to *delete_bikes.asp*. This would be a simple page with an HTML form. The form needs to include a text box named *username* and a submit button.

2 Set the HTML form to post to *delete_bikes.asp*.

3 Open *delete_bikes.asp*.

4 Open the Data Bindings window, click on the plus sign (+), and select Command (Stored Procedure) from the list to open the Command window.

5 Name the command *cmdDeleteBikes*.

6 Select the applicable connection from the Connection drop-down list.

7 Select Delete from the Type drop-down list.

8 Click the triangle to the left of *Tables* in the Database Items region to list the tables in the databse. Next, click once on the *bikes* table listed in the Database Items region, and click on the Delete button to the right of the Database Items region.

9 Click on the triangle to the left of the *bikes* table to reveal the fields.

10 Click once on the *username* field, and then click on the Where button to the right of the Database Items region.

11 Click on the plus sign (+) in the Variables region to add an empty variable line, and type *varUsername* in the Name column and *request.form("username")* in the Run-time Value column.

12 Type = *'varUsername'* after *WHERE username appears* in the SQL region.

13 Click on the OK button to close the window.

Figure 10-36 shows the Command window for deleting the records bearing a specific user name. This deletion procedure is very useful. You could also delete all records with an ID less than a specific number or within a specific range. As long as you can identify a group of records in some way, you can delete them with a delete command.

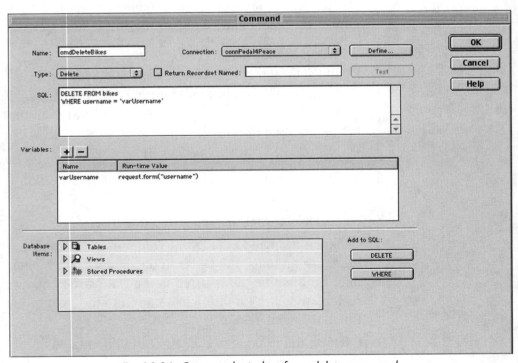

Fig. 10-36. Command window for a delete command.

Working with Multiple Tables

The ability to insert information into, and update information within, multiple tables with a single HTML form is incredibly useful and surprisingly simple. Because commands are nothing more than server-side scripts, it is possible to place multiple commands on one page. The server starts at the top of the page and works downward, executing one script after another.

For example, if there were a need to have a user provide his name, a simple insert command or Insert Record server behavior could handle it. However, if the user's name needed to be stored in two different tables, things would get a little tricky. Although it is possible to accomplish this task without using a command, it would typically take a lot more work and rely on the user to follow directions very closely. However, using commands makes this a simple task, as demonstrated in exercise 10-11.

 Exercise 10-11: Inserting Information in Multiple Tables

Assume you have two database tables, *Table1* and *Table2*, and you want to put the user's first and last name in each from one form. Earlier in this chapter you saw how to insert the first and last name of a user into a table using the Insert command. All you really have to do here is make another command for inserting the information into the other table. For this exercise, you need a page with an HTML form with two text boxes, *f_name* and *l_name*, and a submit button. The form should post to *multiple.asp*.

1 Open *multiple.asp*.

2 Open the Data Bindings window and click on the plus sign (+). Select Command (Stored Procedure) from the list to open the Command window.

3 Name the command *cmd2Table1*.

4 Select the applicable connection from the Connection drop-down list.

5 Select Insert from the Type drop-down list.

6 Click on the plus sign (+) in the Variables region to add an empty variable line. Enter *varFirstName* in the Name column and *request.form("f_name")* in the Run-time Value column.

7 Repeat step 6 for *l_name*, using *varLastName* in the Name column and *request.form("l_name")* in the Run-time Value column.

8 Click on the triangle to the left of *Table1* in the Database Items region to show the fields in the table.

9 Click once on *f_name*, and then click on the Column button to the right of the Database Items region.

10 Repeat step 9 for *l_name*.

11 Type the following between the parentheses after *VALUES* in the SQL region.

```
'varFirstName', 'varLastName'
```

12 Click on the OK button to close the Command window.

13 Repeat steps 1 through 12, this time selecting *f_name* and *l_name* from *Table2* in steps 6 through 10.

That's it! *Multiple.asp* would take the first name and last name sent to it from an HTML form and insert it into *Table1* and then into *Table2*. Again, because these are commands, form validation and formatting can easily be added. The code produced by these two commands follows.

```
1. <%@LANGUAGE="VBSCRIPT"%>
2. <!--#include file="../Connections/connPedal4Peace.asp" -->
3. <%
4. if(request.form("f_name") <> "") then cmd2Table1__varFirst =
   request.form("f_name")
```

```
5. if(request.form("l_name") <> "") then cmd2Table1__varLast =
   request.form("l_name")
6. %>
7. <%
8. if(request.form("f_name") <> "") then cmd2Table2__varFirst =
   request.form("f_name")
9. if(request.form("l_name") <> "") then cmd2Table2__varLast =
   request.form("l_name")
10. %>
11. <%
12. set cmd2Table1 = Server.CreateObject("ADODB.Command")
13. cmd2Table1.ActiveConnection = MM_connPedal4Peace_STRING
14. cmd2Table1.CommandText = "INSERT INTO riders (f_name, l_name)
    VALUES ('" + Replace(cmd2Table1__varFirst, "'", "''") + "', '"
    + Replace(cmd2Table1__varLast, "'", "''") + "') "
15. cmd2Table1.CommandType = 1
16. cmd2Table1.CommandTimeout = 0
17. cmd2Table1.Prepared = true
18. cmd2Table1.Execute()
19. %>
20. <%
21. set cmd2Table2 = Server.CreateObject("ADODB.Command")
22. cmd2Table2.ActiveConnection = MM_connPedal4Peace_STRING
23. cmd2Table2.CommandText = "INSERT INTO Table2 (f_name, l_name)
    VALUES ('" + Replace(cmd2Table2__varFirst, "'", "''") + "', '"
    + Replace(cmd2Table2__varLast, "'", "''") + "') "
24. cmd2Table2.CommandType = 1
25. cmd2Table2.CommandTimeout = 0
26. cmd2Table2.Prepared = true
27. cmd2Table2.Execute()
28. %>
```

Lines 3 through 6 and 11 through 19 in the previous code were written by *cmd2Table1*. Lines 7 through 10 and 20 through 28 were written by *cmd2Table2*. Both commands used the same connection (see line 2); however, this is not a requirement.

■■ Tips and Tricks

The sections that follow provide further neat tricks regarding learning SQL and dealing with dates within SQL.

Learning a Little More SQL

In addition to looking at the SQL code created by UltraDev in the Advanced Recordset and Command windows, you can also use Microsoft Access to learn some basic SQL. When a user creates queries in Access, SQL code is generated. To see the code, open the query and select SQL from the View menu (see figure 10-37). This is an excellent way for novice developers to learn the basic syntax of SQL.

Fig. 10-37. View menu for Microsoft Access.

■■ Summary

The goal of this chapter was to provide you with some ideas and resources that go beyond the visual development of UltraDev. The chapter included examples the authors struggled with when beginning to develop web applications with UltraDev.

Some of the information presented in the chapter, such as the use of hidden fields, deals more with a development approach or philosophy than with programming tricks. From talking with first-time users, it is clear that some of these simple steps are overlooked or do not occur to developers.

Even many first-time UltraDev users have some programming background. The skills gained from such a background can really enhance a developer's abilities in UltraDev. The use of *If/Then* logic or other programming skills supported in ASP, JSP, or ColdFusion can only improve the level of web applications created. The use of *If/Then* statements can achieve a number of functional and impressive things when combined with the database capabilities found in UltraDev.

Combining the programming functions found in the server model being used (be it ASP, JSP, or ColdFusion) with the many different extensions and server components can yield incredible results. Generating e-mails and validating forms is only the beginning. However, these simple skills are very helpful and serve as building blocks for other skills you can acquire from additional reading and experimentation.

The more SQL you can learn the more you can get out of UltraDev. There are features found in UltraDev that are outside the scope of this book. As you begin using the skills discussed in this chapter and previous chapters, you will begin to feel more comfortable using UltraDev and start looking at additional features, such as Commands and Stored Procedures.

The key to creating useful web applications is having good data to work from and combining a variety of tools into one seamless working unit, as you did in the section dealing with retrieving a lost or forgotten password. The use of *If/Then* statements and advanced recordsets, and generating e-mails, are in themselves helpful capabilities, but combining them

into one function is where the usefulness of an application begins to appear.

■■ Things to Think About

If you have gotten this far in this book, the question you should be asking yourself is "what next?" UltraDev is an incredibly powerful tool and you have learned a number of skills throughout this book. Most likely, you will be able to keep yourself rather busy with the skills you now have. However, do not stop there. There are many additional resources on the Web (such as news groups, list servs, and web sites) devoted to the further development and use of UltraDev. These are great places to interact with other UltraDev users, get and give assistance, and get some ideas of how others are using UltraDev.

If you gave five different UltraDev users the same task to accomplish, you would most likely get at least three different ways of doing the same thing. All of the approaches might be correct and useful; they would simply be different. There is a large degree of creativity involved in creating web applications and database solutions. If you have become comfortable with ASP, try to get access to a ColdFusion or JSP server to experiment on. You may find you like another server model better, or that you can accomplish things with one server model more easily than you can with another.

Most of all, have fun with this and experiment.

■■ Resources

❒ *http://www.magicbeat.com*

Provides a public news group for UltraDev users. This group is very active and includes some of the best UltraDev developers in the world as members. If you have a question, they will have answers.

❒ *http://www.udzone.com*

A great web site full of extensions and tutorials.

❒ *http://www.basic-ultradev.com*

Another great web site containing extensions and articles about using UltraDev. This site is maintained by Ray West and Tom Muck, two excellent UltraDev developers and authors.

❒ *http://www.ultradevextensions.com*

This web site offers information on many extensions, tutorials, and samples. This site also maintains a list of UltraDev forums and mailing lists, a list of UltraDev-friendly hosting services, and a list of sites developed with UltraDev to get some ideas from.

APPENDIX A

VBScript and JavaScript Reserved Words

ASP can use either VBScript or JavaScript. The following are reserved words for VBScript and JavaScript.

■■ VBScript

The following words are reserved in Microsoft VBScript.

And	Const	Empty
As	Currency	End
Boolean	Debug	EndIf
ByRef	Dim	Enum
Byte	Do	Eqv
ByVal	Double	Event
Call	Each	Exit
Case	Else	False
Class	ElseIf	For

Function	Not	Shared
Get	Nothing	Single
GoTo	Null	Static
If	On	Stop
Imp	Option	Sub
Implements	Optional	Then
In	Or	To
Integer	ParamArray	True
Is	Preserve	Type
Let	Private	TypeOf
Like	Public	Until
Long	RaiseEvent	Variant
Loop	ReDim	Wend
LSet	Rem	While
Me	Resume	With
Mod	RSet	Xor
New	Select	
Next	Set	

■■ JavaScript

The following words are reserved in Microsoft JavaScript.

break	export	return
case	extends	super
catch	false	switch
class	finally	this
const	for	throw
continue	function	true
debugger	if	try
default	import	typeof
delete	in	var
do	instanceof	void
else	new	while
enum	null	with

APPENDIX B

Java Reserved Words

The following are Java reserved words.

abstract	double	instanceof
boolean	else	int
break	extends	interface
byte	false	long
case	final	native
catch	finally	new
char	float	null
class	for	package
const	goto	private
continue	if	protected
default	implements	public
do	import	return

short	this	try
static	throw	void
super	throws	volatile
switch	transient	while
synchronized	true	

ColdFusion Reserved Words

The following are ColdFusion reserved words.

And	Default	Gt
Application	Do	Gte
Attributes	Else	If
Break	Eq	Imp
Caller	Equal	In
Case	Eqv	Integer
Cf[Anything]	Error	Is
Cgi	Error(Cferror)	Lt
Client	File	Lte
Contains	Float	Mod
Cookie	For	Neq
Date	Form	Not

Or	Session	Variables
Range	Switch	While
Request	Thistag	Xor
Required	Time	
Server	URL	

SQL Reserved Words

The following are SQL reserved words. SQL is *not* case sensitive. All words appear in uppercase letters as a matter of standard practice in denoting SQL.

ADD	AVG	BY
ALL	BACKUP	BY CREATE
ALPHANUMERIC	BEGIN	BYTE
ALTER	BETWEEN	CASCADE
AND	BINARY	CASE
ANY	BIT	CHAR
AS	BOOLEAN	CHARACTER
ASC	BREAK	CHECK
AUTOINCREMENT	BROWSE	CHECKPOINT
AVA	BULK	CLOSE

CLUSTERED	CURRENT_DATE	DISTRIBUTED
COALESCE	CURRENT_TIME	DOUBLE
COLUMN	CURRENT_TIMESTAMP	DROP
COMMIT		DUMMY
COMMITTED	CURRENT_USER	DUMP
	CURSOR	
COMPUTE		ELSE
	DATABASE	
CONFIRM		END
	DATE	
CONSTRAINT		ERRLVL
	DATETIME W	
CONTAINS		ERROREXIT
	DBCC	
CONTAINSTABLE		ESCAPE
	DEALLOCATE	
CONTINUE		EXCEPT
	DECLARE	
CONTROLROW		EXEC
	DEFAULT	
CONVERT		EXECUTE
	DELETE	
COUNT		EXISTS
	DENY	
COUNTER		EXIT
	DESC	
CREATE		FETCH
	DISALLOW	
CROSS		FILE
	DISK	
CURRENCY		FILLFACTOR
	DISTINCT	
CURRENT		FLOAT
	DISTINCTRO	

FLOAT4	IEEEDOUBLE	LEFT
FLOAT8	IEEESINGLE	LEVEL
FLOPPY	IF	LIKE
FOR	IGNORE	LINENO
FOREIGN	III	LOAD
FREETEXT	IMP	LOGICAL
FREETEXTTABLE	IN	LONG
FROM	INDEX	LONGBINARY
FULL	INNER	LONGTEXT
GENERAL	INSERT	MAX
GOTO	INT	MEMO
GRANT	INTEGER	MIN
GROUP	INTERSECT	MIRROREXIT
GUID	INTO	MOD
HAVING	IS	MONEY
HOLDLOCK	ISOLATION	NATIONAL
IDENTITY	JOIN	NOCHECK
IDENTITY_INSERT	KEY	NONCLUSTERED
IDENTITYCOL	KILL	NOT

NULL	OR PROCEDURE	PROCESSEXIT
NULLIF	ORDER	PUBLIC
NUMBER	ORDER	RAISERROR
NUMERIC	OUTER	READ
OF	OVER	READTEXT
OFF	OWNERACCESS	REAL
OFFSETS	PARAMETERS	RECONFIGURE
OLEOBJECT	PERCENT	REFERENCES
ON	PERM	REPEATABLE
ON PIVOT	PERMANENT	REPLICATION
ONCE	PIPE	RESTORE
ONLY	PLAN	RESTRICT
OPEN	PRECISION	RETURN
OPENDATASOURCE	PREPARE	REVOKE
OPENQUERY	PRIMARY	RIGHT
OPENROWSET	PRINT	ROLLBACK
OPTION	PRIVILEGES	ROWCOUNT
OPTION PRIMARY	PROC	ROWGUIDCOL
OR	PROCEDURE	RULE

SAVE	TABLELD	UNIQUE
SCHEMA	TAPE	UPDATE
SELECT	TEMP	UPDATETEXT
SERIALIZABLE	TEMPORARY	USE
SESSION_USER	TEXT	USER
SET	TEXTSIZE	VALUE
SETUSER	THEN	VALUES
SHORT	TIME	VAR
SHUTDOWN	TIMESTAMP	VARBINARY
SINGLE	TO	VARCHAR
SMALLINT	TOP	VARP
SOME	TRAN	VARYING
STATISTICS	TRANSACTION	VIEW
STDEV	TRANSFORM	WAITFOR
STDEVP	TRIGGER	WHEN
STRING	TRUNCATE	WHERE
SUM	TSEQUAL	WHILE
SYSTEM_USER	UNCOMMITTED	WITH
TABLE	UNION	WORK

WRITETEXT

XOR

YESNO

MySQL Reserved Words

The following are MySQL reserved words. MySQL is *not* case sensitive. These terms are set in capital letters per standard practice in denoting MySQL.

ADD	BREAK	COMMIT
ALL	BROWSE	COMMITTED
ALTER	BULK	COMPUTE
AND	BY	CONFIRM
ANY	CASE	CONSTRAINT
AS	CHECK	CONTINUE
ASC	CHECKPOINT	CONTROLROW
AVG	CLOSE	CONVERT
BEGIN	CLUSTERED	COUNT
BETWEEN	COALESCE	CREATE

CURRENT

CURRENT_DATE

CURRENT_TIME

CURRENT_
TIMESTAMP

CURRENT_USER

CURSOR

DATABASE

DBCC

DEALLOCATE

DECLARE

DEFAULT

DELETE

DESC

DISK

DISTINCT

DOUBLE

DROP

DUMMY

DUMP

ELSE

END

ERRLVL

ERROREXIT

EXCEPT

EXEC

EXECUTE

EXISTS

EXIT

FETCH

FILLFACTOR

FLOPPY

FOR

FOREIGN

FROM

GOTO

GRANT

GROUP

HAVING

HOLDLOCK

IDENTITY

IDENTITY_INSERT

IDENTITYCOL

IF

IN

INDEX

INSENSITIVE

INSERT

INTERSECT

INTO

IS

ISOLATION

KEY

KILL

LEVEL

LIKE

LINENO

LOAD

MAX	PERM	REVOKE
MIN	PERMANENT	ROLLBACK
MIRROREXIT	PIPE	ROWCOUNT
NOCHECK	PLAN	RULE
NONCLUSTERED	PRECISION	SAVE
NOT	PREPARE	SCROLL
NULL	PRIMARY	SELECT
NULLIF	PRINT	SERIALIZABLE
OF	PROC	SESSION_USER
OFF	PROCEDURE	SET
OFFSETS	PROCESSEXIT	SETUSER
ON	PUBLIC	SHUTDOWN
ONCE	RAISERROR	SOME
ONLY	READ	STATISTICS
OPEN	RECONFIGURE	SUM
OPTION	REFERENCES	SYSTEM_USER
OR	REPEATABLE	TABLE
ORDER	REPLICATION	TAPE
OVER	RETURN	TEMP

TEMPORARY	UNCOMMITTED	VIEW
TEXTSIZE	UNION	WAITFOR
THEN	UNIQUE	WHEN
TO	UPDATE	WHERE
TRAN	UPDATETEXT	WHILE
TRANSACTION	USE	WITH
TRIGGER	USER	WRITETEXT
TRUNCATE	VALUES	
TSEQUAL	VARYING	

APPENDIX F

Making an OLE DB Connection

Throughout this book we have used an ODBC connection using a DSN. However, using an OLE DB connection improves the performance of your web application. OLE DB connections are used on Windows NT/2000 servers. The following information is a simplified discussion of how to set up an OLE DB connection.

You will need physical access to the server to set up this type of connection. Remember, a lunch or two with the system administrator may get you some help in this area.

The difference between a DSN and an OLE DB connection can be explained using a "layers" analogy. Figure F-1 depicts the differences. ADO is the web application that interacts with the database. The right-hand side of the figure shows the way things work using a DSN connection. A request from the web application (ADO) must first go through the ODBC layer. The ODBC layer is then sent to the OLE DB layer. The OLE DB layer is basically where the communication between the database and the ADO occurs. The left-hand side of the figure shows how an OLE DB connection works. Basically, the ODBC layer is removed, thereby giving your web application quicker access to the database.

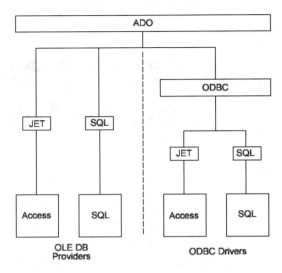

Fig. F-1. Comparison of the use of ODBC and OLE DB connections.

In addition to the performance gain, there is another plus to using OLE DB connections. Many of the servers you might administer or interact with on a regular basis are occasionally reformatted. If you use DSN connections, you need to remember which DSN goes with which database, and recreate all DSNs anytime a server is reformatted.

Because the actual data from the server is backed up and replaced after the format, OLE DB connections still work. This added bonus happens because the directory structure and drive structure of the servers do not change. This may not sound like much, but it saves time and frustration. Exercise F-1 takes you through the process of making an OLE DB connection.

Exercise F-1: Making an OLE DB Connection

To make an OLE DB connection, you need to have physical access to the server. There are only a few steps that need to be done at the server level. Therefore, if you cannot get access to the server, you could ask the server administra-

tor to perform the first few steps and then finish everything else yourself in UltraDev.

1 At the server, navigate to the *Connections* directory of the site you want to make an OLE DB connection for. Because every server is configured differently, you need to determine the path for your site. It is the actual place your site sits on the server.

2 Within the *Connections* folder, right-click to access the pop-up menu.

3 Select New, and then select Text Document from the menu that appears (see figure F-2).

Fig. F-2. Contextual menu for creating a new text document.

4 Name the file *OLEDB.udl*. A warning will appear on screen telling you that if you change the file extension it may become unusable and asking you if you really want to do this. Click on the Yes button (see figure F-3).

Fig. F-3. Warning regarding file extension change.

NOTE: *Windows operating systems often hide file extensions. To show file extensions, consult the help menus for your operating system, found in the Start menu.*

5 Double click on *OLEDB.udl* to open the Data Link Properties window (see figure F-4).

Fig. F-4. Data Link Properties window.

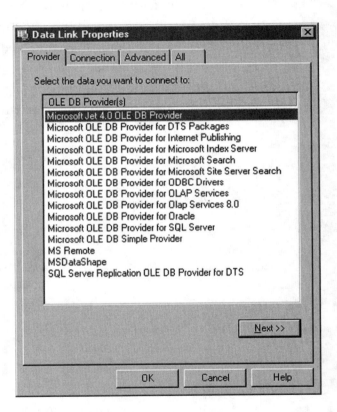

6 Click on the Provider tab at the top of the window to reveal the OLE DB providers.

7 Select Microsoft Jet 4.0 OLE DB Provider from the list.

NOTE: *The Microsoft Jet 4.0 OLE DB Provider is used for Microsoft Access databases. See the list for other database providers, such as SQL Server.*

8 Click on the Next button to go to the Connection tab.

9 Click on the small button to the right of the text box for selecting a database name. The button is a small square with "..." in it. This will open the Select Access Database window (see figure F-5).

Fig. F-5. Select Access Database window.

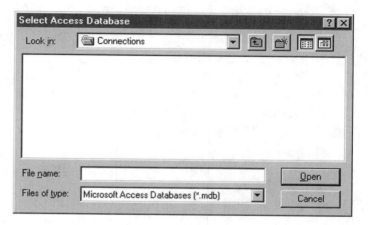

10 Navigate to the directory where the Access database is stored, select the database, and click on Open. The exact path to the database will appear in the text box, as shown in figure F-6.

NOTE: *The path to your database will most likely not match the path shown in this example.*

11 In most cases, you will not need to provide a user name and password. These are required if the database requires user names and passwords to access the information stored within the database.

12 Click on the Test Connection button to make sure the system can communicate with the database. If everything is correct, you will see a pop-up window telling you that the test connection succeeded (see figure F-7). Click on OK in the pop-up window to close it. If you receive an error message, confirm that you have selected the correct OLE DB provider in step 7, and test the connection again.

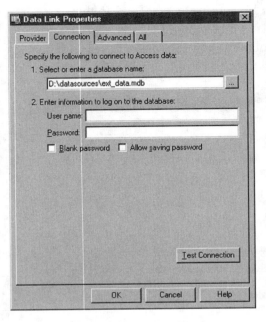

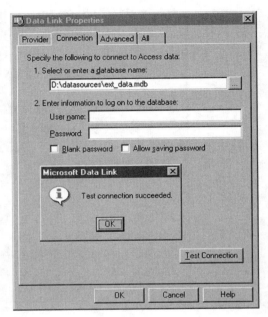

Fig. F-6. Complete path shown in the Data Link Properties window.

Fig. F-7. Indication of a successful OLE DB connection on the server.

Fig. F-8. Modify menu.

13 Click on the OK button in the Data Link Properties window to close it.

 NOTE: *At this point, a system administrator would be done. The following steps could be completed on your personal computer by downloading* OLEDB.udl *from the server to your hard drive.*

14 Open UltraDev.

15 Open a page from your site and select Connections from the Modify menu (see figure F-8).

16 Click on the New button and select Custom Connection String from the list that appears (see figure F-9).

Fig. F-9.
Connections
window.

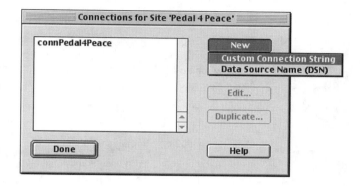

17 In the Custom Connection String window, name the connection. In the example, the connection is named *connOLE_DB*.

18 Hide or minimize UltraDev for a moment and using a text editor such as Notepage or SimpleText open *OLEDB.udl* (see figure F-10).

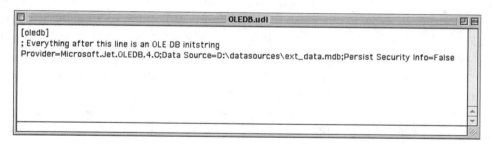

Fig. F-10. OLEDB.udl *opened in a text editor.*

19 Copy everything from the word *Provider* to the end of the file.

20 Return to UltraDev and paste the information you just copied into the Custom Connection String text box, shown in figure F-11. If you are using Windows, make sure to select the Using Driver On Application Server radio button. Macintosh users do not have this option.

Fig. F-11. Custom Connection String window for both Macintosh and Windows.

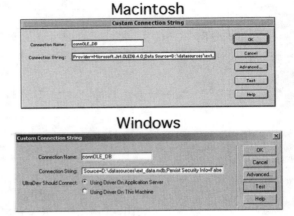

21 Click on the Test button to confirm that the connection has been made. If the connection was successful, a pop-up window will appear that says *Connection was made successfully* (see figure F-12). If you receive an error message at this point, it is most likely something in the information you copied. Go back and expand the text editor window to allow the information you copied to appear on one line. This sometimes causes a problem. If problems continue, double check that *OLEDB.udl* was created correctly by going through the steps of this exercise again.

Fig. F-12. Indication of a successful connection.

22 Click on the OK button to close the Custom Connection String window, and save your new connection.

Glossary

The following are brief definitions of acronyms and terms used in this book.

ADO ActiveX Data Object; Microsoft's high-level interface to a variety of data.

Apache A very powerful and common web server that can be run on nearly any operating system.

ASCII American Standard Code for Information Interchange uses simple character codes, such as *chr(13)*, to represent text characters.

ASP Active Server Pages use VBScript or JavaScript to deliver dynamic data.

CFML ColdFusion Markup Language is a tag-based language used to deliver dynamic content.

ChiliSoft Enables UNIX web servers to use ASP pages.

ColdFusion An application server that uses CFML.

Connection A script used to allow a web page to communicate with a database.

Cookie A small text file stored on the user's computer for future use.

CSS Cascading style sheets define format attributes of a web page or pages.

DSN Data Source Name is a label used on a server to point to a specific database.

Dynamic page A web page that changes based on server or user information.

Extensions Additional UltraDev-compatible and/or UltraDev-based features and tools created by developers.

Form An HTML tag that contains objects such as text boxes and radio buttons.

FTP File Transfer Protocol is used to move files to and from a server.

Get method Sends variables from one page to another in the URL.

Java An object-oriented language used in Java Server Pages.

JavaScript A scripting language based on Java.

JSP Java Server Pages use Java to deliver dynamic content.

LAN Local area network.

MDAC Microsoft Data Access Component is used when connecting to a database.

MM_UserAuthorization Access-level session variable set by the Log In User behavior.

MM_Username User name session variable set by the Log In User behavior.

MySQL An Open Source database that uses SQL.

ODBC Open database connectivity is used to link web pages to databases.

OLE DB An object linking and embedding database is an alternative means of linking web pages to databases.

Post **method** Sends variables from one page to another in the header of a web page.

Primary Key Database field that contains a unique identifier.

Query A search of a database.

Recordset A group of database records resulting from a query.

Request.Form ASP code used to refer to a variable sent from a form.

Request.Querystring ASP code used to refer to a variable sent in a URL.

Server-side script A piece of code executed on the server.

Session variable A temporary variable held on the server for a specific amount of time.

SQL Structure Query Language is a standard language used to interact with databases.

Static page A traditional web page.

Stored procedure A pre-compiled SQL statement that resides on a server.

VBScript A scripting language based on Visual Basic.

WebDAV Web-based Distributed Authoring and Versioning.

WYSIWYG What you see is what you get.

Index

Symbols

(pound sign), dates in SQL queries 272

$ (dollar sign) 136
 42

< / > delimiters 46

< > delimiters 46

< % ~ } % > delimiters 46

< %...% > delimiters 44

< cfoutput > 47

_ (underscore), in field names 27

Numerics

80004005 error message 157

A

A_Pedal4Peace.mdb file 20

absolute links, verifying 81

Accept nulls 31

Access
 and Macintosh users 16
 basic interface 21
 sample databases 21–22

access levels, databases 75

access-level restrictions 197–201

Active Server Pages (ASP)
 < %...% > delimiters 44
 .asp extension 40
 code example 44–45
 database connections 106
 definition 10
 description 40–41
 For/Next loops 44–45
 "Hello World" exercise 44–45

loops 44–45

Macintosh 65

on Linux/UNIX servers 40–41

on Windows servers 40

pros and cons 38–39

PWS 40

timestamping database records
 221–222

UltraDev output 65

UltraDev support 11

vs. JSP 41

Add Extension when Saving 68

adding
 folders, Site Files window 82
 meta tags 214
 pages, Site Files window 82
 records
 HTML forms 150–152
 Server Behavior window 75
 users 191–194
 See also inserting

Advance Open Window extension
 212–213

alignment, Web page elements 136

Allaire Corporation 66

Allow nulls 31

Allow Zero Record Length property
 31

applets, inserting 70

.asp extension 40

ASP (Active Server Pages)
 < %...% > delimiters 44
 .asp extension 40
 code example 44–45